SEEDS ON ICE

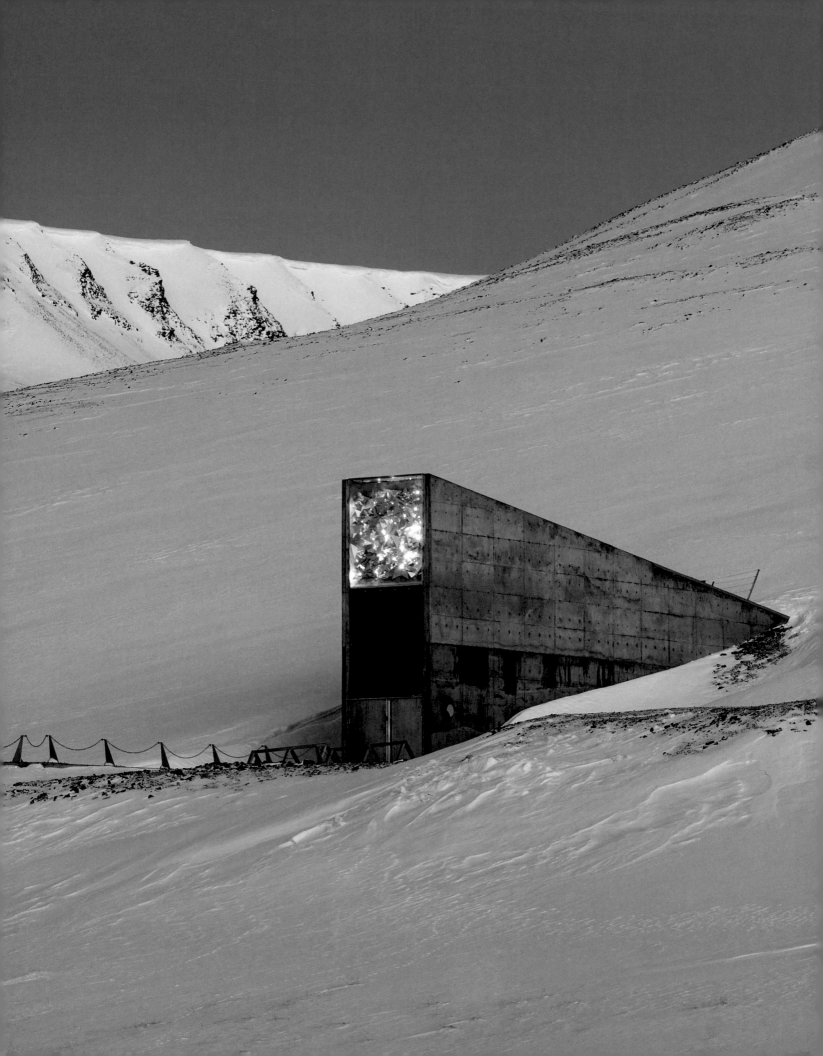

These resources stand between
us and catastrophic starvation
on a scale we cannot imagine.
In a very real sense the future
of the human race rides
on these materials.

Who would survive if wheat, rice
or maize were to be destroyed?
To suggest such a possibility
would have seemed absurd a few
years ago. It is not absurd now.
How real are the dangers?
One might as well ask how serious
is atomic warfare. The consequences
of failure of one of our major food
plants are beyond imagination.

JACK HARLAN

(1917-1998) President of the Crop Science Society of America, member of the
National Academy of Sciences, chair of the Third International Technical Conference on
Plant Genetic Resources, professor of plant genetics.

Preceeding
Wheat in Ethiopia
being tested for a
virulent disease,
wheat stem rust.

Right
Collected in
Columbia, "Carcha"
belongs to gene
pool of Lima
beans with ancient
Andean origins,
possibly 6,000
years ago.

Prospecta Press
Westport, Connecticut, USA

Seeds on Ice copyright © 2016,
2024 by Cary Fowler

Published by Prospecta Press,
an imprint of Easton Studio Press
P.O. Box 3131
Westport, CT 06880
(203) 571-0781
www.prospectapress.com

Cover by Doyle Partners

Original hardcover edition
published 2016.
Revised, updated hardcover
edition, April 2024

Manufactured in China

ISBN: 978-1-63226-139-7

SVALBARD AND THE

S E
B
O N
O N
C A R Y F

DESIGN BY DOYLE PARTNERS

GLOBAL SEED VAULT

S
E
E
D
S

O
N

I
C
E

F
O
W
L
E
R

PHOTOGRAPHS BY **MARI TEFRE**

WITH ADDITIONAL PHOTOGRAPHS BY **JIM RICHARDSON**

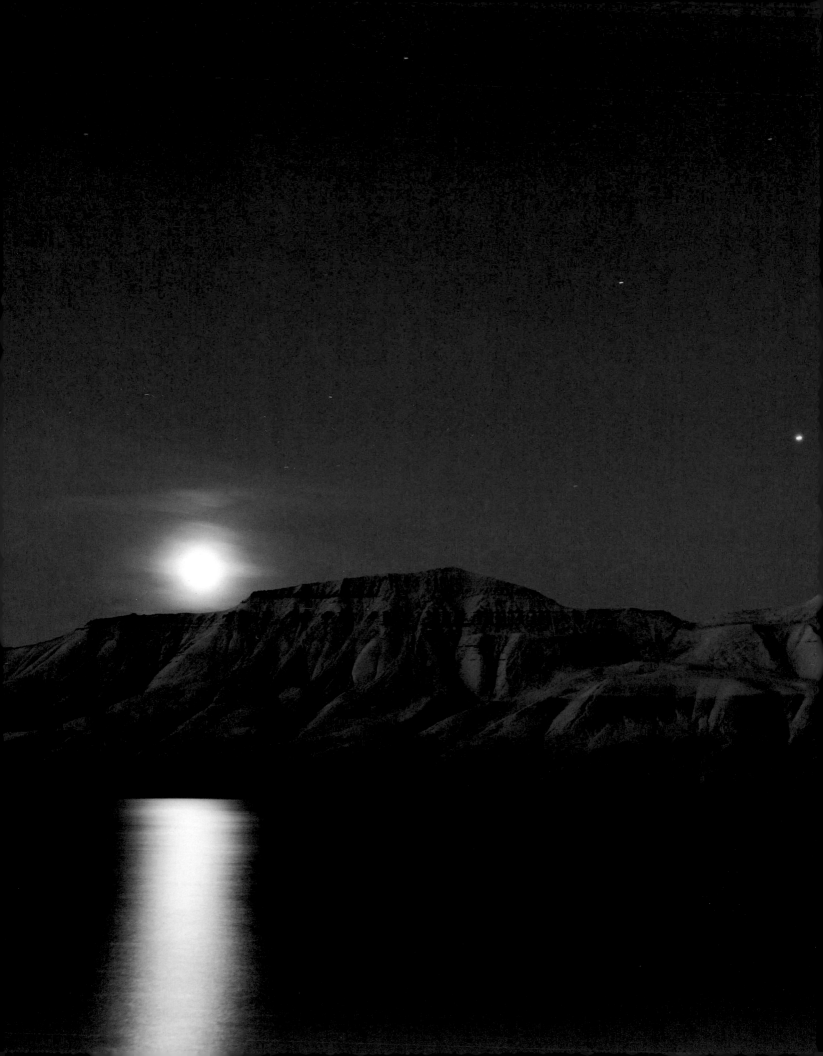

Dato	Firma	Navn	Besøker	Inn	Ut	Signatur

Secretary General of the United Nations
Visit to the Polar Ice Brim 31 Aug - 2 Sep 09

I am impressed by the very creative initiative to preserve food security.

This is an inspirational symbol of peace and food security for the entire humanity.

Ki M. Boon

Erik Solheim

Lars P. Brelch

Ralph Payet (Seychelles)

Young Mook Kim

FOREWORD

Every day, as more and more people move to the cities, and as rapid advances in technology become ever more central in every aspect of our daily lives, it is easy to forget one of the few fundamentals that unites us all: the basic human requirement for food. No one can opt out of this seemingly simple human need. It is non-negotiable, and as a result everyone is dependent on the world of plants. It is the magic molecular trickery of plants that transforms the sun's energy into the chemical energy on which we, and other animals, ultimately depend.

Visitors' Log entry by UN Secretary General Ban Ki-moon upon his visit to the Seed Vault.

In this readable and beautifully illustrated book, Cary Fowler reminds us of our debt to the world of plants and our responsibility for forward-looking stewardship of the variety of plant life, especially of the genetic variety of those plants that are the foundation of global agriculture. It is a personal and passionate reminder that we should not take our reliance on the world of plants for granted, and that in a changing and unpredictable world, the only way to make sure that agriculture remains productive and is resilient for the future, is to ensure that it is adaptable. This book is a plea for the importance of diversity and the need for action to secure the future of plentiful and nutritious food for all. Along with water, food is a prerequisite for our continuing human existence.

The history of agriculture is the history of human civilization, but the inexorable trend, especially over the past half-century, has been toward supporting a growing human population on a steadily diminishing number of varieties of just a few key crops. Our ancestors routinely used a great variety of plants for food. Today our food supply depends on just a handful of the more than 350,000 species of plants on the planet. And within each of our critical crop species our modern varieties themselves rest on a narrower and narrower genetic base. The end result is that we are putting more and more of our metaphorical eggs into fewer and fewer baskets.

In the face of these trends, the core message of this book is that when it comes to ensuring the future of food, humility, rather than hubris, should be our watchword. Many of the world's poorest people understand this very well. They know that the difference between a good harvest and bad one can mean the difference between a happy life and misery, or even the difference between life and death. But too often, especially in the developed world, we assume that food will always be plentiful and cheap. This book reminds us that we would do well not to assume too much. We need to think ahead, anticipate the difficulties that agriculture will need to confront, and act accordingly. Over the long term, the global food supply will face many challenges. As emphasized by the Global Crop Diversity Trust, of which Cary Fowler was the inaugural director, "We know that conserving the vast diversity within crops globally is the only way to guarantee that farmers and plant breeders will have the raw material needed to adapt to whatever the future brings." It is just common sense to keep our options open.

Sustaining and continuing to develop high-yielding varieties of our most important crops is vital, especially when they can be paired with cultivation techniques that reduce the need for lavish inputs of fertilizer and water. High-yielding crops help global agriculture keep pace with increasing demand, and higher yield from the same land area helps spare other potentially productive land from being cleared for agriculture. But everywhere these crops are planted every variety is under constant assault from rapidly evolving pathogens and pests that move easily from place to place in our ever-smaller world. Evolution is endlessly creative at circumventing our attempts to gain the upper hand. All our crops are in a Darwinian arms race for survival. And so are we, because we depend on them.

Today agriculture also faces another severe challenge. In many parts of the world, long-standing threats from pests and pathogens, which crops have faced since the very beginning, are being exacerbated by changing climates. Climate change is a game changer for agriculture and introduces new complexity into an already challenging situation. We should not assume that crop varieties that perform well today will also perform well under higher temperatures and changing patterns of precipitation. Changing and less predictable patterns of droughts and floods are already a significant problem.

The Svalbard Global Seed Vault is a key component of global efforts to secure the diversity of our most important crop plants to ensure that they meet our needs for the long term, and this book tells us the inside story of how the vault came to be. It is a more complex and nuanced story than the "Doomsday Vault" romanticized by the popular press, but in the end the Svalbard Global Seed Vault is an elegantly simple and pragmatic response to a pressing global need. It is an insurance policy for the future of global agriculture. And one that we hope will rarely need to be cashed in.

I have had the great privilege of making the long journey north to the Svalbard Global Seed Vault twice, both times in winter. It is stunningly beautiful from the outside, even more

so in the strange winter twilight of this windswept Arctic archipelago. Inside it is sparse and utilitarian: almost brutal in its simplicity. This is not a facility of bright laboratories, gleaming stainless steel and legions of white-coated scientists. It is a vault: bare, dry, cold, secure from the elements, and far removed from most of the turmoil of the outside world. The remarkable photographs by Mari Tefre and Jim Richardson capture the essence of this unique place.

Deep in this remote mountain the great seed store contains seeds of thousands of varieties, of many kinds of crops, from all over the world. These millions of living seeds, each with the potential to develop into a new plant, are the failsafe for the raw materials that farmers and plant breeders will use to meet the agricultural challenges of coming millennia. And the Svalbard Global Seed Vault is also a model of international collaboration. Seed from the seed banks of North Korea, the United States of America, and many other countries—seeds still owned by their respective national governments—sit easily alongside one another. The Svalbard Global Seed Vault is a trusted, simple solution that most of the world has quickly adopted. And it has already proved its worth. Over the next decade the seeds stored at the International Center for Agricultural Research in the Dry Areas in Aleppo, Syria, which are inaccessible because of the current fighting, are being regenerated from the back-up collections at Svalbard and made available once again to the world.

This is an engaging book on a serious subject. The Svalbard Global Seed Vault began only a few years ago as a visionary concept. Today it is reality. Its importance for the long term is hard to overstate. If you doubt it, just stop for moment and reflect on two simple questions: can we afford to take chances with the future of agriculture? And what else that we are creating today will still be relevant, many centuries from now, not just for a select few, but also for all of humanity?

Professor Sir Peter Crane FRS

President (2016–)
Oak Spring Garden Foundation

Carl W. Knobloch Jr., Dean (2009–2016)
Yale School of Forestry and Environmental Studies

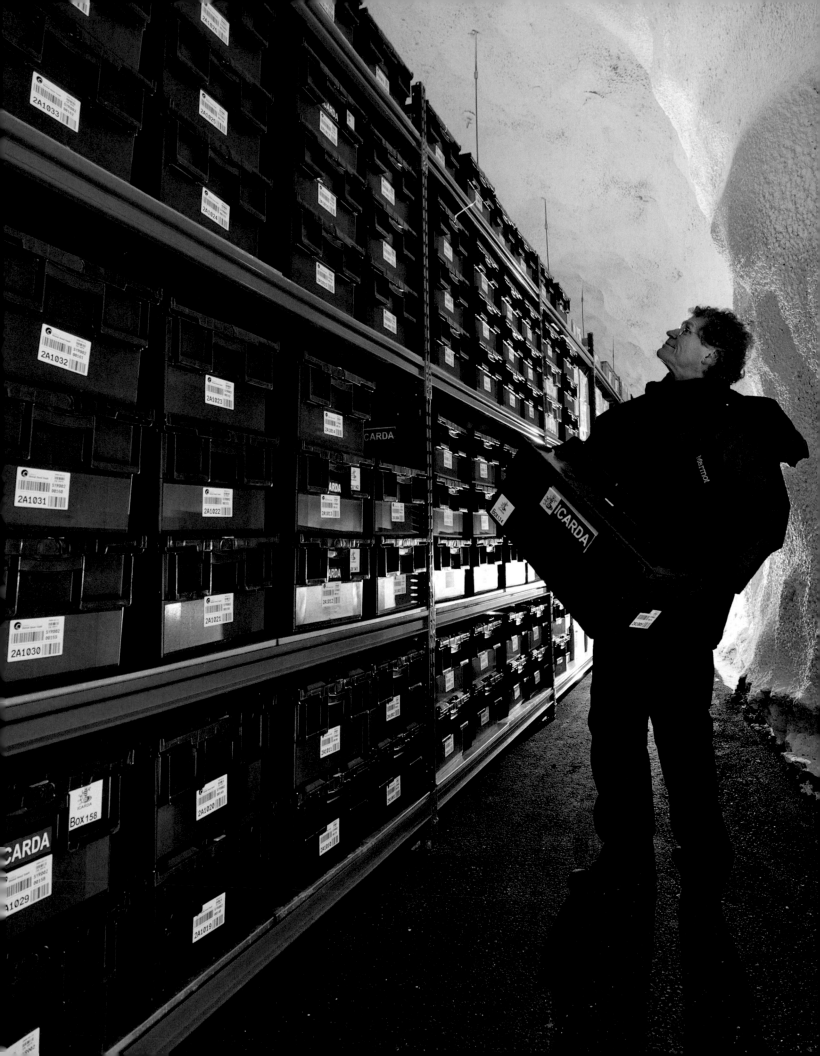

PREFACE

Closer to the North Pole than to the Arctic Circle, remote and rocky Plateau Mountain in the Norwegian archipelago of Svalbard seems an unlikely spot for any global effort, much less one to safeguard agriculture. In this frigid and dramatically desolate environment, no grains, no gardens, no trees can grow. Yet at the end of a 130-meter-long tunnel chiseled out of solid stone is a room filled with humanity's most precious treasure, the largest and most diverse seed collection ever assembled: more than a half billion seeds.

A quiet rescue mission is under way. With growing evidence that unchecked climate change will seriously undermine food production and threaten the diversity of crops around the world, the Svalbard Global Seed Vault represents a major step toward ensuring—you might even say guaranteeing—the preservation of hundreds of thousands of unique crop varieties. This is a seed collection, but more importantly it is a collection of the traits found within the seeds: the genes that give one variety resistance to a particular pest and another variety tolerance for hot, dry weather. Plant breeders and farmers will draw upon this diversity to help crops keep pace with a warmer climate and ever-evolving pests and diseases. Virtually everything,

every trait we might want our crops to have in the future—all the options—can be found in this genetic diversity. And the lion's share of the world's crop diversity, the "stuff" that will enable crops to evolve and adapt for as long as human beings have agriculture, can be found in the Svalbard Global Seed Vault.

Simply put, the mission of the Seed Vault is to safeguard the diversity of our agricultural crops in perpetuity. It exists to conserve the seeds that contain this diversity. Formally, the Seed Vault is a noncommercial international partnership among the Royal Norwegian Ministry of Agriculture and Food, the Nordic Genetic Resource Center (Alnarp, Sweden), and the Global Crop Diversity Trust (Bonn, Germany). But the partnership extends far beyond that to include the many genebanks that have sent seeds to Svalbard for safekeeping, and beyond that to the farming communities and ultimately the consumers they serve—in other words, to all of us.

Few people will ever see or come into contact with the contents of this vault. In sealed boxes, behind multiple locked doors, monitored by electronic security systems (not to mention the occasional visit from indigenous polar bears), enveloped in frigid below-zero temperatures, and surrounded and insulated by tons of rock, hundreds of millions of seeds are protected in their mountain fortress. Frozen in such conditions inside the mountain, seeds of most major crops will remain viable for hundreds of years, or longer. Seeds of some are capable of retaining their ability to sprout for thousands of years.

This book is about the Seed Vault and the remarkable effort to save the past and the future of agriculture in an enchantingly beautiful place that I have come to love, and that Mari Tefre, the principal photographer for this book, both loves and has called home. It is about hope and it is about commitment—about what can be done if countries come together, shed suspicion and cynicism, and work cooperatively to accomplish something significant, long lasting, and worthy of who we are and wish to be. Look deeply into the photos, read between the lines of text, and you will discern the stories of farmers, scientists, and those of us who persisted in pursuing the dream of establishing a global seed vault.

Turn the pages and you will also be given your own guided tour, as the Seed Vault—or the "doomsday vault" as the media often terms it—is not open to the public. From groundbreaking to finished seed repository, from the entrance door to the frozen, off-limits seed storage rooms, we'll show you the Seed Vault in its arctic context, the splendor of Svalbard. As we do that, we'll address the questions everyone seems to have: Why was it constructed? Who was behind it? How does it operate? Why was it built in such a cold and remote place? What kinds of seeds are inside? Where did they come from? Why is it important to save all these seeds? What does the Seed Vault really do? And how, exactly does it do it—how will it be used? What will this accomplish?

Seeds on Ice is my plea for the conservation of crop diversity, the biological foundation of agriculture and arguably humankind's most important natural resource. It is also a tribute

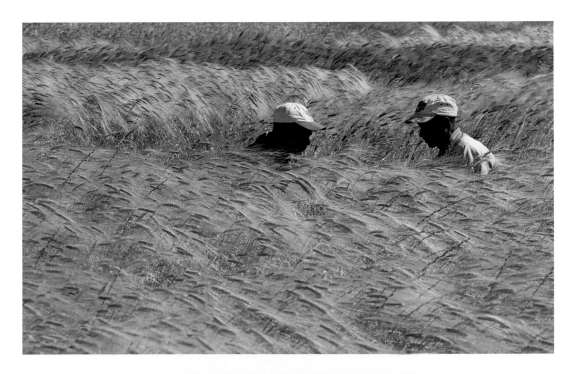

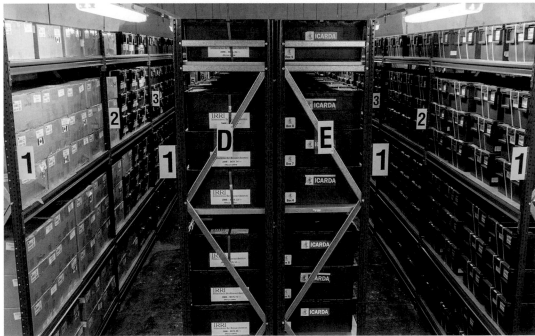

to our farming ancestors—yours and mine—as well as to today's farmers, for it is farmers, past and present, who have developed and nurtured this diversity. This book is a love letter to Svalbard and its beauty and majesty, to the Seed Vault, to the people involved, to the community of Longyearbyen, and to the belief that the biodiversity the Seed Vault protects is a common heritage of all humanity. By default and necessity, we are its guardians.

Lastly this book is a testimonial to unvanquished optimism, to my conviction and my experience that global problems, even huge ones, can be solved through trust, good will, cooperation, and perseverance.

Left
The diversity of grains and legumes forms the basis for most of the world's major agricultural systems.

Right
The entrance of the Seed Vault as seen from a helicopter.

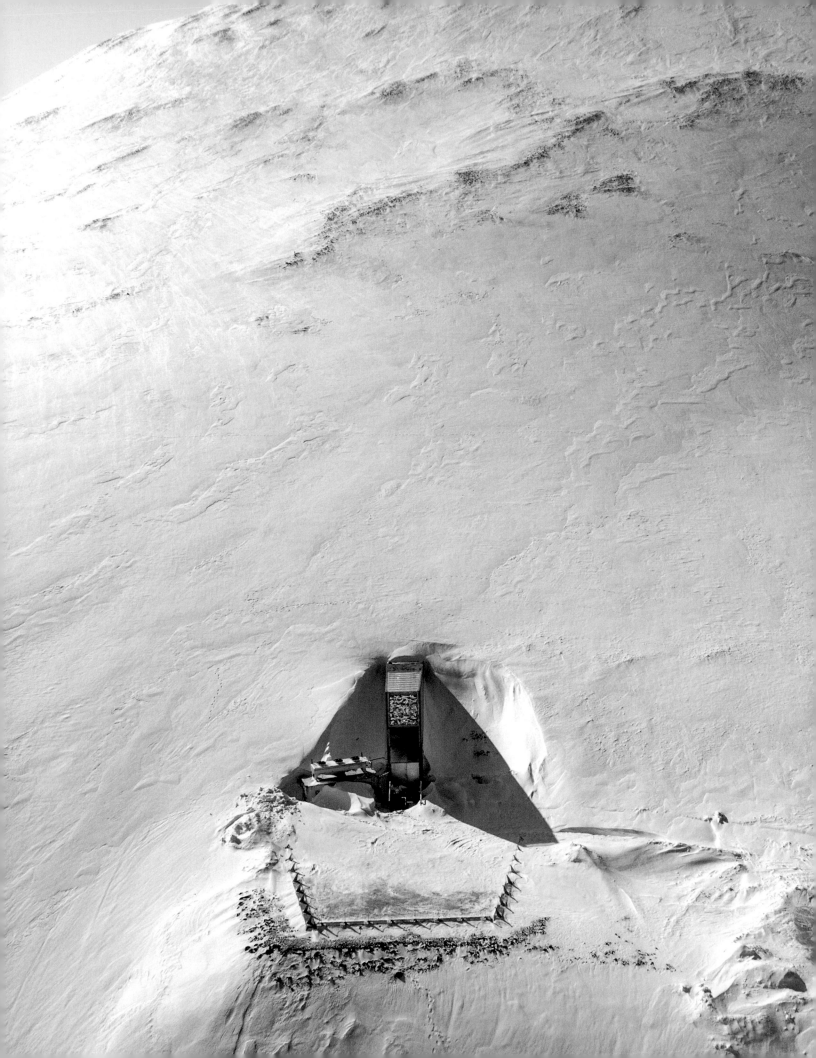

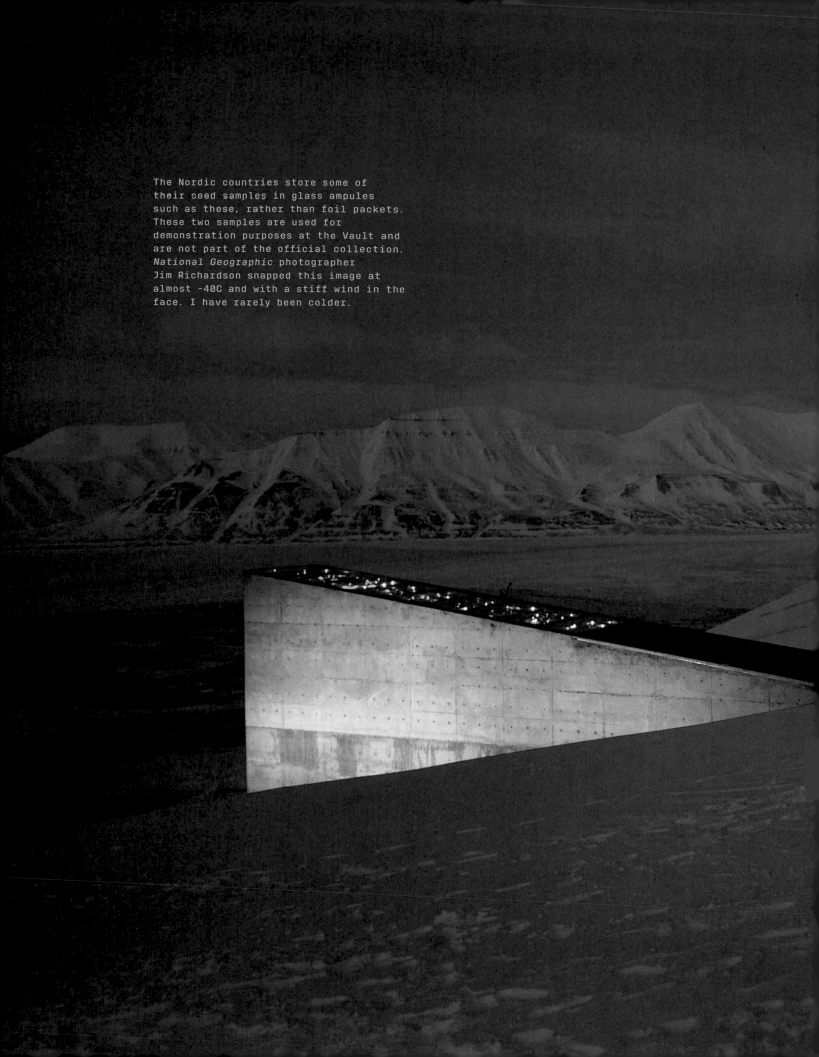

The Nordic countries store some of
their seed samples in glass ampules
such as these, rather than foil packets.
These two samples are used for
demonstration purposes at the Vault and
are not part of the official collection.
National Geographic photographer
Jim Richardson snapped this image at
almost -40C and with a stiff wind in the
face. I have rarely been colder.

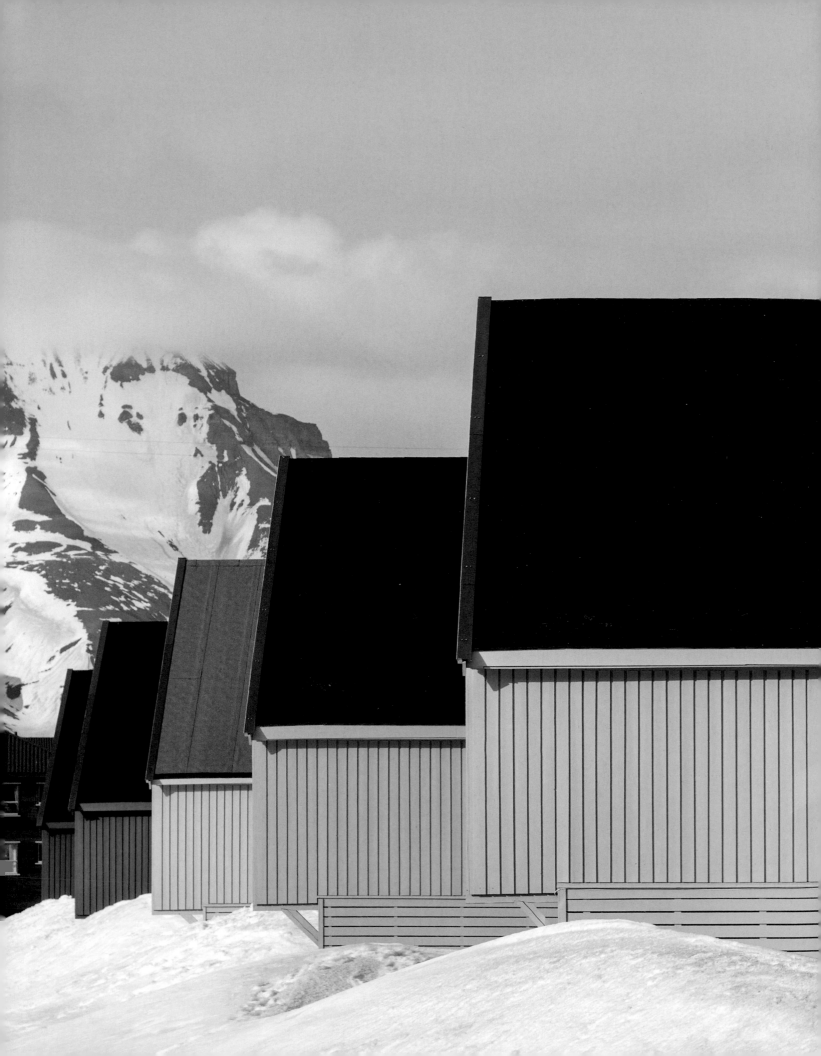

SVALBARD

To understand the Seed Vault, you first need a feeling for its home, Svalbard. Until recently Svalbard was, to those who even recognized the name, an inhospitable and inconsequential outpost uncomfortably near the North Pole. Geopolitics, scientific interest in the far north, and a daily SAS flight bringing adventuresome tourists helped change that. As did the Seed Vault itself, one of the world's most recognizable structures.

Colorful houses in Longyearbyen, Svalbard.

Discovered in 1596 by Willem Barents, Svalbard is a group of islands lying north of mainland Norway between 74° and 81° north. Its 23,561 square miles make it twice the size of Belgium. Here polar bears outnumber people two to one, and reindeer outnumber everything.

Board a plane in Rome and fly across Europe to Oslo, and you are almost halfway to the little village of Longyearbyen, the main settlement in Svalbard. It's that far north. At a latitude of 78° this is as far north as one can fly on a regularly scheduled commercial airplane, and as close as anyone can get by air to the North Pole.

Except for Norwegians, a trip to Svalbard is inevitably a two-day journey. The regular flight up from Oslo departs around nine-thirty in the morning, before incoming flights from overseas have arrived, so an overnight stay in Norway's capital is required. The flight to Svalbard stops in Tromsø, 315 kilometers (217 miles) north of the

Arctic Circle, Norway's seventh-largest city and home to the world's northernmost university and medical school.

Leaving Tromsø on the last leg of the journey over the sea to Svalbard, one notices a sign just before entering the plane. It features a photo of a polar bear eating a bloody carcass. The caption reads "Take the Polar Bear Danger Seriously." Ten years ago, Svalbard residents, a smattering of intrepid polar researchers, and a couple of tourists might get on the plane toting their rifles. Now weapons are stowed below in the cargo area. Guns are still common enough in Longyearbyen, Svalbard's main town, that the bank posts an image of a gun in a circle with a line drawn across it, indicating that firearms are forbidden inside.

Residents do not live in fear of polar bears, which are called *isbjørn*, literally "ice bear," in Norwegian. But they are watchful and they do take precautions. On snow scooter trips outside the village, or on hikes in the mountains that dominate the landscape, locals take a large-bore rifle and perhaps a pistol or flare gun as well, for frightening away any bears they might encounter. Some years, bears come into Longyearbyen several dozen times. Adult males can easily weigh over a thousand pounds. Huge, fast, well camouflaged, perched atop the food chain, and able to eviscerate a person with

a single swipe of their paw, they are unpredictable and very dangerous. Furthermore, they can be found anywhere and at any time in Svalbard, as road signs on the edge of Longyearbyen warn. Everyone who lives in Svalbard has a polar bear story, and everyone who visits yearns to see one. But not up close.

Svalbard's climate and terrain can be described by one word: *extreme*. It can snow any day of the year, and has. Case in point: it snowed and was bitterly cold during a trip I took in June 2013 on the twelve-passenger MS *Stockholm* around the southern tip of the island of Spitsbergen and northward up the east coast. We saw about a dozen polar bears. One pulled a seal bigger than itself out of the water; another crouched over a hole in the ice for an hour, waiting for a seal to pop up. We melted when we saw this mother bear nurse her two cubs.

Catching a glimpse in the distance of one of these huge elegant bears silently walking on the ice, a solitary dot against a gigantic unmarred vista of glaciers, mountains, and shoreline, I began to feel the enormity of this place called Svalbard, how I am no more than a small and ill-prepared alien in this environment. Outside the village of Longyearbyen, humans simply

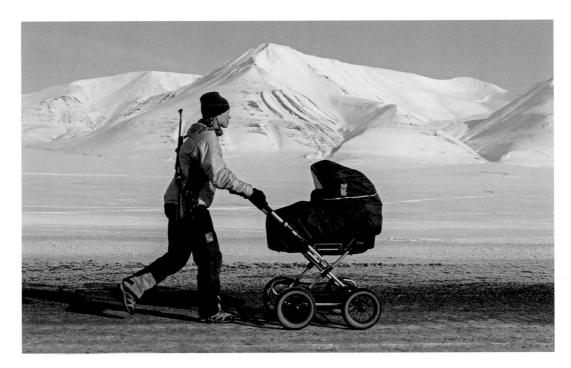

Family life
in Svalbard.
A daily stroll
with the baby
and a gun
for protection
from polar
bears which
can be found
anywhere
anytime in
Svalbard.

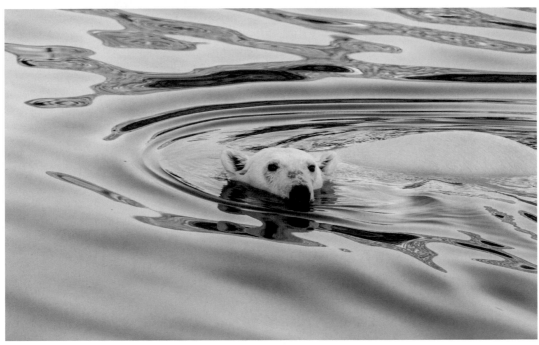

are not in control the way they are virtually everywhere else on the planet. It is an eerie, humbling, disturbing, exhilarating feeling.

On more than one occasion, the *Stockholm* was blocked by thick ice floes. Once, returning to the ship on a Zodiac inflatable boat after going ashore to take a closer look at a family of walruses, eight of us were nearly trapped by rapidly encircling sheets of floating ice. We slowly and apprehensively threaded our way through the maze and made it back to a dressing down by the captain. In this environment, there is no such thing as a small mistake.

One particularly haunting story about life in this environment stays with me. In February 1922, two men, Harald Simonsen and Torgeir Møkleby, set out in an open rowboat with a gun, some ammunition, and a six-week supply of food to check on an old trapper who was overwintering north of Lonyearbyen. He had not been heard of in many months. They did not intend to be gone long. The food was intended for the old trapper, who as it turned out, had already died. Soon after they began, Simonsen and Møkleby encountered brash ice, a form of pack ice consisting of an expanse of small pieces, perhaps a meter or two long and wide, blown together by the wind and the currents, rather like that we occasionally encountered on the MS *Stockholm* in 2013. But this was winter and they were totally at its mercy; they could neither navigate through the ice nor get out of the boat and cross the ice to shore.

For three weeks they survived in an open boat during a brutal period of winter. Finally, with dwindling supplies, they made it to land where they found a tiny hut. All the while the two kept remarkable diaries, full of perseverance, kindness and consideration

for one another, and for much of the period, uncommonly hopeful. At this stage they aspired simply to last long enough for the ice to clear, for ships to pass by; long enough to be rescued in the spring. But, slowly, they were starving. By June, Møkelby had shot thirty-six birds and had three bullets left, yet was too weak to stand and hunt. Between June 4 and 8, they were able to make soup four times with bird skins they had saved.

Right
Longyearbyen, the northernmost permanent settlement in the world. Power is generated from locally mined coal.

Left
Brash ice, a form of pack ice consisting of an expanse of small pieces blown together by the wind and the currents.

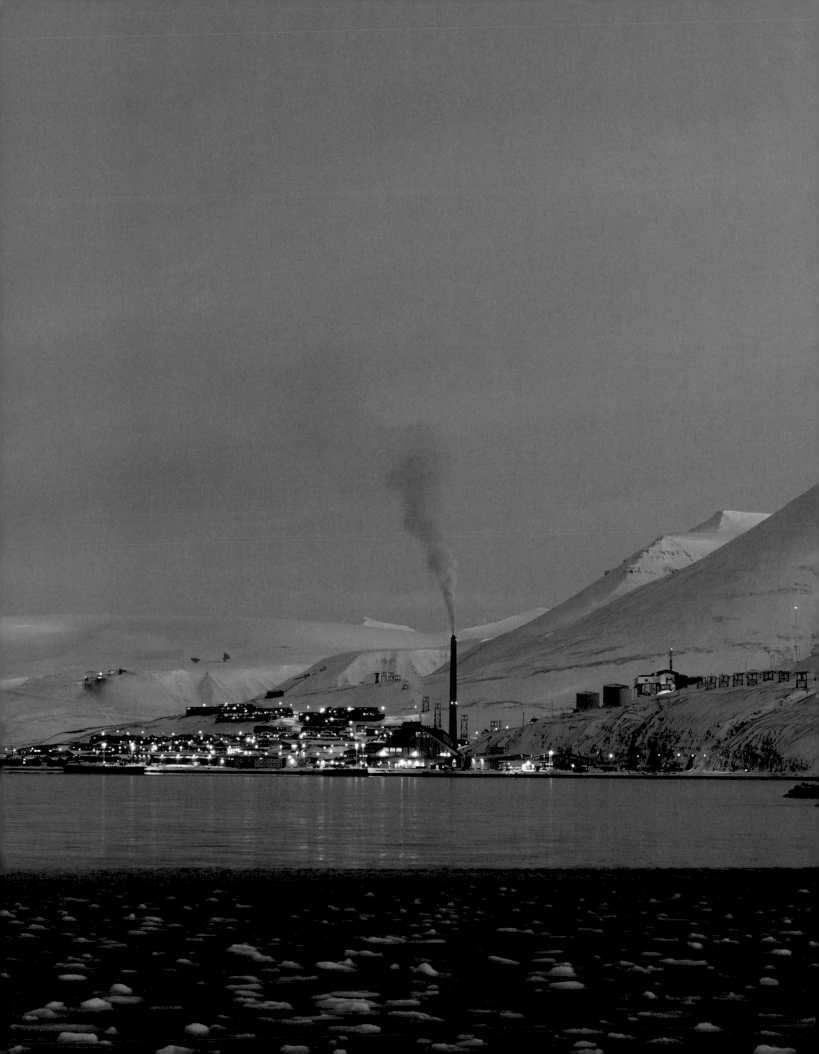

Simonsen's diary entries end on the twelfth. On June 7, knowing the end was near, Møkelby wrote: "We are tired and happy to slip away . . . If our remains are found, it is my last wish to come home and be a moment in a church before I am laid in the welcoming earth. This is now my hope. But not a white coffin or a white headstone. I have seen only white now for so long, that I long for something else. And plant flowers on my grave. Blue and red."

Simonsen's last words, a letter to his mother, are dated June 13. Møkelby's final diary entry was written the same day. Their bodies and their diaries were discovered the following summer.

Simonsen and Møkelby could not escape Svalbard's ice. In a sense, no one can. Glaciers cover 60 percent of the landmass, despite the fact that Svalbard is an arctic desert, receiving little annual precipitation. The largest glacier, Austfonna, is up to eighteen hundred feet thick in places with a long eighty-mile front to the sea. The glaciers are receding, however; in many places it is now possible to walk hundreds of yards across newly uncovered barren, pebble-strewn land that until recently was "permanently" under ice.

Between November 14 and January 29 every year, Svalbard is in the grips of "polar night," when the sun never gets close enough to the horizon to offer a glimpse of direct light. Even after the sun peaks above the horizon, it still can be hidden from view for weeks by the mountains. The sun returns to Longyearbyen on March 8, when residents pile out of their houses to catch the first rays, and children dress up in sun-themed attire to initiate the weeklong Sun Festival.

The Arctic fox can often be seen in the Svalbard landscape and even darting through the village of Longyearbyen.

It's a joyous time. From April 19 to August 23, the sun never dips below the horizon. Nonstop sunshine, twenty-four hours a day.

The seasonally changing light conditions this far north produce some of the most remarkable colors seen anywhere on earth especially when the sun is slightly below the horizon and the light is indirect. Palettes of blues and pinks, sometimes vivid, sometimes pastel, dominate the skies settling upon an austere landscape. The most jaded professional photographers marvel at the light, saying it's like nothing they have experienced.

Blues, greens, and pinks can also dart and dance above in the skies on the darkest of winter nights; Svalbard is the land of the aurora borealis, or northern lights, and home to a research station studying the phenomenon.

While Norway has sovereignty over the islands, the largest of which is Spitsbergen, they are regulated according to the 1920 Treaty of Svalbard, to which forty-three countries are party. Whaling and fishing attracted ships and adventurers to Svalbard in the early 1600s. Later, they were joined by hunters and trappers and in the beginning of the 1900s, by coal miners. There was no preexisting indigenous population in Svalbard.

There are three "major" settlements in Svalbard: Longyearbyen, with twenty-two hundred mostly Norwegian residents, is the administrative, cultural, and economic "center." Barentsburg, a forlorn Russian coal mining village of five hundred, lies to the west, untethered to Longyearbyen by road. And, 113 kilometers (71 miles) to the north of Longyearbyen, lies Ny-Ålesund, a tiny Norwegian polar research community with a year-round population of around twenty-five.

Longyearbyen is named after John Longyear (*byen* is Norwegian for "the town"), who founded it in 1906 as a coal mining village. Norwegians will sometimes further "nordicize" Longyearbyen by using the Norwegian word for "year," which sounds similar to the English word "oar," when saying the town's name: long-oar-byen.

A small town by any standard, Longyearbyen is a collection of improbabilities. Its population declines significantly during the winter months, and in any case few residents can be considered "permanent," not because they don't like Svalbard—they absolutely love it—but because of the temporary nature of most jobs and limits on growth. Nevertheless many residents, intending to stay only a couple of years, find ways to extend their time. It is wrenching to let go of the panoramas, the wildlife, and the particularly close and cozy little society of Longyearbyen. A "Svalbard feeling" takes hold. Welcome trips to the mainland inevitably end with a longing to return.

About a third of the population of Longyearbyen is involved with either government administration or research. The governor's office is in charge of laws, regulations, security, and environmental affairs for all of Svalbard. It houses a small police force, but there is very little crime. During the planning process, the governor whispered to me that if a teenager so much as spray painted a word of graffiti on the side of the Seed Vault, the police would instantly

know who the perpetrator was. But there's been no graffiti.

The modern University Center is the focal point in Svalbard for arctic research, including an impressive amount of climate-related work. It is not a degree-granting institution but rather a facility where students and other researchers come to study, learn, and explore. There are also specialized enterprises including SvalSat, the major satellite tracking and information downloading facility for NASA, NOAA, and the European Space Agency. And there is the impressive Svalbard Museum that won the Council of Europe's Museum Prize in 2008. The museum has fascinating and informative displays covering the history, culture, nature, and science of Svalbard.

A third but declining share of the population is employed by the coal mines that supply fuel not only to keep Longyearbyen lit and warm, but also for export to Japan, Germany, and elsewhere for the manufacture of specialty steels, for example. Remnants of early coal mining days are ubiquitous, including trellises supporting cables that transported bins of coal from mines high up the sides of the mountains to the plant that crushed the coal and prepared it for shipping. The effort to pull gigantic timbers halfway up nearly vertical mountainsides and string heavy steel cables in the cold (perhaps even in the dark) must have been enormous. While the mines that once encircled Longyearbyen and fed coal into bins have now closed, a labyrinth of mine shafts still exists in the mountains all around the town. Other mines have now opened in the valley outside the town and beyond. In the center of town, in the middle of

the main street, stands a life-size statue of a coal miner heading home.

A third and increasing share of the population is connected with tourism. The presence of tourists is rapidly changing the appearance and atmosphere of Longyearbyen, especially in the summer when cruise boats dock in the harbor and day-trippers disembark to wander through the town and shop for quality Norwegian sweaters and souvenirs.

Today there are several fine small hotels in Longyearbyen that accommodate summer tourists and those intrepid and curious enough to visit at other times. My favorite is the Spitsbergen Hotel, also called "Funken." The oldest of the town's hotels, it once served as lodging for mining functionaries (*funksjonær* means "white-collar worker") from the mainland, thus "Funken." Black-and-white photos from the old mining days adorn the hallways and rooms. As in all buildings in Longyearbyen, shoes are taken off when entering from the street. When I pad my way up to the reception desk in my socks to check in and am greeted as a familiar guest, I'm at home. Batter for waffles is put out for guests at four o'clock every afternoon. Self-serve. And breakfast is a feast in the dining room, which overlooks the town in one direction and a glacier in the other. It was at this hotel, in a small sitting room off the lobby, graced with pictures of the Norwegian royal family, that we formulated the initial plans for the Seed Vault.

Above
Ice from one
of Svalbard's
many glaciers
sculpted by
the sea.

Below
Virtually
every resident
has one
or more snow
scooters.

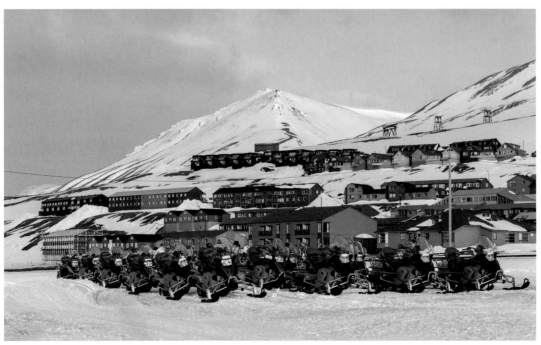

33

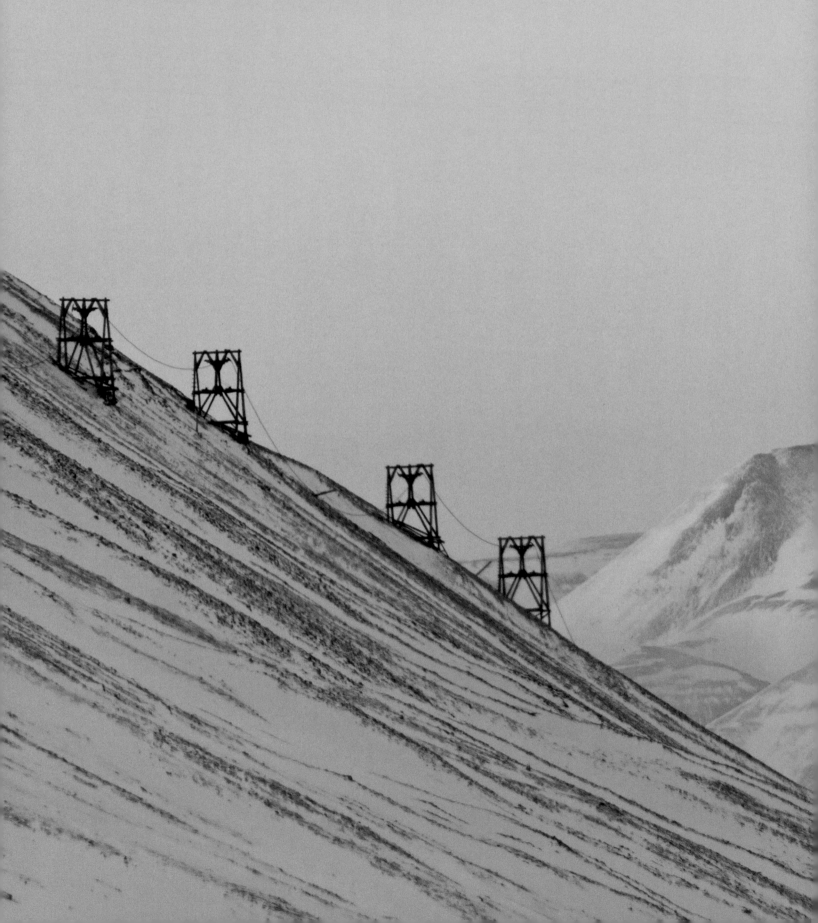

One day in 2004, I called my friend Rune Bergstrøm from my office at the Norwegian University of Life Sciences located south of Oslo. He was then the chief environmental officer in Svalbard. Rune was married to my friend and PhD student, Cassandra Bergstrøm, who was studying ownership and management of reindeer among the Sami people. I was due to fly up to Svalbard a couple of days later with other members of the small committee tasked with assessing the feasibility of establishing a long-term seed conservation facility in Svalbard. Rune had volunteered to pull together local officials to discuss the matter with us.

"Oh!" he suddenly interrupted. "There's a polar bear outside!" In some ways, one could say that Rune's job put him in charge of polar bears in Svalbard. Having one outside the window, however, was a conversation stopper. He politely said good-bye and hung up. A few days later in Svalbard, I inquired what had become of the bear. It was very sad, he explained. Before anyone could try to scare the bear off with flares, it had charged someone who shot and wounded the bear in self-defense, and Rune had to finish the job: the only humane thing to do.

That night at dinner the waitress came and told our little group that the specials for the night were whale and seal in addition to the standard reindeer and cod on the regular menu. Out of curiosity, I asked about polar bear, knowing that one had just been killed and nothing goes to waste here. Without the slightest hesitation, she said she would check to see if any polar bear meat were left. She returned quickly to tell me there wasn't enough for a main course for our table, but the chef could prepare a really nice "polar bear carpaccio" as an appetizer. What could I do? It's the only time I have eaten polar bear, raw or cooked.

So rare is such an occasion, however, that few Longyearbyen residents will ever taste bear meat: fewer than one a year on average is shot in self-defense. My experience was exceptional and colorful. The polar bear is revered in Svalbard. It is considered the "king of the Arctic." Local people love and exalt these majestic animals and will do whatever they can to avoid harming them.

There are not many restaurants in Longyearbyen and all are small. Menus can include reindeer, seal, grouse, and whale. One restaurant,

This trestle and cable system was once used to transport coal from the mines into the village for power generation and export.

Huset, meaning "the house," boasts the best and largest wine cellar in Scandinavia. I often join the locals and crowd into rustic Kroa for a hearty meal. The draft beer is served from a bar featuring a bigger-than-life-size bust of Lenin, which was liberated from Barentsburg, the Russian mining village, in the days following the downfall of the Soviet Union.

There is one small supermarket, a post office, a bank, a couple of bars in addition to Kroa, and two weekly newspapers, one in Norwegian and a much smaller one in English: *Svalbardposten* and *Icepeople*. A number of small shops offer serious winter clothing. As Norwegians are fond of saying, "There is no such thing as bad weather; there are only bad clothes."

Several companies have sprung up in recent years to rent out snow scooters and to take visitors dogsledding or on other outings. Periodically, the fenced compounds where the dogs are kept (one to a doghouse) attract polar bears, and occasionally this leads to some trouble or tragedy.

Everyone who lives in Svalbard must have a means of support. Social services are limited so residency is regulated. Fewer than forty residents of Longyearbyen have lived there since the 1970s. There is a hospital, but pregnant women are required to go back to the mainland

Left Artifacts from the old mining and trapping days before 1946 are legally protected in Svalbard.

Right The King of the Arctic, *isbjørn*, or ice bears, as they are called in Norwegian, are the real royalty of Svalbard.

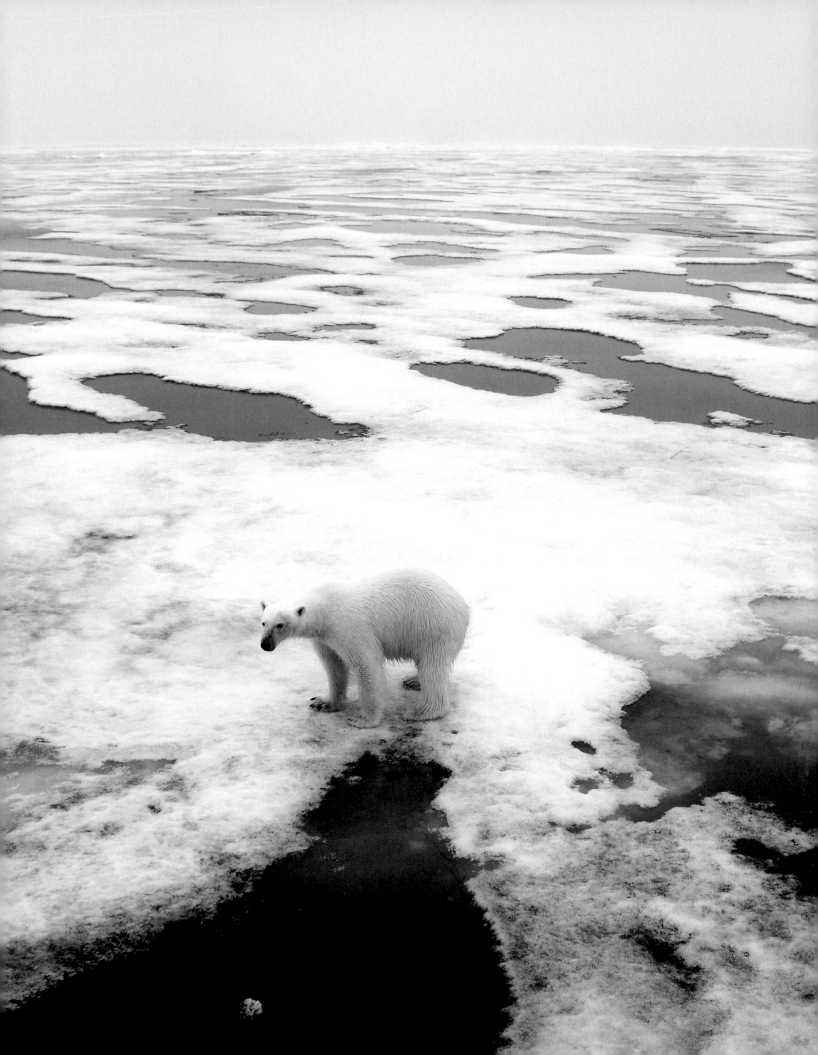

Above
A mountain
scene near
Longyearbyen.

Below
Arctic
cotton grass.

in plenty of time to deliver their babies. And there is a small cemetery, where victims of the flu pandemic in the early twentieth century are interred. You can die in Svalbard but you can't spend eternity there. No more burials are allowed.

Virtually everything in Longyearbyen is the world's northernmost "whatever." The northernmost bar, hospital, kindergarten (which also claims to be the only polar bear proof one in the world), newspaper, taxi service, post office, swimming pool, and bluegrass band (Mari Tefre is a member).

Longyearbyen is a cultural change of pace as well for generally reserved Norwegians. Drawn together by love of the Arctic, and thrown together, usually for a limited time, in a small community on the edge of civilization, people cooperate. They're informal. They help. Rules don't usually get in the way. People make things work. They must. There is considerable human warmth in this cold environment. And, contrary to what one might expect to find so near the North Pole, there are plenty of things to do. Despite the tiny population, there are frequent concerts and performances (many brought in and subsidized by the national government), and more informal social activities than might be found in much larger communities on the mainland. Government support of Longyearbyen means that infrastructure is world class. And the town enjoys status as a tax haven.

Nevertheless, there is isolation. No roads connect Svalbard's settlements. Transportation between them is solely by boat, helicopter, or in the winter by snow scooter. Weather permitting, one or sometimes two commercial flights a day arrive from mainland Norway. Several times, my own northbound flight to Longyearbyen has attempted a landing only to pull up short and return to Tromsø. When this happens, would-be southbound passengers expecting to depart Svalbard return to their homes and hotels and wait a day for the next plane. Prolonged bad weather inevitably means that supplies, brought in by plane in the winter when the harbor is frozen, run low in the supermarket and restaurants. It is not terribly uncommon to find that there is no milk for coffee in the hotel and that fresh fruit is scarce. Everyone simply adjusts.

The weather governs almost everything on Svalbard. But it was not always so cold there. Svalbard was located at the equator 350 million years ago, and home to forests, ferns, and dinosaurs, whose tracks and fossils can be found on Svalbard today. With such a history it is not so surprising that the mountains contain large coal deposits. Sixty million years ago, Svalbard was at the latitude of Oslo. Slowly it's headed to the North Pole.

While Svalbard can be frighteningly cold, and life threatening to anyone foolish enough to venture beyond the settlements without serious and proper clothing as well as a gun, it is not as uniformly frigid as some might imagine. Temperatures average above freezing in many areas during the summer months, though in winter the average temperature is around −18° Celsius, or between 0° and −1° Fahrenheit. In part, the "warmth" comes from the North Atlantic current that bathes the western shores of Svalbard. The interior and eastern portions of the archipelago are colder.

On a winter day, in the dark, with temperatures below zero and nothing to stop fierce northern winds, nature is in control. This realization can be startling and profound to visitors accustomed to being tethered to civilization and safety by nearby roads, cell phones, and other people. For most visitors to Svalbard, a walk around Longyearbyen is exotic and memorable. Beyond the village, it's a new emotional experience, exhilarating but unsettling to the core for many.

Svalbard is more than winter and ice. There is a summer season. The "growing season" is rarely longer than a hundred days and often much less, but it is long enough for the valleys to be blanketed with patches of small, beautiful wildflowers—white, pink, blue, purple—and short grasses. Svalbard's purple saxifrage (*Saxifraga oppositifolia*) has the distinction of growing farther north than any other flower in the world. The climate prevents farming or gardening. No crops, no ornamentals, no shrubs, no trees are to be found anywhere in Svalbard. Livestock is raised, however. The miners in Barentsburg keep some hogs indoors for pork to complement the considerable rations of vodka they get monthly as part of their pay.

Svalbard is home to some ten thousand reindeer, mostly inhabiting the valleys but also routinely found nibbling away at the short native grasses in the village of Longyearbyen. Locals comment that during hunting season the reindeer will always seem particularly abundant in Longyearbyen, where they are safe. These hearty animals eat constantly during the summer to stave off enforced dieting during the winter. They can lose up to half their weight before the land thaws and the grass reemerges.

Arctic foxes with snow-white fur superbly adapted to their surroundings scavenge everywhere and can also be seen darting through Longyearbyen. During construction of the Seed Vault, one (nicknamed "Salami") appeared at noon every day during the workers' lunch break.

During the summer birds can be found in abundance, among them colorful puffins, the northern fulmar (which spends its life in and above the water except when it is nesting), and the arctic tern, a modest-sized bird that will furiously dive-bomb and hurt anyone coming close to its nesting area on the ground. The Svalbard ptarmigan, a type of grouse, is the only bird that overwinters. It can sometimes be found on the menu in restaurants.

Offshore are walrus, a protected species since 1952, multiple species of seal, and whales including beluga, killer, sperm, northern minke, fin, humpback, and bowhead.

Flora, fauna, and sites of historical importance are fragile in Svalbard and environmental and cultural heritage laws are strict. Transgressions are rare, however, as residents are deeply committed to conservation.

In 2008, with the opening of the Seed Vault, a very different kind of biodiversity, also fragile and vulnerable, came under protection in Svalbard. While the Seed Vault is situated in this unique and enchanting archipelago, it is even more rooted in the farmlands and cultures that gave rise to the seed it now protects.

Above
A medicinal plant in a number of cultures, the Mountain Aven is found in many locations in Svalbard.

Below
Children gliding and sliding to school in Longyearbyen on their "spark," a Norwegian kick-sled.

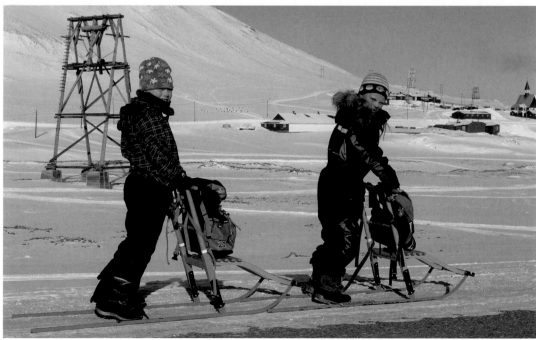

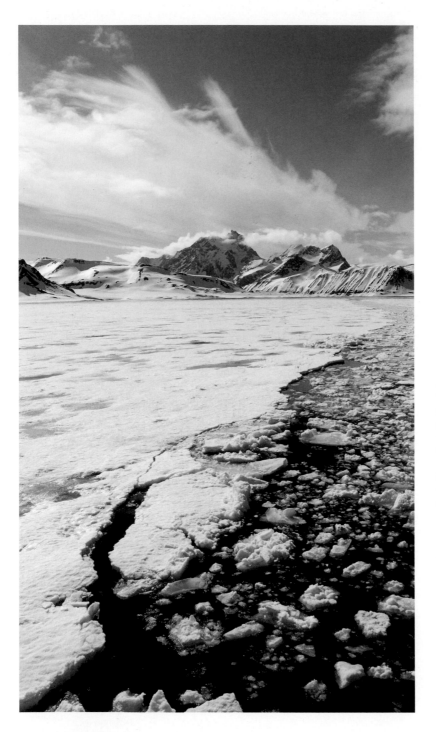

Left
The waters around Svalbard can still be frozen even in the summer.

Right
The Norwegian village of Longyearbyen in the polar night, taken from the nearest glacier.

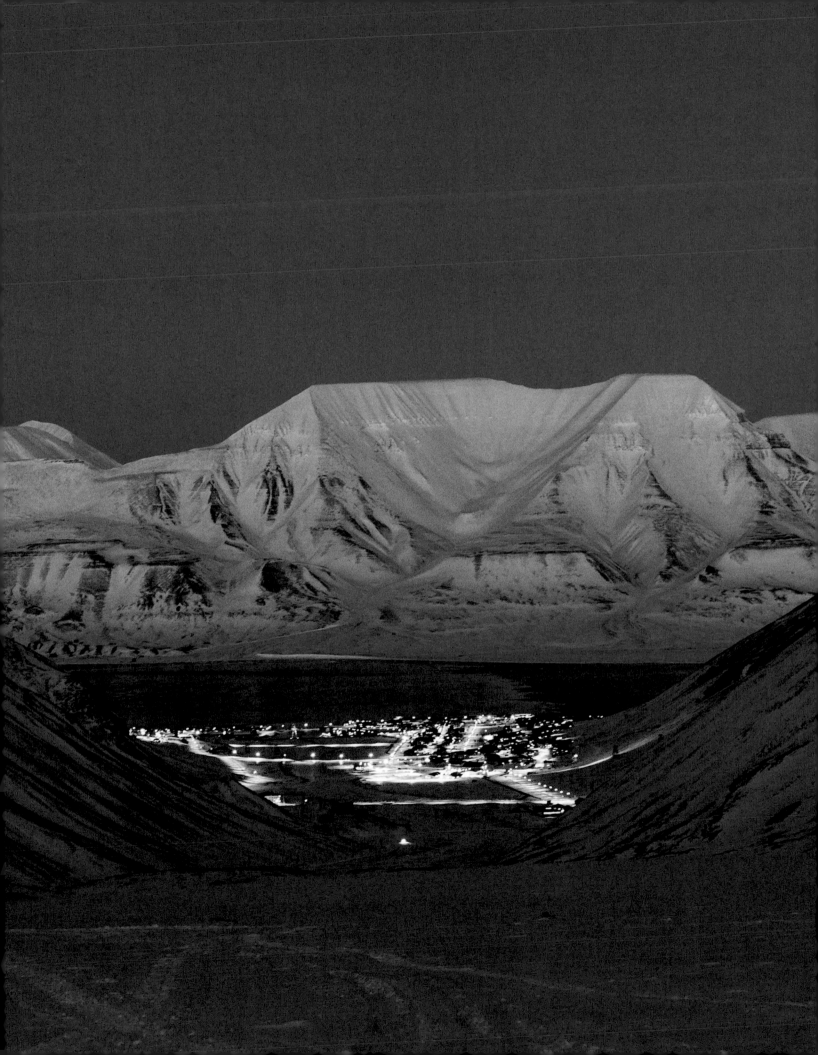

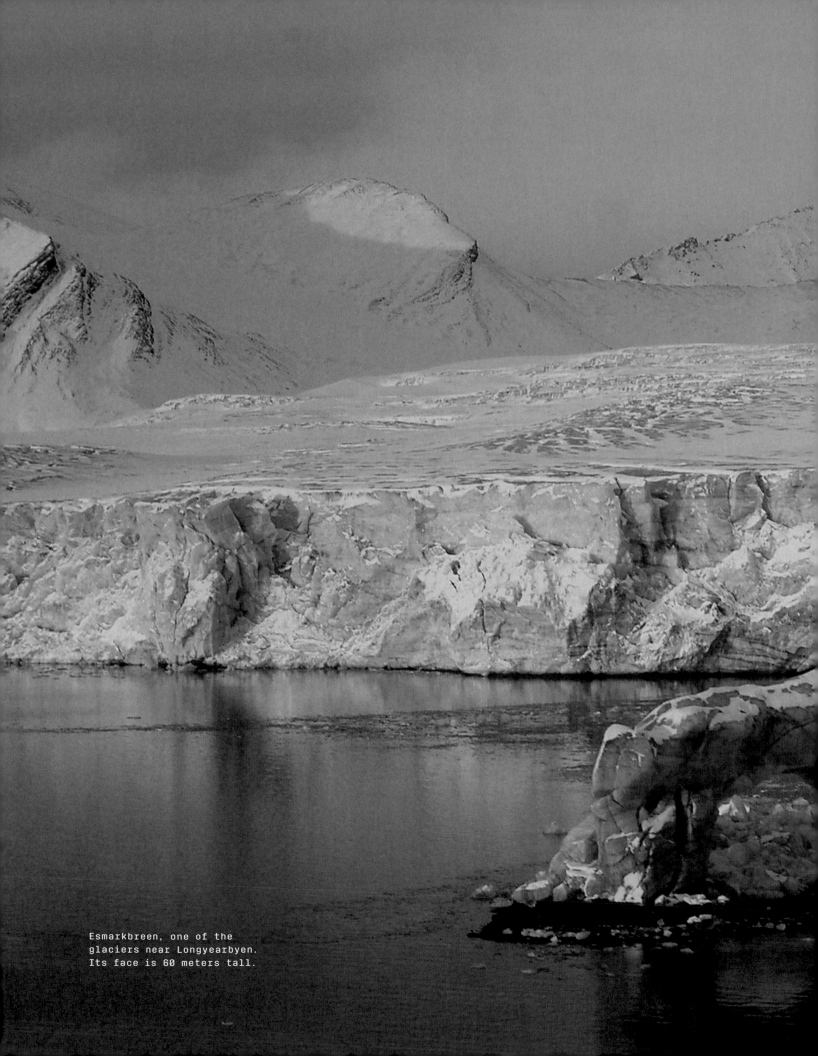

Esmarkbreen, one of the
glaciers near Longyearbyen.
Its face is 60 meters tall.

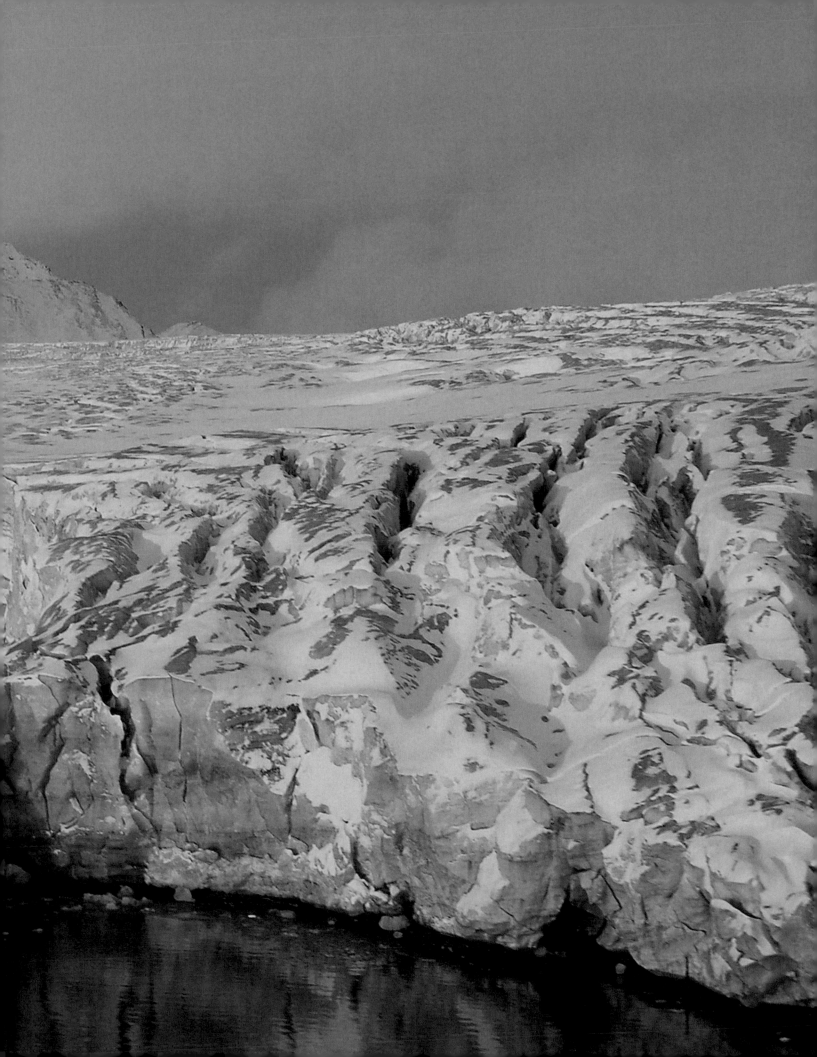

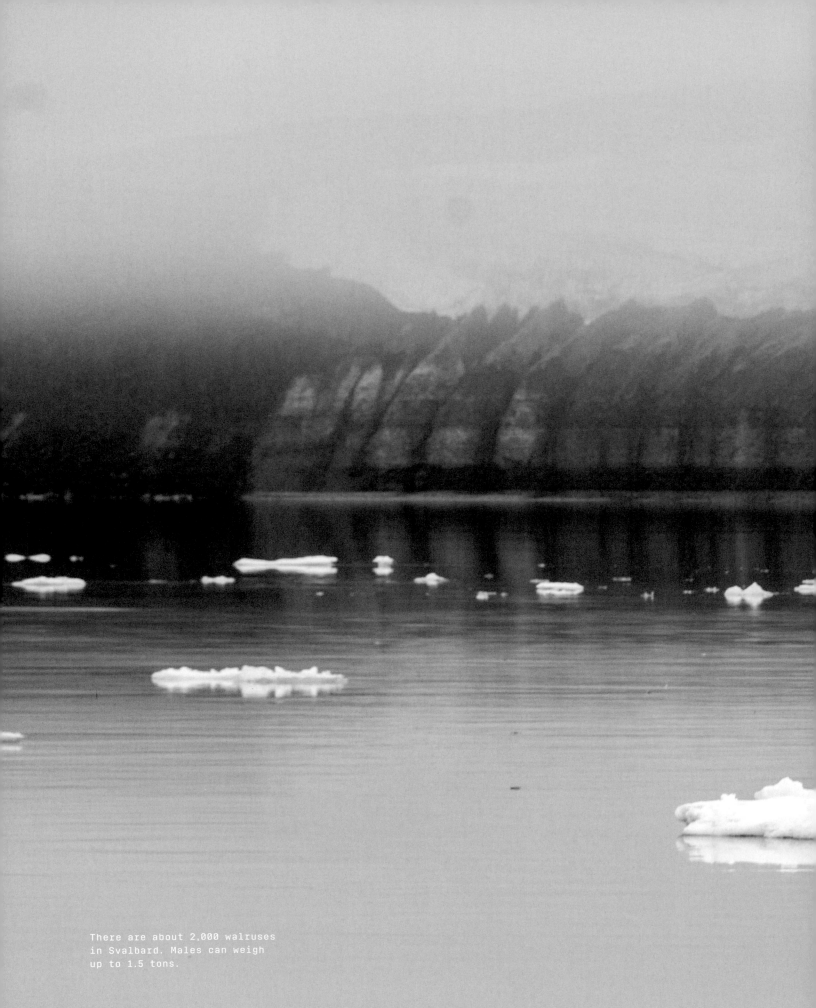

There are about 2,000 walruses
in Svalbard. Males can weigh
up to 1.5 tons.

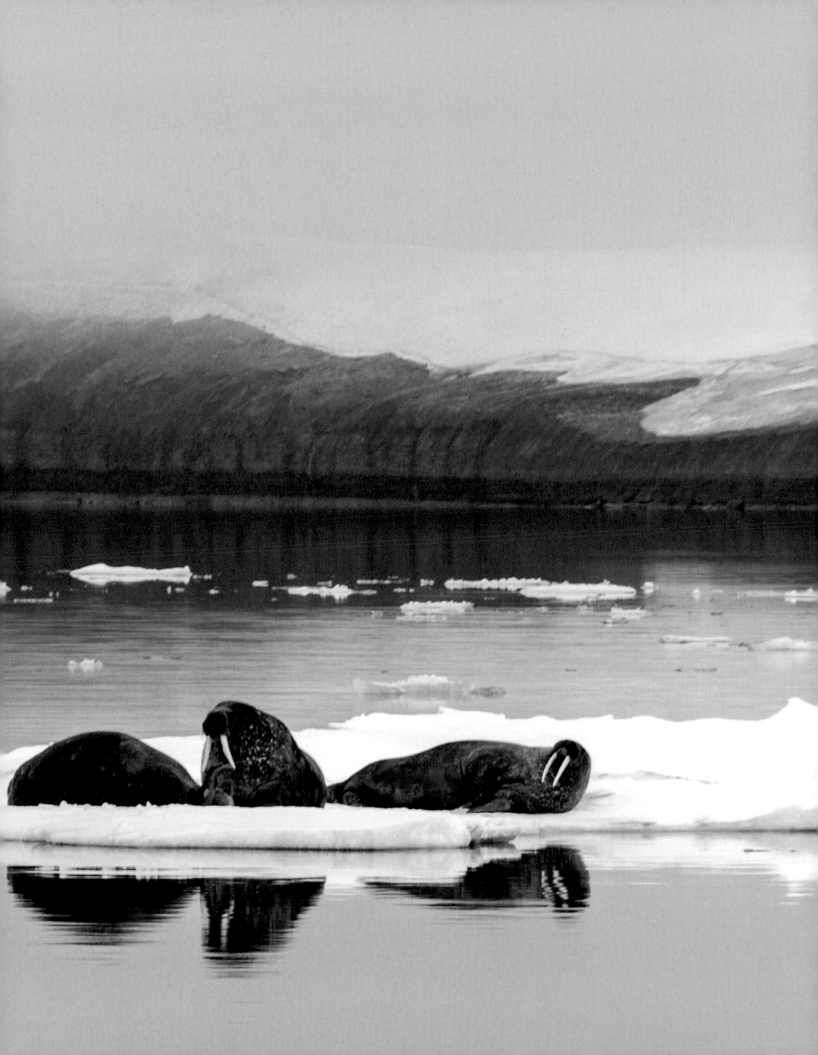

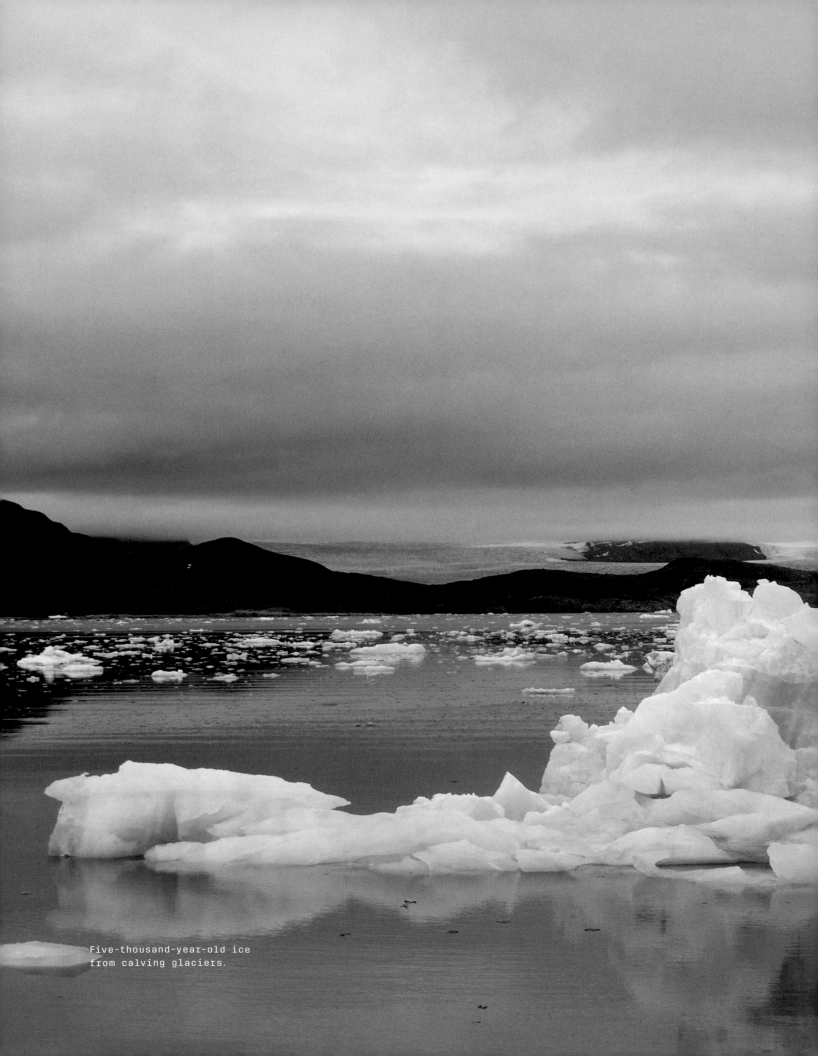

Five-thousand-year-old ice
from calving glaciers.

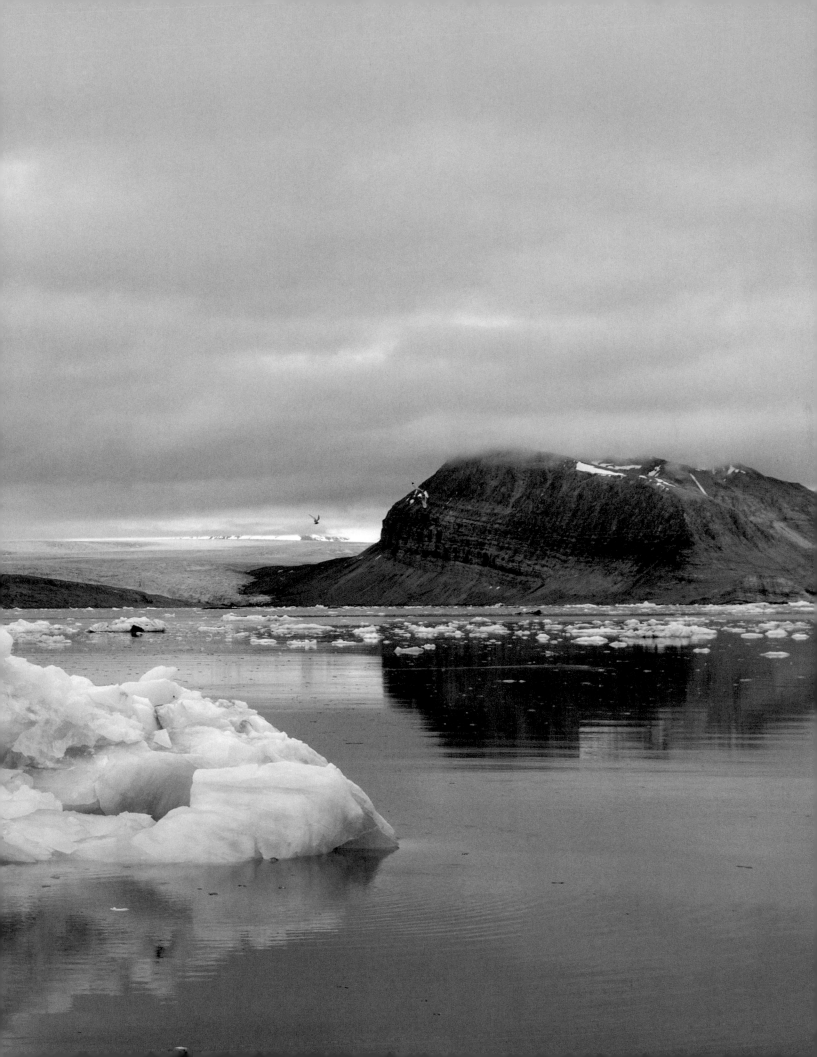

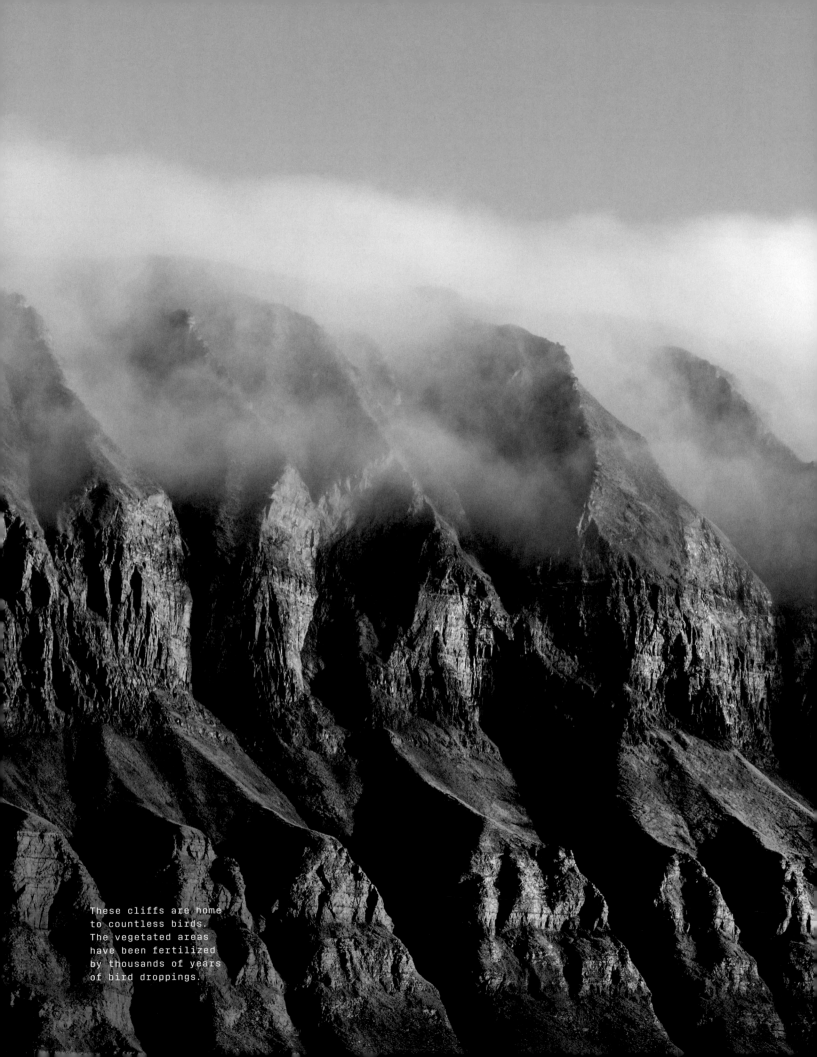

These cliffs are home
to countless birds.
The vegetated areas
have been fertilized
by thousands of years
of bird droppings.

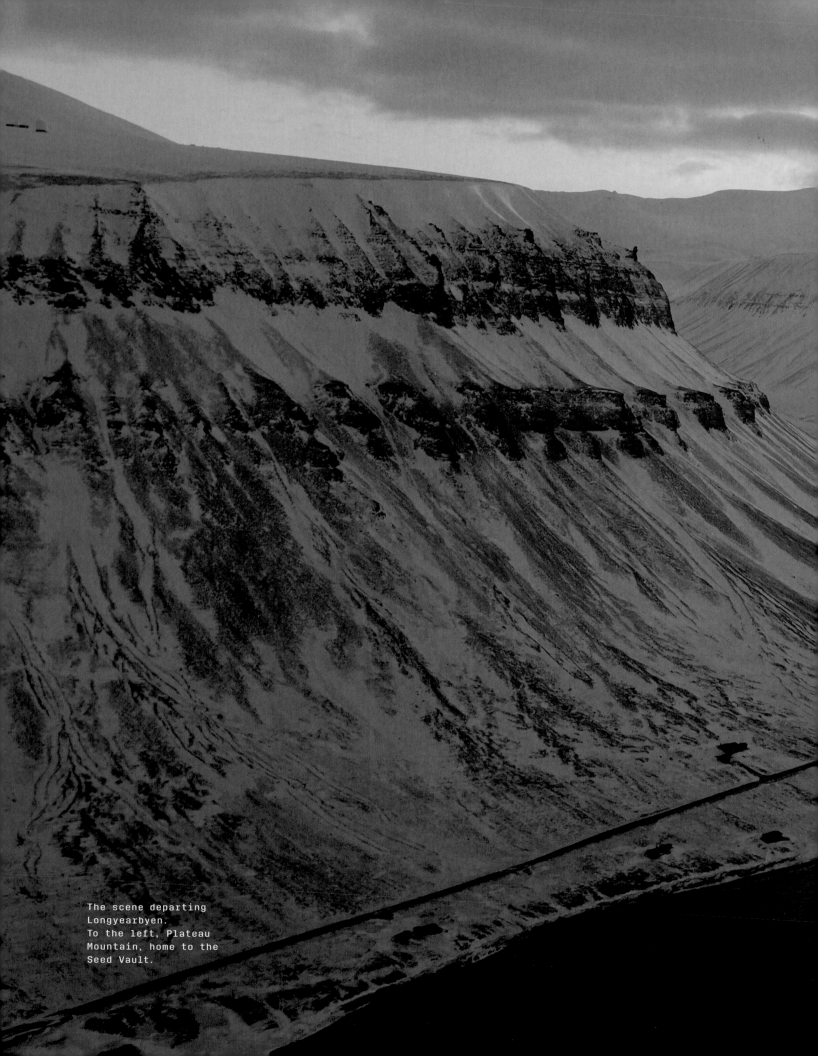

The scene departing
Longyearbyen.
To the left, Plateau
Mountain, home to the
Seed Vault.

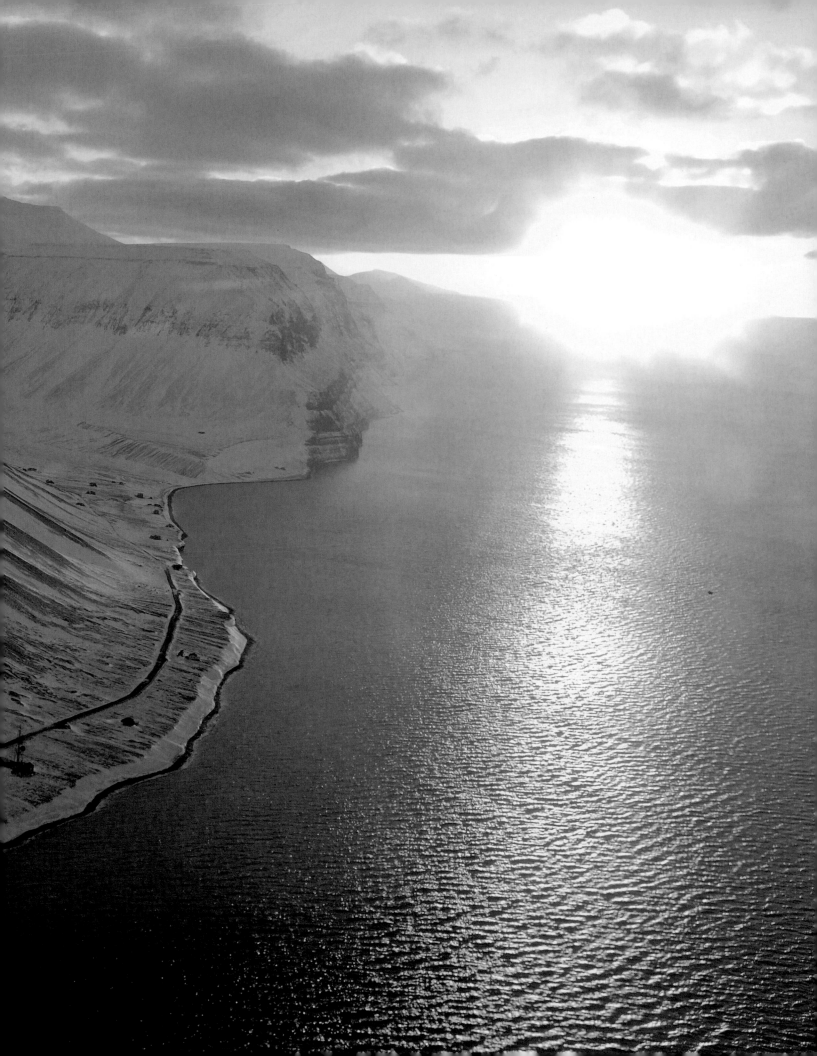

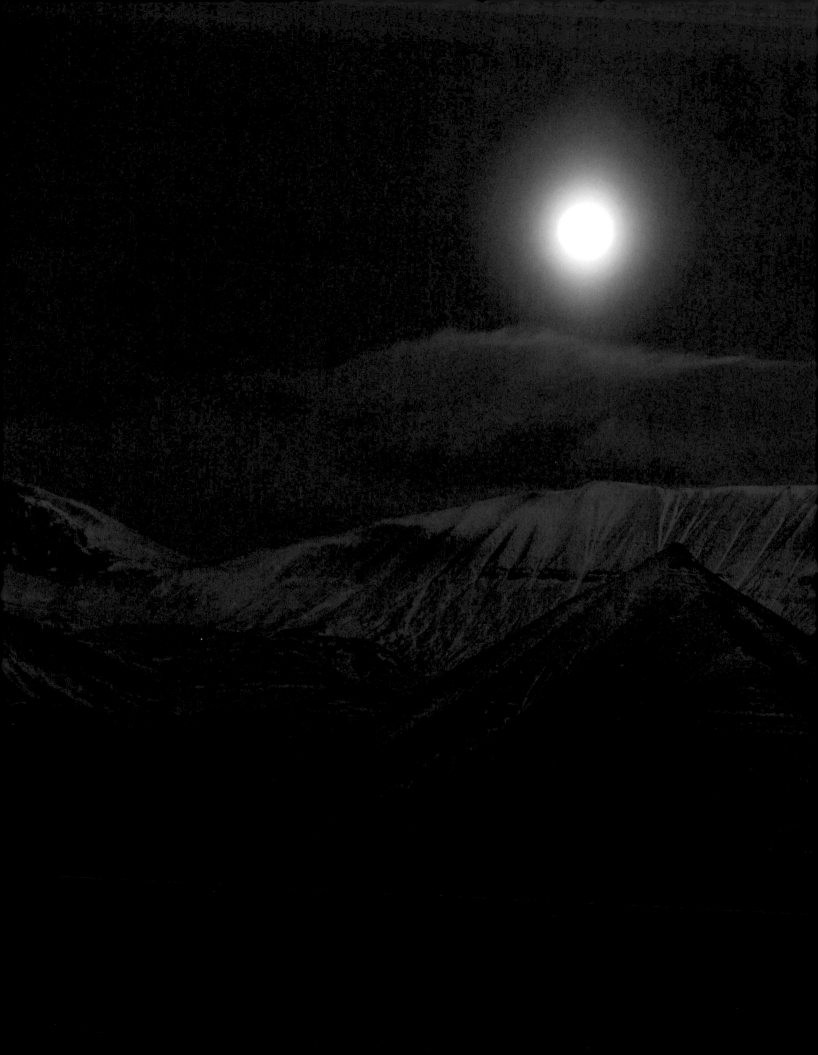

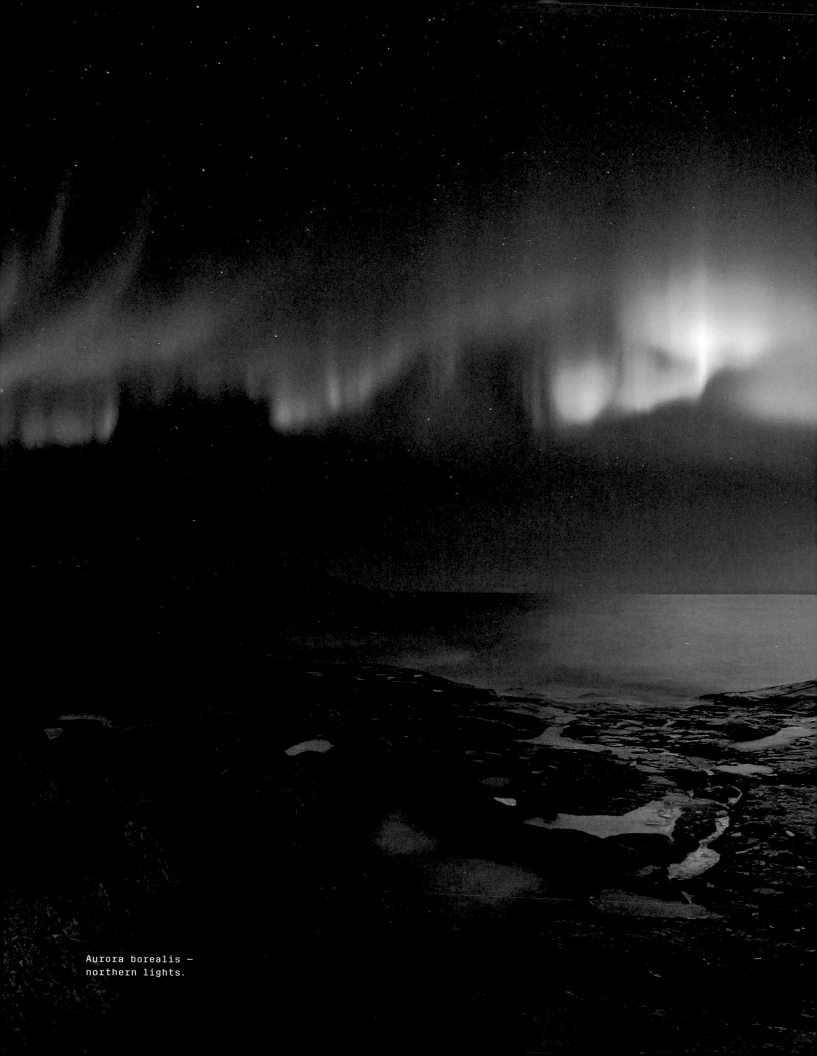

Aurora borealis —
northern lights.

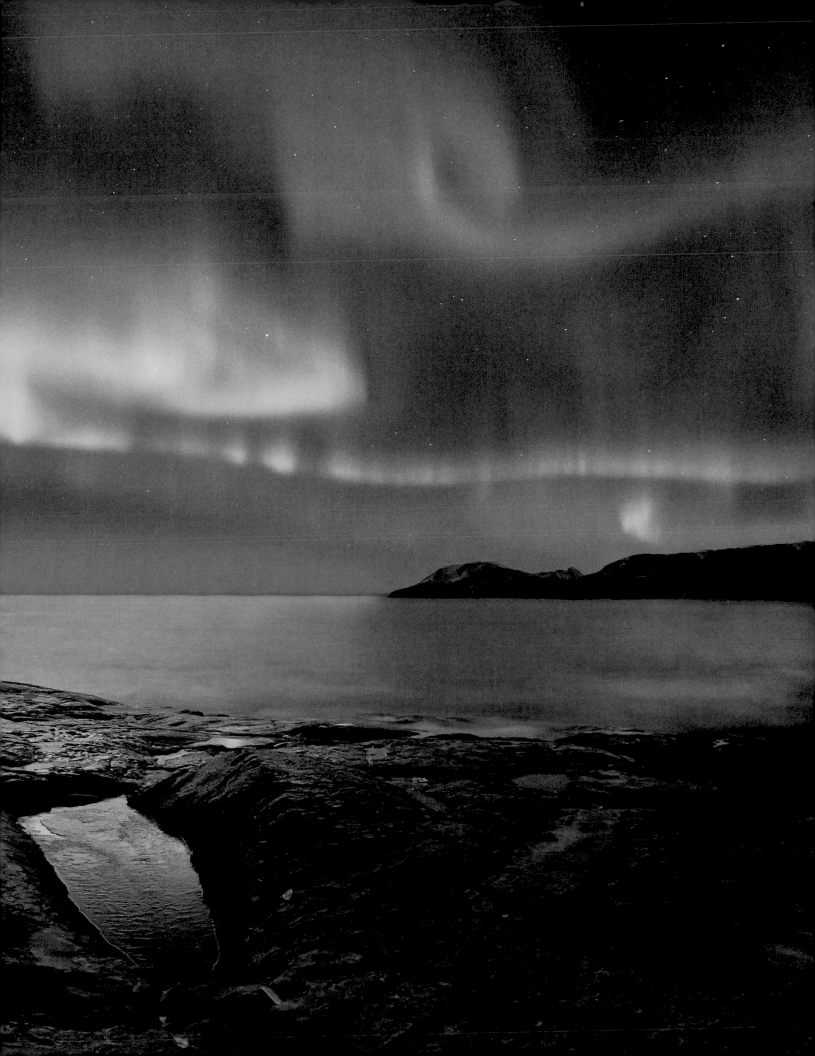

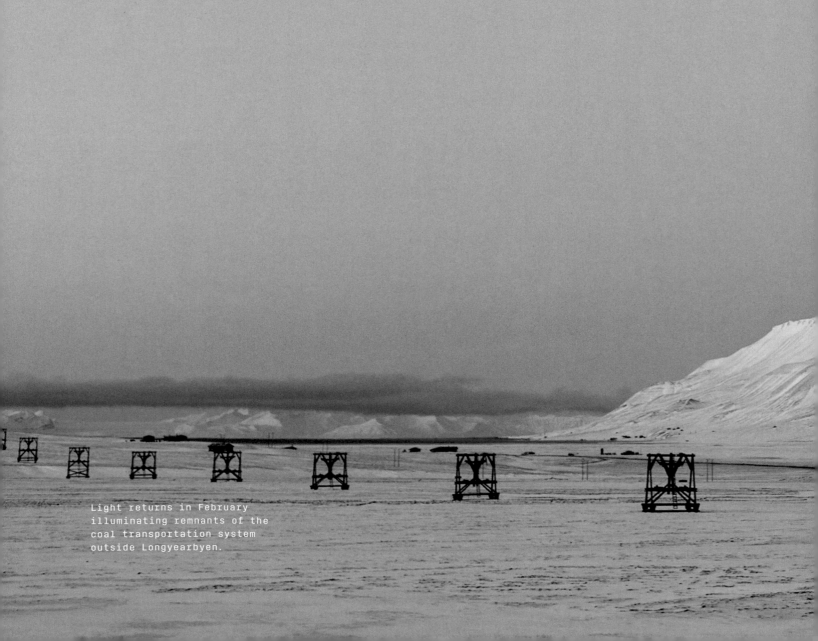

Light returns in February
illuminating remnants of the
coal transportation system
outside Longyearbyen.

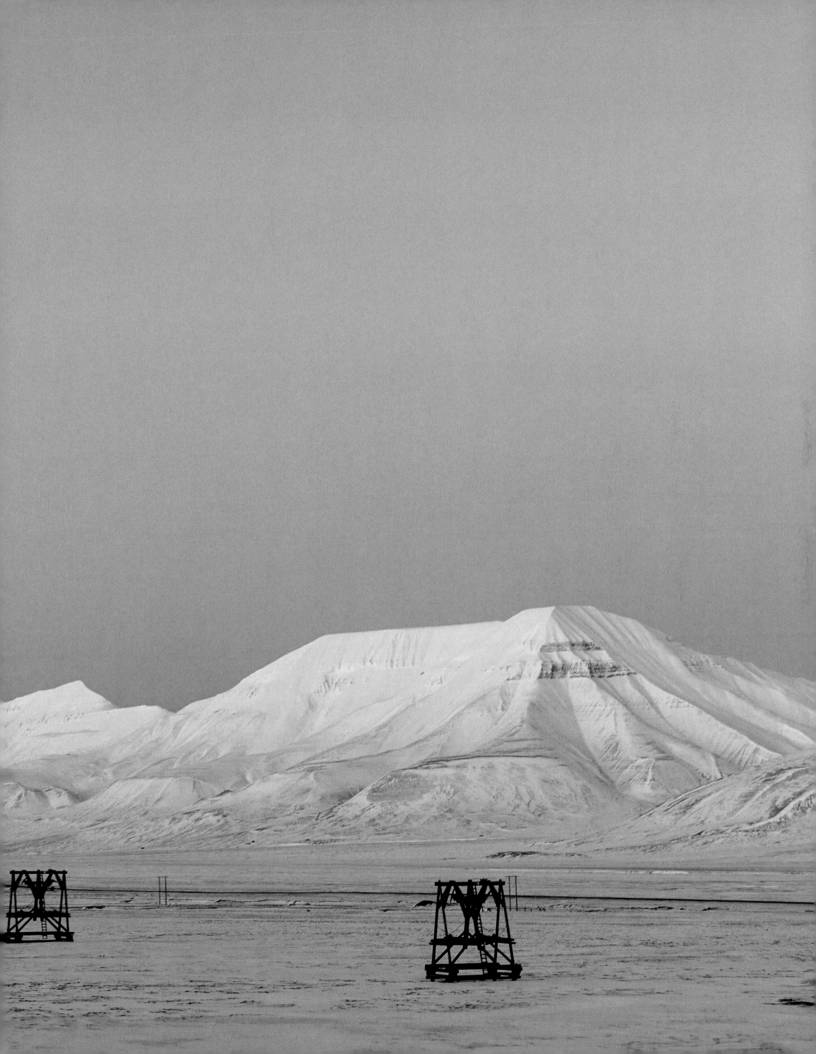

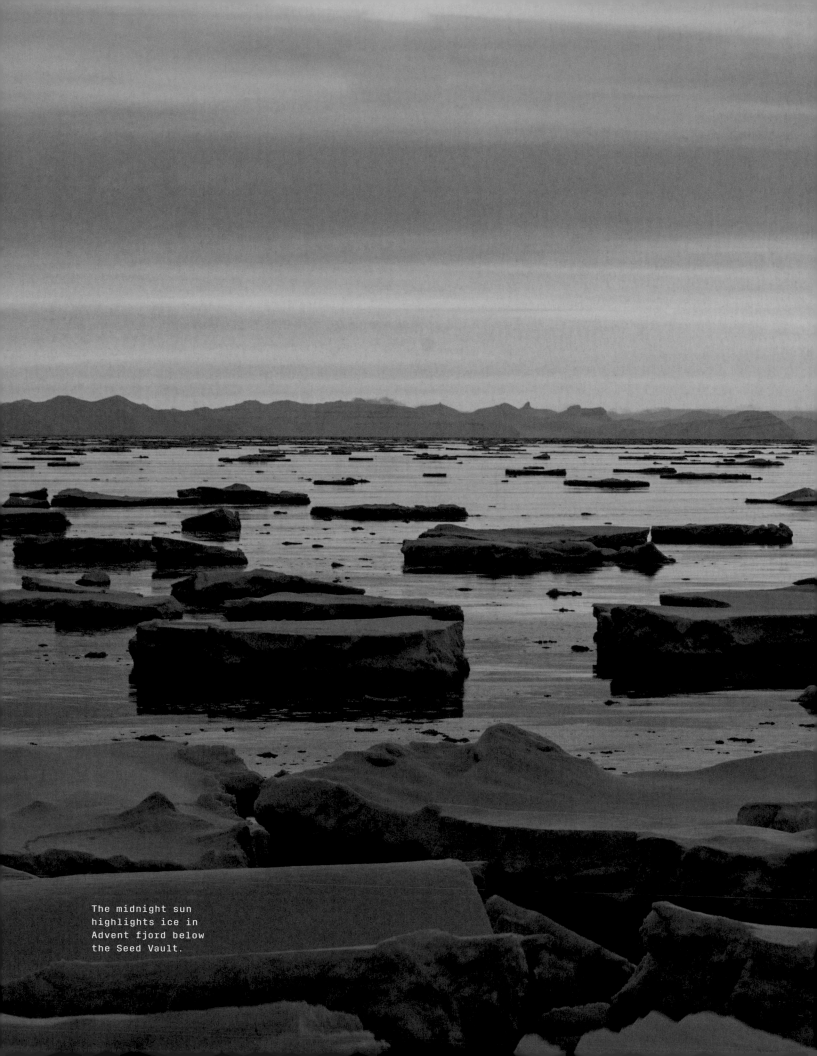

The midnight sun
highlights ice in
Advent fjord below
the Seed Vault.

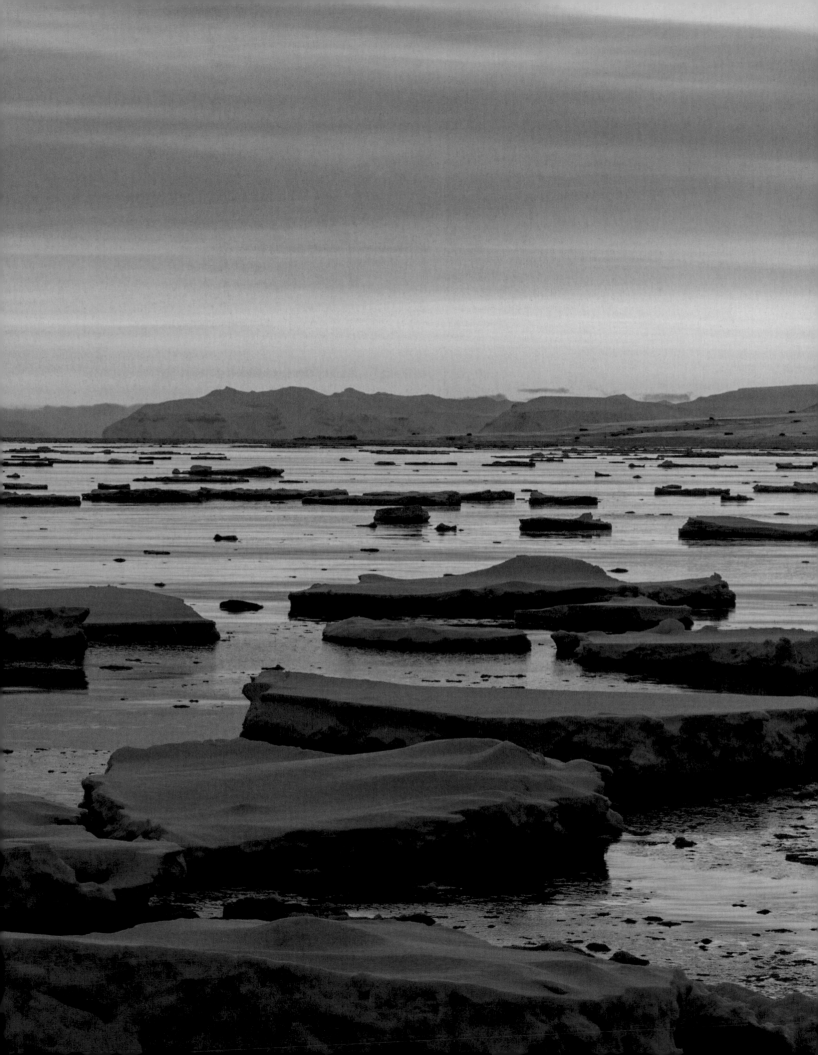

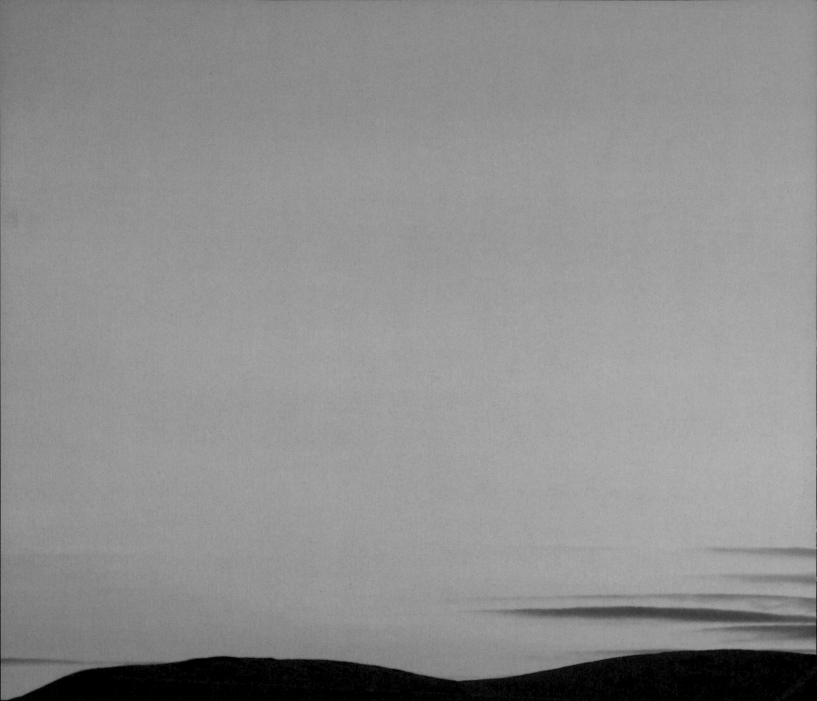

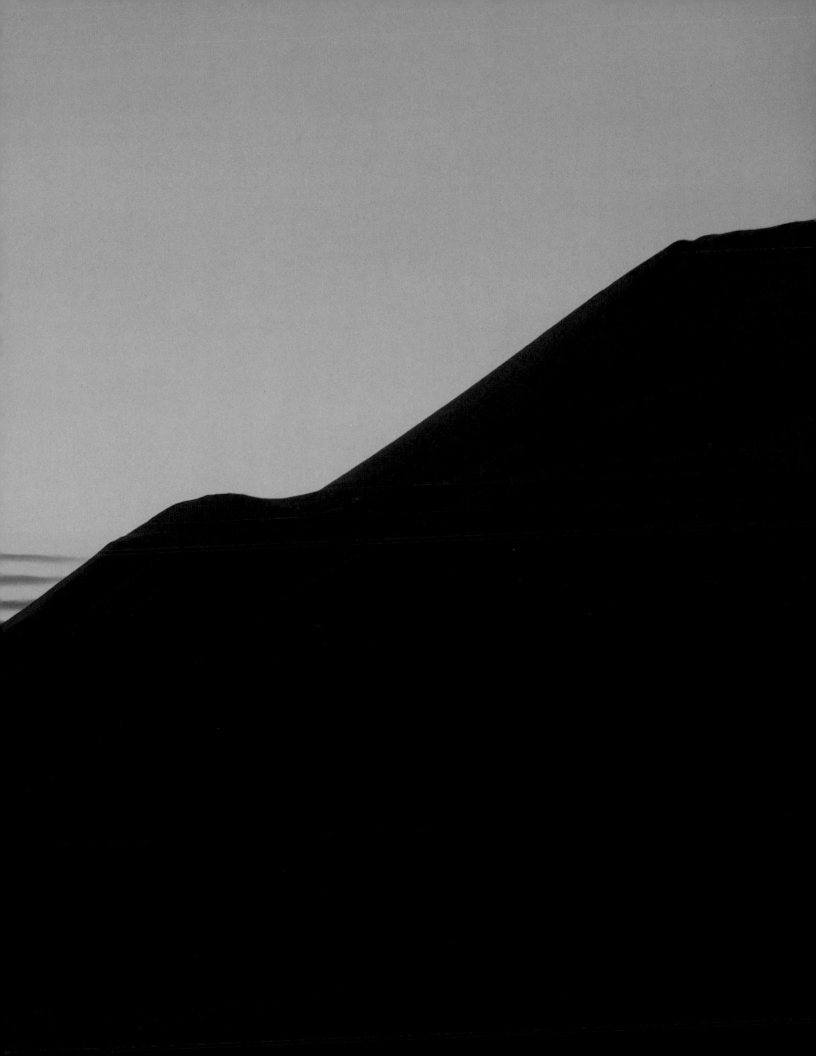

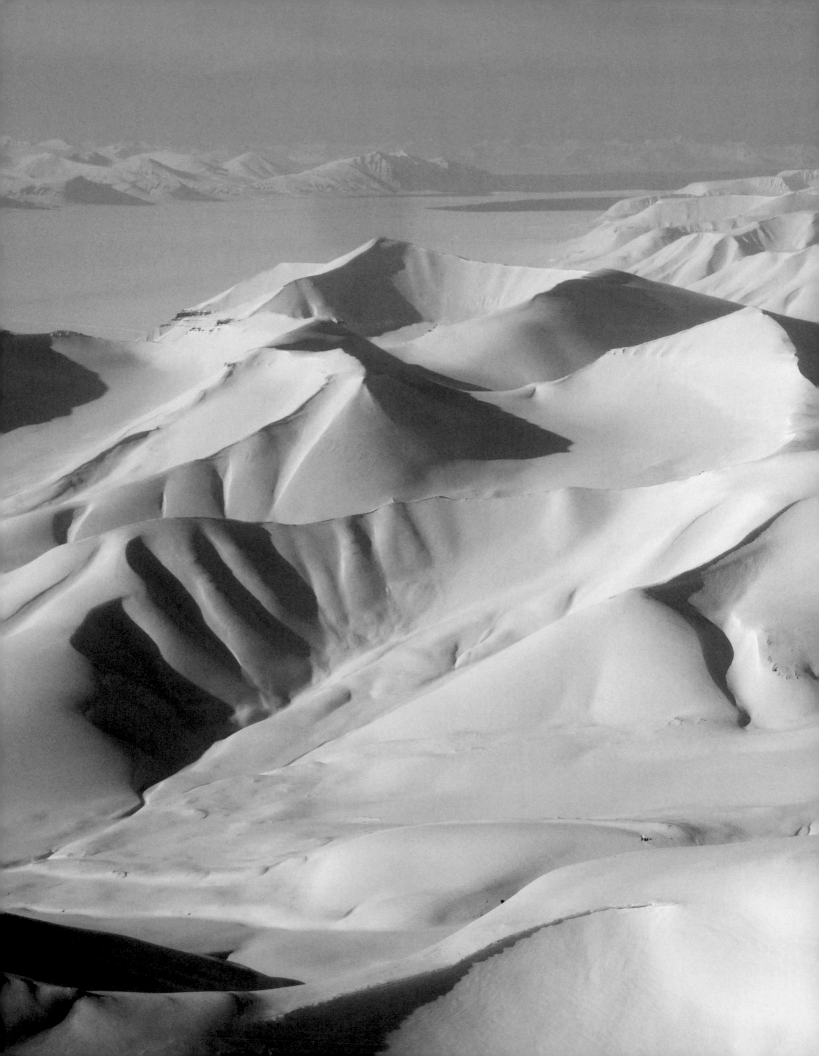

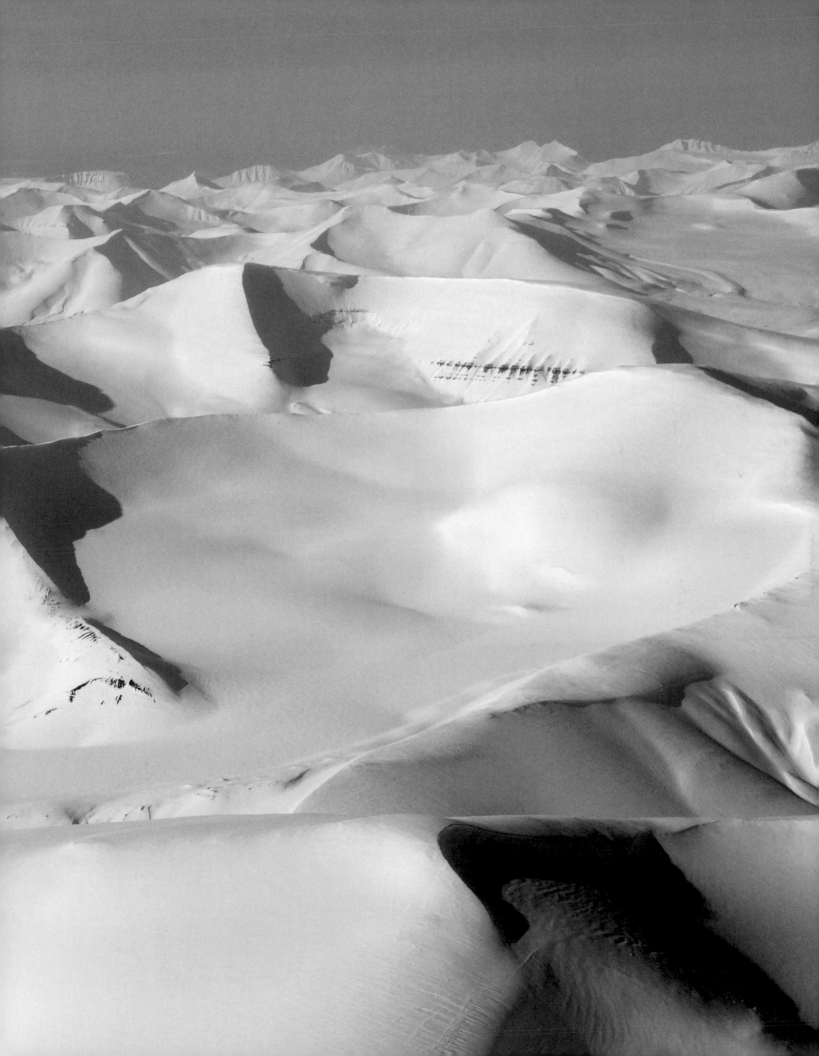

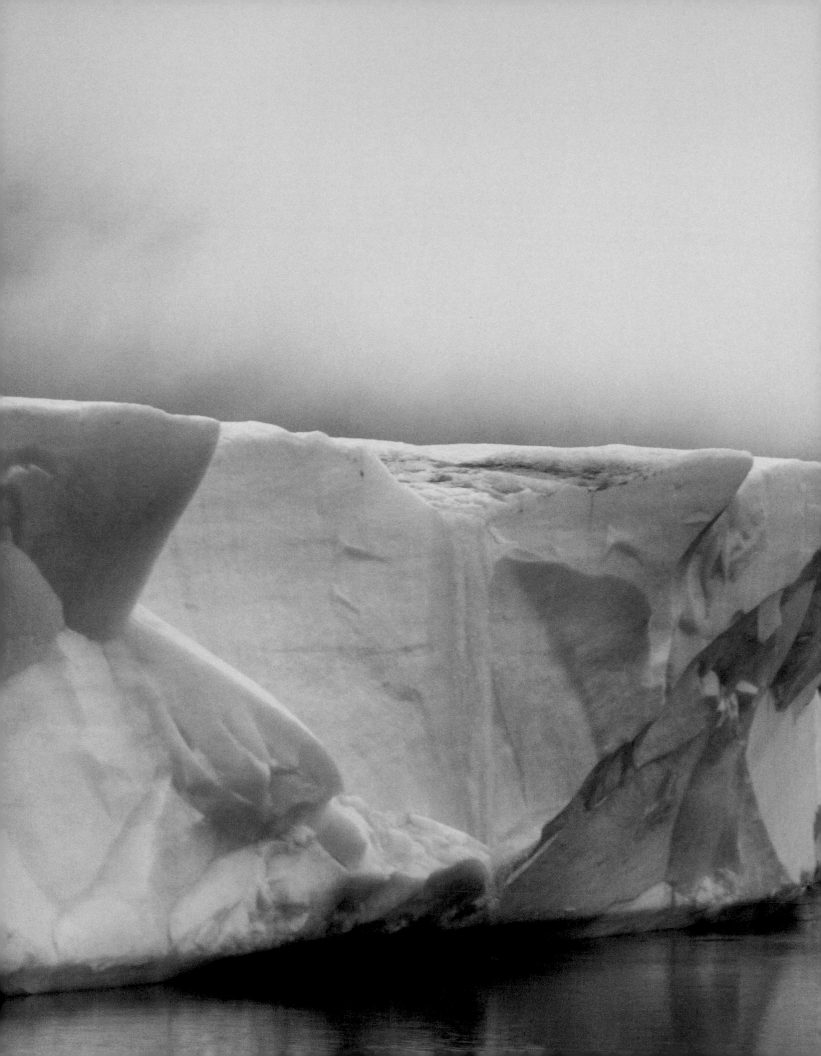

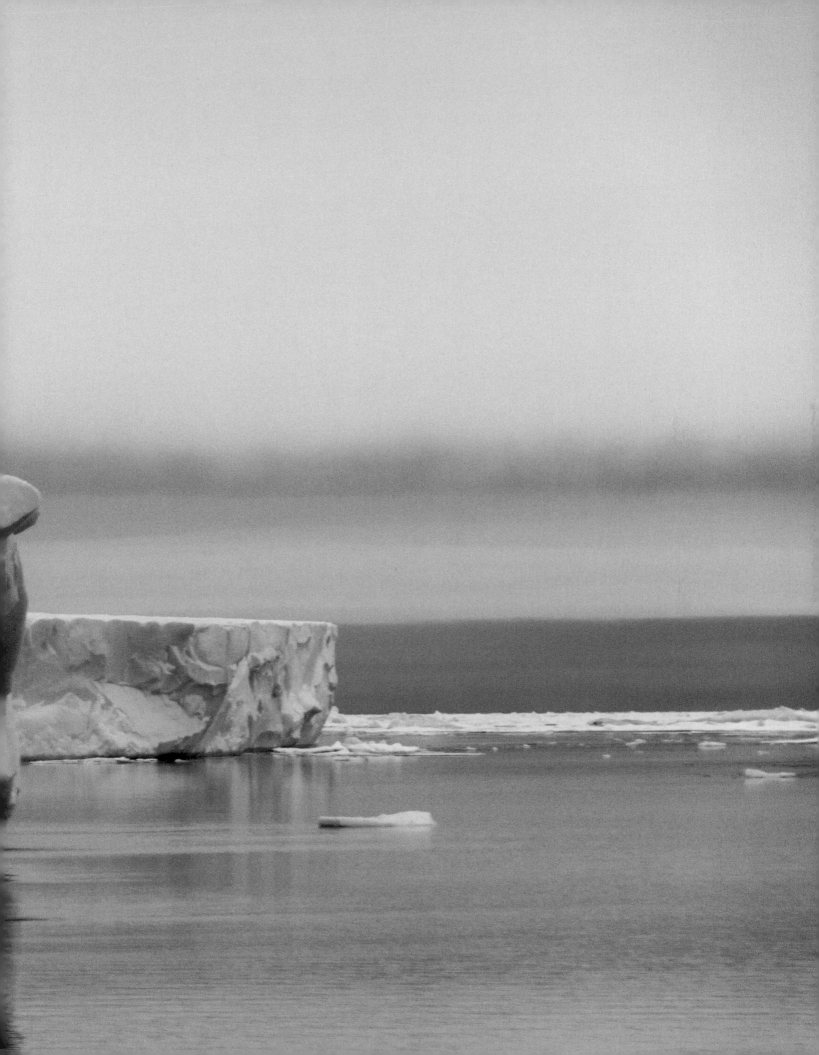

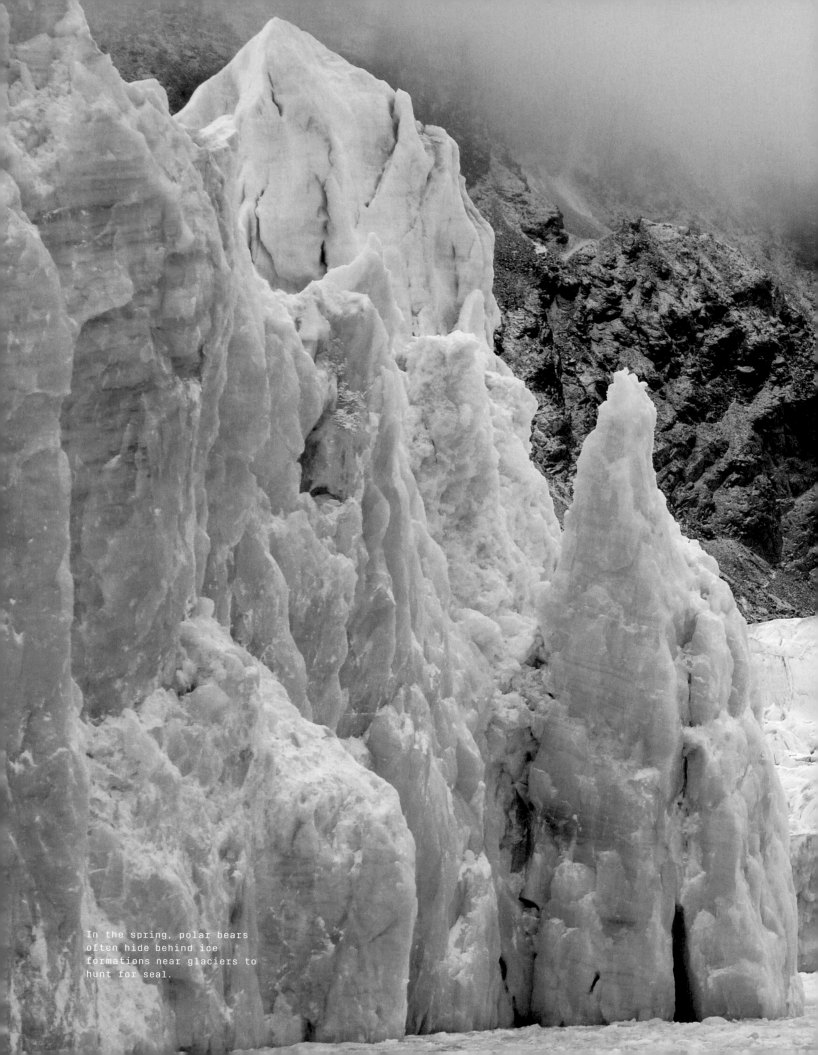

In the spring, polar bears often hide behind ice formations near glaciers to hunt for seal.

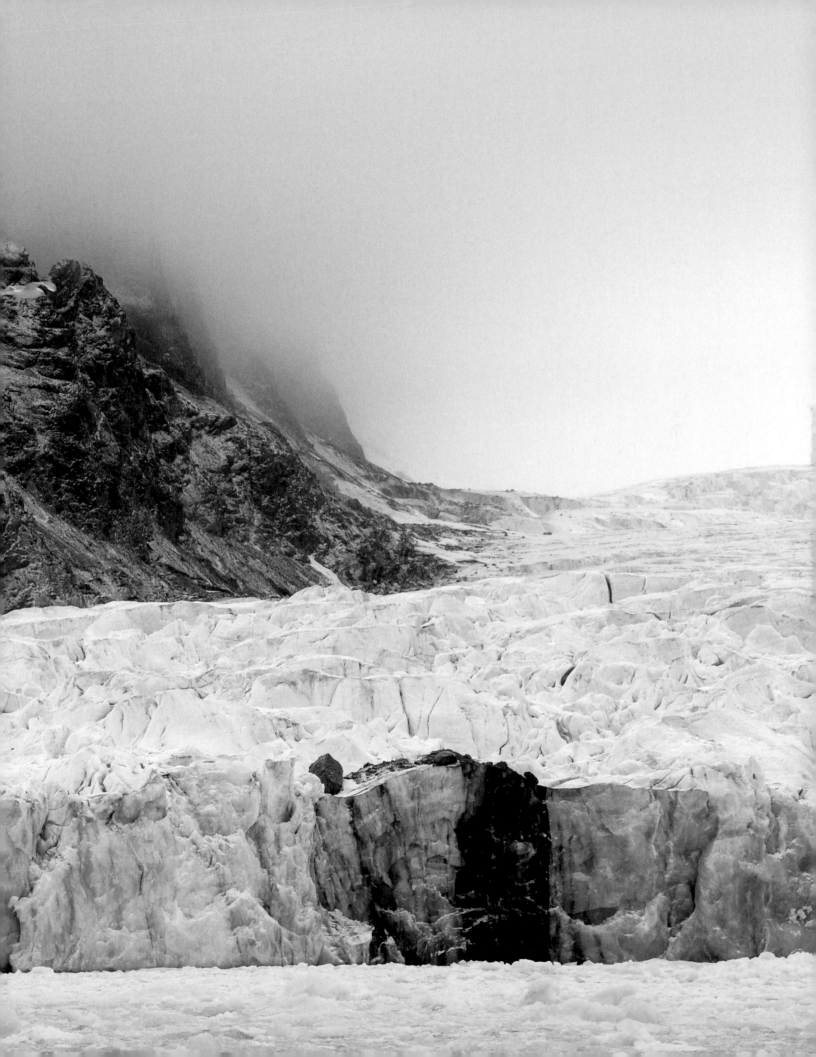

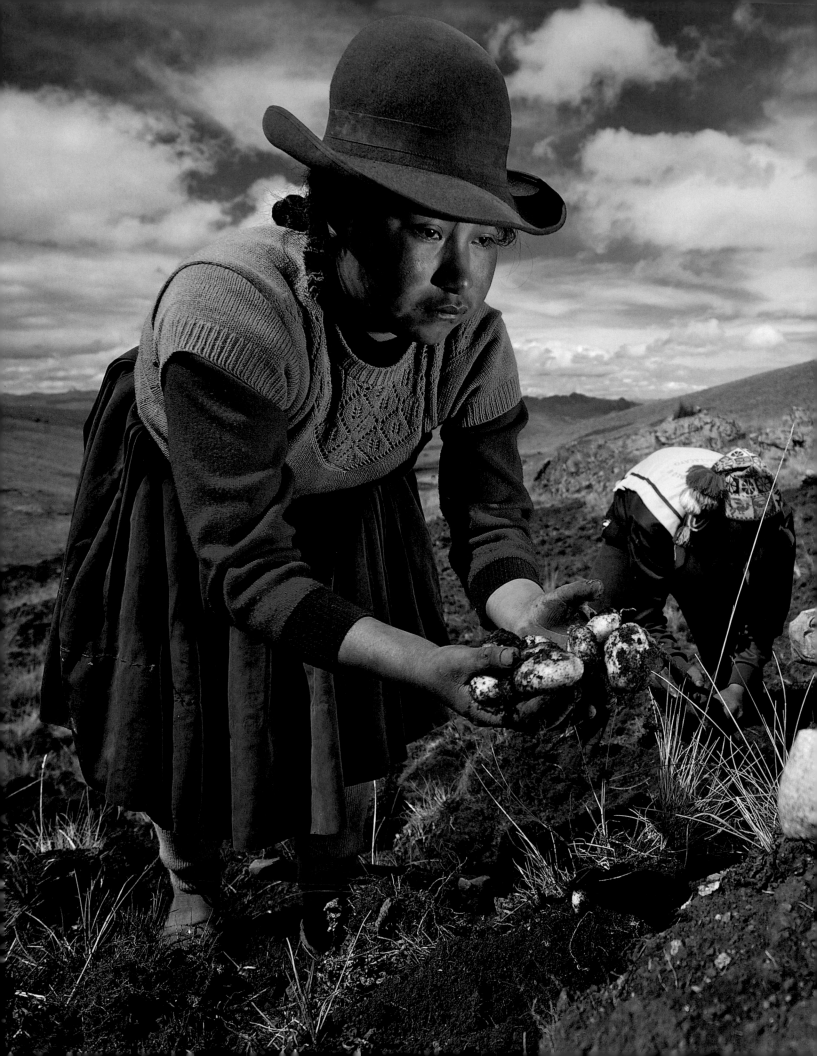

SEEDS AND FOOD

PHOTOGRAPHY BY JIM RICHARDSON

For most of human history, people have lived by means of hunting and gathering. A large portion of the people who have ever lived on earth survived in this way. Agriculture is a relatively recent phenomenon. The slow transition from hunting and gathering to agriculture began about twelve thousand years ago, following the end of the Ice Age when Svalbard and mainland Norway were covered with ice and snow, and uninhabitable.

Digging potatoes in the Andean community of Pampallacta, near Pisac, Peru.

There is an important difference between the seed of wild plants and of domesticated plants. Wild plants are engineered to scatter their seeds easily and widely. They "shatter," to use a biological term. Our early hunting and gathering ancestors, however, would have found it easier and more lucrative to harvest the odd seeds that stayed on the plant and didn't fall to the ground. Gatherers understood the connection between seeds and plants. By taking the nonshattering harvested seed back to their camps and later growing them, or by encouraging nearby stands of such plants in the wild, they would have increased the percentage of nonshattering plants and correspondingly increased their harvest, putting plants and people on the path to agriculture. Typically, the genetic difference between shattering and nonshattering seeds is spelled out in one or two genes, a difference that our ancestors seized upon and began to exploit in earnest during the Neolithic period. Domestication frequently took place on the fringes where wild forms of the future crop were native but perhaps

not abundant, where people were familiar with them, were already harvesting them, and were inclined toward more intensive encouragement and cultivation.

Domesticated crops arose, they "originated," in certain specific regions. Rice, soya, banana, and oranges are from China and the Far East. Wheat, barley, and lentil hail from the Near East. Sorghum and watermelon originated in Africa. Maize (corn), beans, and potatoes are from Latin America. Most major food crops originated in what are today known as developing countries and they have had their longest history there. It is in these regions that the greatest diversity, the greatest variations in types, has been and continues to be found.

While agriculture is relatively young, twelve thousand years is still a long time. In a very real sense, crops and human society coevolved. The word "agri-culture" embodies this historic partnership. Crops traveled with people and encountered new environments, climates, growing conditions, pests, and diseases. They adapted naturally to such factors with considerable but varying degrees of success. Rice, for instance, is now grown in more than 115 countries in the world. Some types grow in semiarid conditions while others spend their life standing in water. And wheat, a native of the Near East, is grown in every one of the fifty states in the United States and all across the world.

Crops also became part of different human cultures and the foundation for economies. People selected and encouraged different types for different purposes. Maize is not only adapted to growing in conditions from South Africa to Sweden, and from Mexico to China, but also comes in varieties for eating fresh, for grinding into flour, for popping, for beer, medicine, and religious ceremonies, for making into sugar for soft drinks, and now for automobile fuel.

Some crop diversity is "visual." Potatoes come in an array of colors: white, yellow, red, black, blue, and purple. And there are all sorts of shapes. One traditional Andean variety is called "pig droppings." To a farmer, the shape is unmistakable. But different varieties or types also have hidden traits, many of which remain undiscovered because as sophisticated as we might think agriculture has become, much of the diversity found in the field and in genebank collections simply hasn't been thoroughly screened. Some may be heat or drought tolerant or resistant to a disease or pest. You don't know and you can't tell until you have exposed the plant to the pest or disease and assessed its reaction. Others may have enhanced nutritional attributes. You can even taste the difference. Aptly named, the Winter Banana apple has the sheen and aroma of a banana, whereas the Chenango Strawberry apple variety gives a hint of strawberries. The Calville Blanc d'Hiver boasts high vitamin C.

All these characteristics are produced by the genetic makeup of the plant or variety. When scientists speak of conserving the gene pool or conserving crop diversity, they are really talking about conserving all the different traits the crop can exhibit. One does this by conserving the genes that "code" for or produce the traits. And one does this typically by conserving seeds (or in some cases tubers or other planting materials) that contain the genes.

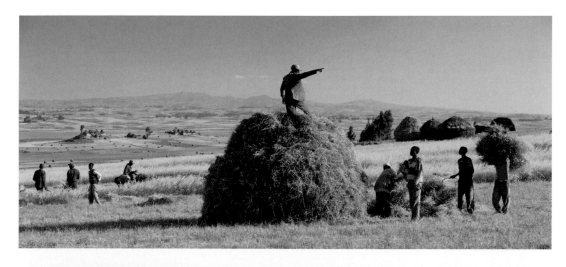

Above
Harvesting and
stacking oats
on the farm of
Melaku Yifku
in the Seriti
Village of the
Chacha district
north of Addis
Ababa, Ethiopia.

Below
The Li Kaixin
family is
harvesting
rice near Sheng
Cun Village in
Yunan province,
China. Grain
is threshed in
the field, then
bagged. Stalks
are laid out
to dry in
the terraces.

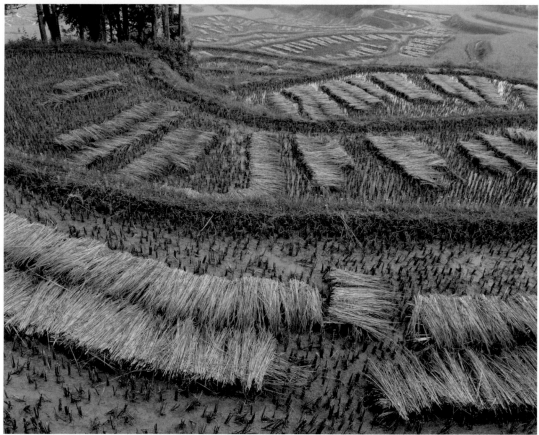

It is difficult to estimate how much crop diversity exists in the world today, and impossible to know how much used to exist and thus how much has been lost. We will never have a head count of the diversity that existed two hundred years ago, much less two thousand years ago.

Also problematic is the question of what is meant by the word "diversity." At one level it's simple: a Crimson Sweet is one variety, a Georgia Rattlesnake is another variety of watermelon. Together that makes two, each being defined technically as a different combination of genes or traits. In the fields of many traditional farmers in developing countries, there are few "uniform" varieties wherein all plants are essentially identical. Instead their "varieties" are really mixtures. A wheat field may contain a number of different types, maturing at different times, with different degrees of pest and disease resistance and susceptibility. Is this assemblage, this population of plants, one variety or many? This complexity explains why it is difficult from a scientific standpoint to answer the simple question about how many varieties exist. And how many varieties or how much diversity has been lost. Varieties and diversity are not synonymous. What portion of the total diversity is being saved in the Seed Vault? There is no easy answer and much possible confusion about the question.

Seven spikes of wheat, all collected from a single field, show the diversity that can be contained in a single sample of a farmer's traditional "variety."

I like to illustrate the difference between varieties and diversity with an analogy. Suppose your task is to conserve the diversity of dogs. You can't conserve all individual dogs, but to capture as much of the overall diversity of dogs as possible, you can conserve a sample. You have a backyard full of poodles. That's one sample. Your neighbor has a backyard full of mutts from the animal shelter. That's another sample. Each of you has one sample of dogs. But who has the most diversity? It's obviously your neighbor because, clearly, not all samples contain an equal amount of diversity. If all the dog diversity in the world really were represented by those two samples, you would not say the sample of poodles contained 50 percent of all diversity. It would contain far less and the other sample far more. In conserving crop diversity, as in conserving dog diversity, it may be desirable to conserve both samples, but it is important to focus on diversity as opposed to sample numbers and, furthermore, to try to make sure the samples represent as much of the underlying diversity as possible.

Most curious people will still yearn for some order-of-magnitude sense of how much diversity or at least how many "varieties" or types, exist. The Global Crop Diversity Trust, which I headed from 2005 to the fall of 2012, and which has the global mandate to ensure the conservation and availability of crop diversity in perpetuity, asked crop experts to answer the unanswerable question: how many varieties of rice, of beans, of wheat, etc., are there? The experts were understandably reluctant to talk in these terms, and when pressed they added numerous caveats to their responses. But they did provide some numbers—huge numbers:

```
Rice: 200,000+
Wheat: 200,000
Sorghum: 47,000
Maize (corn): 30,000
Bean: 30,000
Chickpea: 30,000
Pearl millet: 20,000
Groundnut (peanut): 15,000
Cassava: 8,000
```

We know that much diversity has been lost over time. Elaine Chiosso and I conducted a study that compared named varieties grown in the United States in the 1800s with those stored in genebanks in the early 1980s. We found that a huge number of specific, documented, identifiable varieties had been lost. They had gone extinct.

U.S. Vegetable Varieties Lost (presumed extinct)

Crop	Total 1903 Varieties	1903 Varieties in US collection in 1983	1903 Varieties missing/lost (%)
Beans	578	32	94.5
Beets	288	17	94.1
Cabbage	544	28	94.9
Carrot	287	21	92.7
Sweet Corn	307	12	96.1
Lettuce	497	36	92.8
Onion	357	21	94.1
Peanut	31	2	93.5
Squash	341	40	88.3
Tomato	408	79	80.6
Watermelon	223	20	91.0

The loss of varieties, however, is not the same thing as the loss of genetic diversity, though the two are certainly related. The traits and genes in the extinct varieties might still be found

in varieties that continue to exist. That is, the genes themselves may not have become extinct; just the unique combination of genes that defines a variety might have been lost. It's possible. But varietal loss is at least a surrogate for, an indicator, of the loss of real diversity. It is unlikely, therefore, that such large percentages of crop varieties could be lost without the permanent loss of unique traits. And, to be sure, the combination itself is important. Losing it is not trivial. Once lost, varieties such as these are virtually impossible to recreate. Such are the unknowns and such is their complexity.

How can we ever expect to comprehend this loss? More than 2,300 out of 2,600 pear varieties documented in the United States in the 1800s have been "lost." I consulted Ulysses Prentiss Hedrick's classic and still revered reference work on pears, *The Pears of New York,* published in 1922, to get a feel for what has been forfeited. There was a color plate showing the Ansault pear, a variety once grown in the United States,

now extinct. Hedrick knew this pear. He rhapsodized, "In particular, the flesh is notable, and is described by the term *buttery*, so common in pear parlance, rather better than that of any other variety. The rich sweet flavor, and distinct but delicate perfume contribute to make the fruits of highest quality." Who knows why the Ansault became extinct. Maybe its combination of genes wasn't ideal. Maybe it was susceptible to a disease or maybe it just didn't ship or store well for the commercial market. Clearly, however, it had qualities worth conserving, traits that could be bred into modern varieties today were the Ansault still with us.

The United States, an agricultural superpower, is the country of origin of only a few crops, pears not being one of them. The crop diversity found in the United States is small compared to what once existed in the centers of agricultural origin in developing countries. An absolutely massive amount of diversity has been lost forever there. Until the 1960s, most farmers in developing countries were cultivating highly diverse "populations." The widespread replacement of these populations with modern uniform varieties has resulted in the unintended consequence of significant "genetic erosion"—the permanent loss of unique crop diversity.

As Australian plant physiologist Lloyd Evans explains in his book *Feeding the Ten Billion*, our species employed different strategies to acquire and produce more food as populations grew. Until the second half of the twentieth century, the easiest and most effective strategy for increasing production was to cut down the forests and expand cropland. There is a natural limit to this strategy, and it has been reached.

In recent decades global food production has swelled, primarily because of improvements in yield due to new varieties and more productive farming systems that furnish more fertilizers and water. About 50 percent of the upsurge in production is specifically attributable to new, higher-yielding varieties.

Looking forward, there are only six possible ways, according to Evans, in which our food system might manage to increase food supplies:

- Increase yield on existing lands, per crop
- Increase the number of crops grown on the land; for example, by using shorter season crops
- Reduce post-harvest losses
- Replace lower-yielding crops with higher-yielding crops
- Increase the area of land under cultivation
- Reduce use of grains fed to animals

Crop diversity will be needed for plant breeding in every case. To a large extent, therefore, increasing food production in the future will depend on our willingness, ability, and success in conserving crop diversity for plant breeding through efforts such as the Svalbard Global Seed Vault.

The advent of modern plant breeding post-1900 began a process in which farmers replaced traditional types with new scientifically bred varieties. In most instances, it was the accepted and reasonable thing to do. But it had the unintended consequence, as maize expert Professor Garrison Wilkes pointed out many years ago, of "taking stones from the foundation in order to repair the roof." The modern varieties were based on the diversity they were replacing.

New varieties do not spring into existence *de novo*. They are comprised of traits—genes—assembled from previous, even ancient varieties and populations. They are constructs, fashioned from the raw material of conserved diversity through plant breeding and selection. Therefore, unless crop diversity—the farmer's old variety or "population" or even the crop's wild relative—is collected and conserved, the traits it contains may well be lost; and any unique qualities it might have contained will be forever unavailable to plant breeders and thence to farmers (and consumers). Those traits will not be incorporated into future varieties. And those traits might well be ones that could protect the crop from catastrophic failure, or worse. Thus the stakes are high, not only for wheat or pears, but also for people.

This is not just idle speculation or fearmongering. Agriculture faces its most severe set of challenges since the Neolithic period. Society will need at least a 50 percent increase in food production by the middle of this century to keep pace with population growth and development. We will expect farmers to produce more food on less land with less water (agriculture already consumes 70 percent of the world's fresh water supply) and reduced nutrients (phosphorus production, absolutely essential to plant growth, will peak later in this century and become much more expensive long before that). Then there is climate change.

If even the conservative projections are correct, we are headed toward climates that our crops have never before experienced. Global warming will give us climates that are pre-rice, pre-wheat, pre-potato, pre-agriculture.

This will include higher average temperatures, higher extremes, higher minimum (nighttime) temperatures, longer periods of very hot weather, hot weather at times when plants are vulnerable such as when flowering, and more fluctuation in temperature and rainfall.

Sun Wan Jun winnowing grain in Shaanxi Province, China.

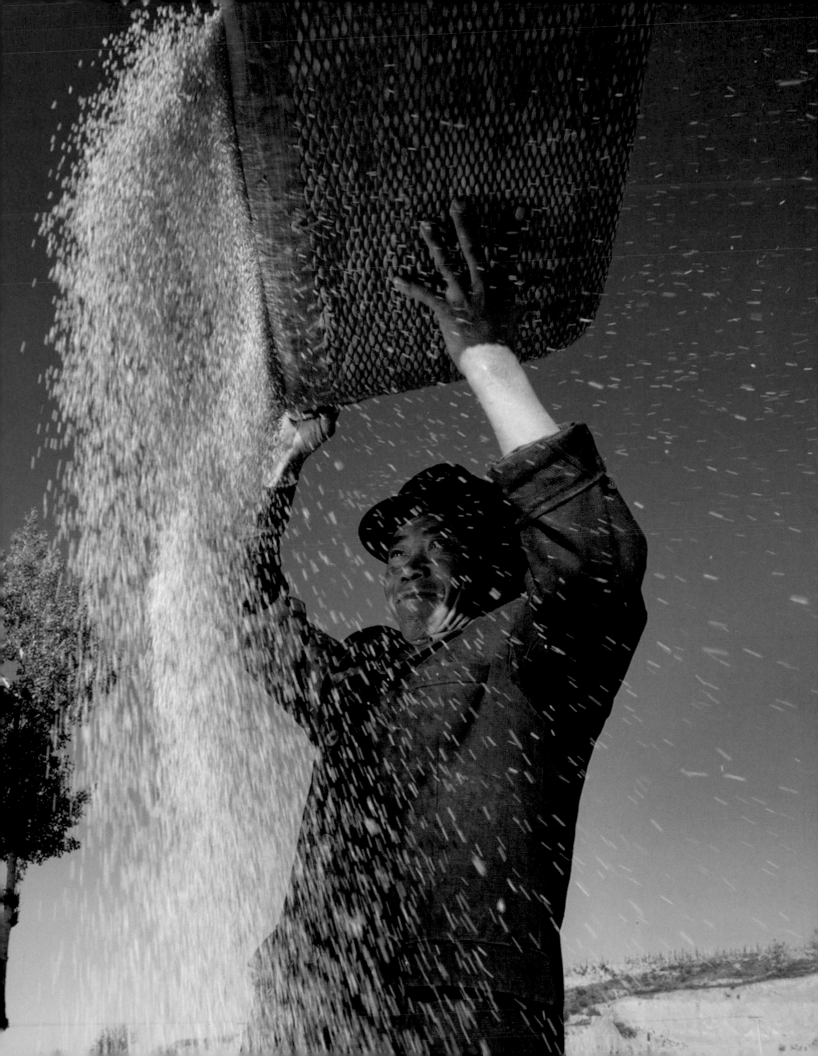

Temperatures above certain thresholds have the effect of sterilizing pollen—not good for production. Above a certain threshold, for example, a 1°C shift in temperature during the period when rice flowers lowers production by 10 percent. There is diversity that might come to the rescue. Most modern varieties open their flowers in midday, when it's hottest. Some wild relatives of rice express a different trait: they open up and make their pollen available in the evening or early morning, providing them with a cushion of several degrees.

With climate change, expect germination to alter and fall out of sync with rainfall patterns, and expect flowering times to shift and perhaps fall out of sync with the presence of pollinators. Expect insect pests and diseases to migrate to new homes, presenting crops with new combinations of species and conditions with which to contend. In this new context, as Professor Townsend Peterson of the University of Kansas notes, there are likely to be "idiosyncratic responses." That's not what you want from your food supply.

Climate change will produce uncertainty, surprises, and heightened risk in agricultural production systems. As in the past when production dropped unexpectedly, we will face market disruptions, food export bans, civil strife, and increased vulnerability of people who are already food insecure.

Disruptions are already evident and documented. Climate change is here now. And crops have not come preadapted to it.

Chasing cooler temperatures by shifting production will not solve the long list of problems associated with climate change. A crop variety happy in southern Italy today may well fail in Germany when it encounters a new photoperiod, new seasonality, new patterns and timing of rainfall, new soils, and new pests and diseases.

The international community is procrastinating, declining to mitigate climate change. An increase of 2°C or more is now baked into the atmosphere and our future. One can call this climate change, natural fluctuation, or just bad weather. Regardless, crops are on the front lines. They cannot escape it. Their evolution, their adaptability to the environment, depends on us and on crop diversity—the stockpile of heat-tolerant traits found in genebank collections that plant breeders and farmers can employ to produce new varieties better suited to new climates than existing varieties bred for climates fast disappearing. In this context, conserving diversity and ensuring its survival in the Seed Vault become essential to crops, food security, and people living in this century and beyond.

COLLECTING AND CONSERVING

Seed collecting did not begin with the Seed Vault. In fact, the Vault has never been involved with gathering seeds directly from the field.

Modest organized seed collecting for plant breeding purposes began in the late 1910s and

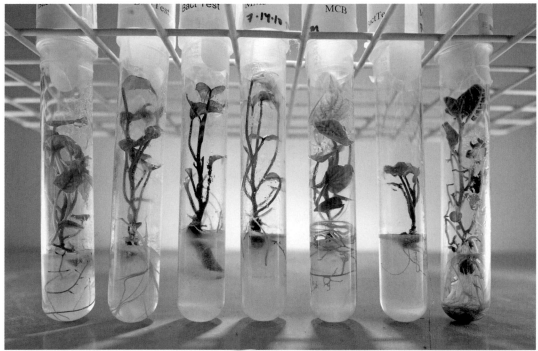

Seed Savers Exchange in Iowa uses tissue culture techniques at its headquarters to conserve certain varieties of tubers, such as heirloom potatoes. Members grow many of these in their gardens.

early 1920s, not long after the rediscovery of Mendel's laws of heredity ushered in the era of scientific plant breeding.

Nikolai Vavilov in the Soviet Union assembled the first truly global collection of crop diversity for the purpose of supplying traits to plant breeders and improving crops. As a geneticist in the 1940s he ran afoul of Stalin who put him in prison, where he ultimately died of starvation. Vavilov's colleagues at what is now the Vavilov Institute in St. Petersburg persisted with their mission. During the nine-hundred-day siege of the city by the Nazis in World War II, more than a dozen staff at the institute perished, mostly as a result of starvation and hunger-related ailments. Such was their devotion that they gave their lives rather than eat the seeds under their care.

It was in the 1970s that agricultural scientists—such as Otto Frankel, Jack Harlan, J. G. Hawkes, T. T. Chang, Erna Bennett, Carlos Ochoa, and Trevor Williams—sounded the alarm. They had begun to realize that the wave of modern seed varieties sweeping across the world, the so-called Green Revolution, was massively displacing traditional varieties and driving them into extinction. The International Board for Plant Genetic Resources was established in Rome. It mobilized collecting expeditions to the centers of diversity of the major food crops, and it

encouraged and helped countries establish genebanks to conserve the seeds being collected.

The thousands of little packages of seed, the diversity kept in those genebanks—often called seed banks because that's mostly what they store—now constitutes the foundation upon which most of the food production in the world is based and will continue to depend. Genebanks freeze seeds, which slows biological processes, lengthens seed longevity, and thus conserves the seed and the genetic diversity it contains until it is needed for plant breeding. Without this diversity, it is inconceivable that agriculture would be able to maintain, much less improve, its productivity. Supporting more than seven billion people today, or nine billion people by midcentury, would be out of the question. Regardless of how much diversity once existed, and despite how much has been lost, what's left is what will have to keep agriculture going for as far into the future as we can imagine.

Today, there are seventeen hundred "collections" of crop diversity ranging in size from one sample to more than half a million. In total, genebanks house more than 7 million samples. Up to 1.5 million of these are thought to be "distinct" samples. About half of the stored samples are in developing countries. About half of all samples are of cereal grains.

In the early 1990s, I was recruited by the Food and Agriculture Organization of the United Nations (FAO) to oversee the UN's first comprehensive global assessment of the state of the world's crop diversity, and to lead the drafting and negotiating of a global plan of action for the conservation and use of this diversity.

A few of the six thousand heirloom tomato varieties being conserved and promoted by Seed Savers Exchange of Decorah, Iowa.

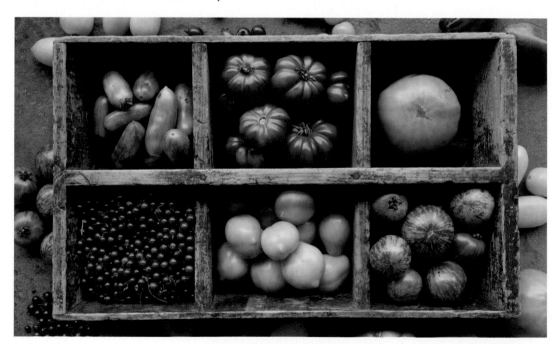

What my small team and I found was shocking. Genebanks with annual budgets of $2,000. Genebanks where staff had taken to cannibalizing equipment in two dysfunctional freezer rooms to keep the third and final one working. Genebanks where, for security purposes, the freezer with the seed had been padlocked but the key lost. The "global system" of genebanks touted by FAO was no system at all. It didn't deserve to be called a system. In nonnuanced language rarely countenanced in UN reports, our report concluded that most of these facilities were "incapable . . . of performing the basic conservation role of a genebank" and, moreover, they were in a "rapid state of deterioration." Extinction was under way, not just in the field but in the very facilities designed to prevent such a loss. Many genebanks were not so much banks as they were hospices. A few were morgues.

Yes, there were a handful of effective facilities, faithful custodians of the crop heritage entrusted to them. A number of the major genebanks, such as those at eleven international research centers of the Consultative Group on International Agricultural Research (CGIAR), as well as certain national facilities such as those in Australia, United States, Canada, Germany, the Netherlands, Sweden, and Japan, operated at very high standards in spite of their less than ideal budgets. Not surprisingly, this is where the world's crop breeders and researchers turned for access to the genetic resources, the traits, they needed. A few genebanks in developing countries provided competent conservation services—China, India, Brazil, and Ethiopia, to name the most prominent.

Even the best genebanks, however, were often succeeding solely because of the heroic actions and dedication of their unsung staff. How long was the world willing to rely on such luck? How long could crop diversity survive it? If this was plan A, what was plan B? We needed one, fast.

For the majority of collections, moreover, life has always been much more tenuous than with the best genebanks. Most genebanks do not operate according to international standards for long-term conservation in keeping seeds cold and dry to maintain viability over time. They need a plan A, not just a plan B. They cannot consistently maintain proper temperature and humidity levels. When seed viability declines, they are unable to produce fresh seed to replace deteriorating stocks expeditiously. This means that unique seeds, and possibly rare or unique traits within a sample are lost. They cannot meet phytosanitary requirements for import or export of seeds and planting materials. Management systems are often poor, and staff are underpaid and unappreciated.

Few genebanks have a multiyear budget and none have an adequate or secure budget. The US government has recently cut the budget and eliminated worthwhile research at its national genebank in Fort Collins, Colorado. Imagine the predicament of a facility in Iraq or Greece or Zimbabwe.

In an interdependent world concerned with economic development, security, and the bottom line, it seems ironic that conservation of crop diversity receives so little priority nationally and internationally. The cost of proper conservation is tiny compared to the benefit stream, and

tiny compared to the human and financial cost of crop failure.

A study published in the *American Journal of Agricultural Economics* found that the value of adding a single sample to the US soybean collection simply to search for resistance to just one of the dozens of soybean pests would likely exceed costs (collection, conservation, and screening) thirty-six to sixty-one times over. This is conservative, because samples can be screened for hundreds of economically valuable traits, and the samples themselves can be made available to researchers all over the world for testing and use. Similarly, another study found that adding a thousand new samples to the genebank at the International Rice Research Institute would, through their use in the institute's rice-breeding program, generate an annual stream of benefits to poor farmers of $325 million, and yet the institute has to worry about meeting the $1.5 million budget it takes annually to manage the 100,000+ sample collection.

LOSSES AND THREATS

Every library loses books occasionally and every genebank, even the best, loses some samples. It seems almost inevitable.

Seeds in a sample are not always identical. The seeds that die first may be genetically different from the rest. The loss of germination ability can be genetically linked with other traits that will also disappear as the first seeds in the sample begin to succumb. And those traits may be useful ones that should not be lost. In more marginal facilities, the losses can be silent and substantial. Poor conditions, such as not being able to keep the storage temperature low enough (−18°C is the ideal) cause the seed to deteriorate, and eventually lose the ability to germinate. Yet many national genebanks have reported that half their samples or more have substandard germination levels, indicating that diversity within samples is being lost.

The major threats to and the principal causes of loss of diversity in genebanks have to do with institution-specific management, infrastructure, and funding problems. They are not usually catastrophic or apocalyptic; they are not the stuff of newspaper headlines. But they are deadly nonetheless. Call it garden-variety extinction. For example, the temperature in Italy's genebank in Bari, home to eighty thousand samples, shot up from −20°C to +22°C in July 2004 when the refrigeration equipment malfunctioned. It took months for repairs to be made. In Madagascar, bundled up and prepared to step into the subfreezing temperatures of the genebank, I quickly removed my jacket realizing that it was hot, really hot, inside. When equipment fails in the tropics, walk-in freezers become large ovens.

Political instability and disasters also pose threats to genebanks. Burundi's collections were destroyed during the fighting and genocide of the early 1990s. Genebanks in Afghanistan and Iraq were severely damaged, both victims of chaos and looting during war. Civil unrest in Albania in the late 1990s led to the destruction of their grape collection. Rebels destroyed a

Tayitis Mohammed makes injera, a fermented bread, from teff near Kombulcha in the Ethiopian highlands. The walls of the house are caulked with teff straw as well. There are more than sixty traditional varieties of teff in the Seed Vault.

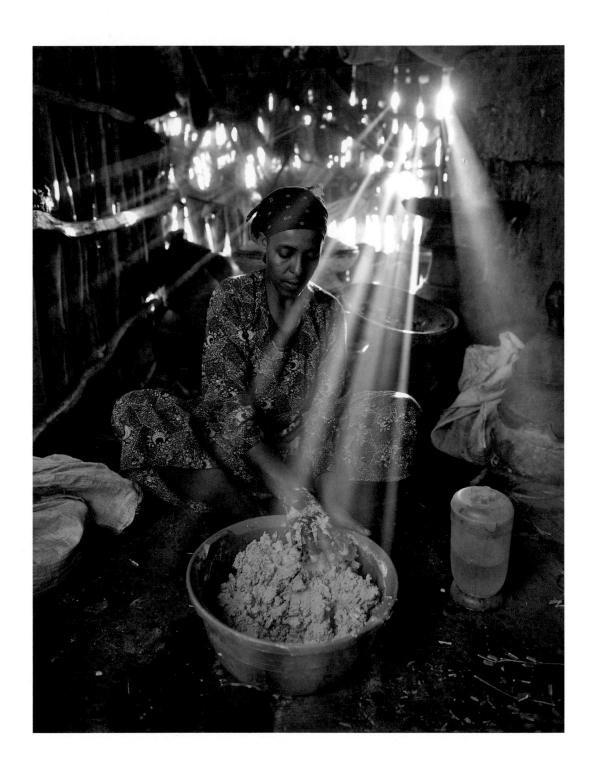

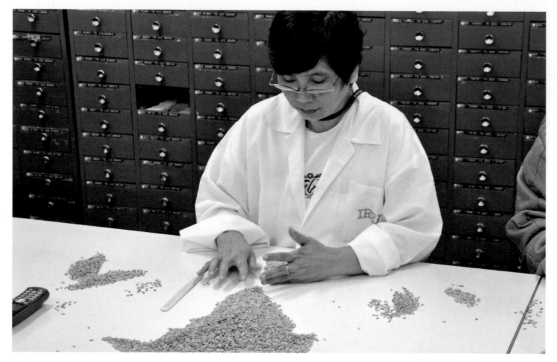

field collection in the Solomon Islands. The national genebank of the Philippines was flooded with a meter of water and mud in a typhoon in 2006 and then partially destroyed by a fire in 2012. A file on my computer titled "Genebank Horror Stories" lists incidents such as these from more than twenty countries, rich and poor, but it is hardly a comprehensive accounting.

When samples or entire collections are lost, genebanks will try to reestablish them. If they know where a duplicate is held, they contact that genebank and ask for some seeds to be returned. But if records are poor, or if no provisions were previously made for safety duplication, the loss becomes permanent. Historically, repatriation has been haphazard and spotty.

In many cases, national genebanks hold seeds that have a long history in the country and are peculiarly adapted to conditions there. The loss of such diversity is particularly unfortunate, because such samples may prove essential in the future breeding of crops tailored to the specific conditions and cuisines within that country.

No individual genebank, no single physical structure, can provide an ironclad guarantee of safety. Not even the best-maintained genebanks in the world are immune to all potential problems. Genebanks are lucky in that no political or religious group is against the conservation of seeds. But genebanks can get caught in the middle of a fight. And many of the best genebanks are located in countries that are experiencing or recently have experienced war or civil strife.

CGIAR's genebanks, which house some of the largest and best collections of the major crops,

are located in Peru, Colombia, Mexico, Ethiopia, Kenya, Nigeria, Syria, Lebanon, Morocco, India, Belgium, and the Philippines. These collections are held "in trust" for the international community under the terms of a treaty, and are available to all. Technically, the genebanks are among the best in the world. Physically, like all genebanks, they are potentially located in harm's way. Some more than others, obviously.

No single genebank, regardless of its size, contains all the diversity of a crop. Any crop. Even large genebanks conserve only a small percentage of the worldwide holdings or samples of a crop. This means that countries are interdependent; no single country has all the crop diversity options it will likely need in the future to ensure a productive agricultural system.

Canada and Australia, wheat-producing powerhouses, have only two and three percent respectively of the wheat samples stored in genebanks globally. The United States has only five percent. India has two percent. China and Ethiopia each have one percent. Is there a wheat breeder in Australia who would be comfortable being restricted to three percent forever? Would anyone argue that Ethiopia will be just fine without access to ninety-nine percent of the wheat samples in genebanks globally?

The figures for other crops mirror wheat, reflecting the simple biological and geopolitical fact that what happens to a collection in one country's genebank really does matter to all. No country can "go it alone" with any crop.

In order to conserve the diversity of a crop, it is necessary to conserve those collections that together encompass the maximum amount of diversity found in the crop samples stored in genebanks. Is it feasible to conserve permanently every genebank-held sample spread among 1,700 facilities? Not, I would argue, if that requires "conserving" 1,700 facilities, 1,700 refrigeration systems, 1,700 electrical supplies, 1,700 roofs. Not if it requires 1,700 great genebank managers and staffs. This is a nonsystem that substantially increases risk of loss. And this is a big reason why having a safe "backup copy" in a place like Svalbard is so critically important.

IMPORTANCE AND USE OF CROP DIVERSITY

"Variety is the very spice of life," as William Cowper put it. It has an "existence value," as economists would say. People like it and want it to exist.

Consumers want diversity within crops; they want tomatoes for eating fresh and for making sauce. They like both tart and sweet apples. And processors need different types of wheat to produce bread and pasta. Farmers want and need diversity not just to supply such marketplace demands, but because different farming and environmental conditions require different crop varieties. Plant breeders address these multiple constituencies and needs.

There is a constant turnover of varieties in farmers' fields. The bread you find in the supermarket today is made from different varieties than twenty years ago, for instance, because

plant breeders and farmers have had to "update" the varieties' disease resistance. The bread may look the same and even taste the same, but the underlying variety changes by necessity.

Spores of a virulent new mutation of wheat stem rust, a disease mentioned in the Bible in association with plague and famine, are now moving with the winds through Africa and the Near East, and breeders are scouring genebank collections to find natural resistance that can be incorporated into new varieties ahead of the disease. Some liken this to the Red Queen strategy in Lewis Carroll's *Through the Looking-Glass*: one has to run faster and faster just to stay in the same place. Indeed, the battle that plant breeders and farmers wage with pests and diseases through the development of resistant varieties can never be won permanently. There is no single "best" variety of any crop, at least not for long. There can't be.

More than two hundred species of pests and pathogens take a bite out of tomato production, and they always have the "best," most commonly planted varieties in their sights. Big Boy tomato, the first popular and successful hybrid tomato, was followed by the Better Boy. Better Girl followed Early Girl. Today's winner is tomorrow's lunch for some insect. Farmers can respond with pesticides, but plant breeding provides a better, greener solution. Nevertheless, great varieties tend to succumb eventually and be replaced by new, more productive, more resistant varieties incorporating genes or characteristics from a number of previous varieties. Crop varietal improvement is evolution directed by human hands. It depends on plant breeders and farmers and their "raw material"—the crop diversity found in genebanks and protected in Svalbard.

For some crops, such as maize, there are hundreds of public- and private-sector scientists working to produce new varieties. For other crops there are surprisingly few breeders. Only about six people are breeding bananas, though bananas are the staple food for 400 million people and the developing world's fourth most important crop in terms of production value. Nearly 100 million tons are produced annually. And only six scientists are breeding yams, despite the fact that 40 million metric tons are produced annually (mostly in Africa), enough to fill every freight train car in North America.

Plant breeders are the primary direct users of genebanks. In a given year they obtain about a quarter of a million samples to test and use

Tomato tasting at Seed Savers Exchange in the US.

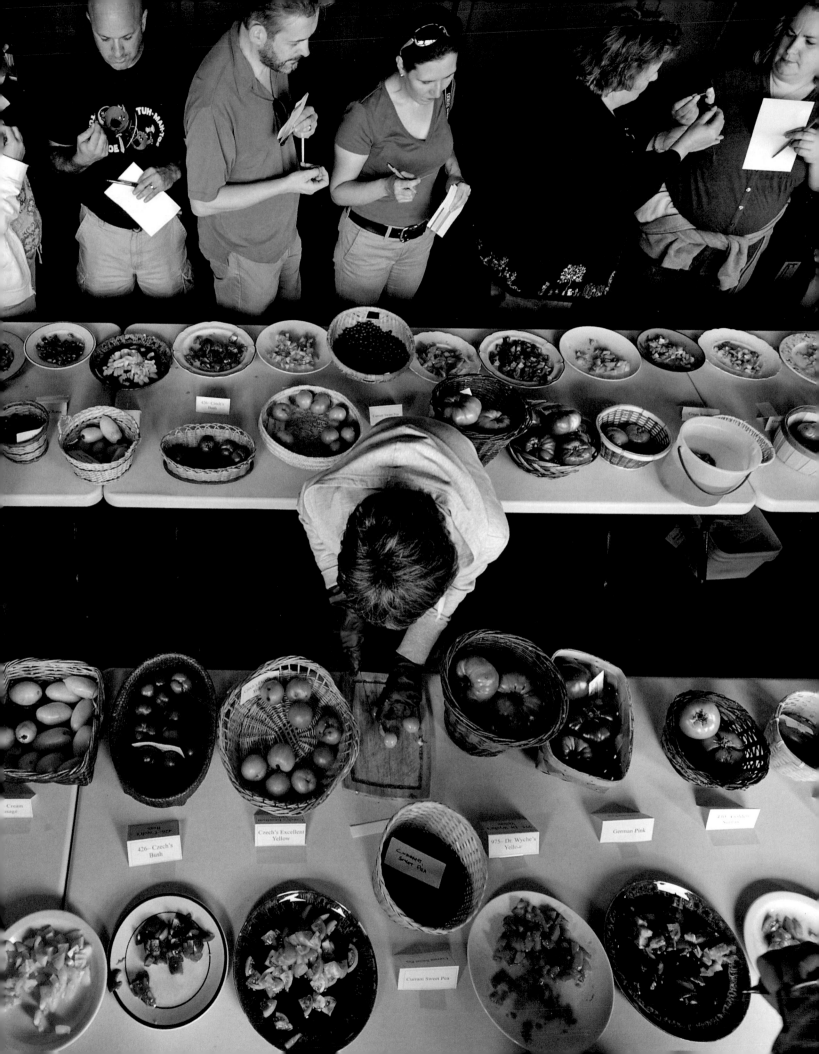

in their breeding programs. The diversity found in genebanks is also the foundation of a great deal of basic biological research published in leading international natural science journals.

Why, some ask, do genebank collections have to be so large? Why not just save "the best"? Of course, it's not a question typically posed to the director of an art collection. We don't ask the director of the Louvre, why so many paintings? Couldn't we get by with representative samples of Picasso and Rembrandt, or even just the best Picasso?

Conserving as much crop diversity as possible is necessary simply because the future cannot be predicted. Conditions change and it is diversity that provides options so our crop varieties can keep pace.

The pedigrees of modern crop varieties are longer than those known for any monarchy. Here is a small section of the pedigree of the Sonalika wheat variety. The full pedigree would show 419 different ancestors. But Sonalika's ancestry is simple compared to the historic Veery wheat variety with eight times as many parental crossings in its pedigree that runs six meters long in small type on paper. And it's more simple still than the Indian variety WH-542 with 3,506 ancestors in its pedigree.

Plant breeders do not create such complicated breeding programs, repeatedly crossing one type with another and then crossing their offspring with another type, just for the fun of it. They do so in order to arrive at the particular combination of genes and traits they desire in the final variety. For this, they draw upon the huge reservoir of traits contained in the seeds being conserved in genebanks. Large collections of crop diversity give breeders, researchers, farmers, and consumers more options. Some of those options might simply be desirable, but some have turned out to be truly essential. A number of crops with daunting disease problems probably could not be produced profitably on a commercial scale were it not for genes obtained from their botanical wild relatives and used in breeding programs. These include tomato, tobacco, and sugarcane, with lettuce, rice, and sunflower not far behind.

A farmer in her field of grass pea (*Lathyrus sativus*) in Ethiopia. The Seed Vault conserves more than 1,000 samples of grass pea, promising a future for this beautiful, nutritious, drought-tolerant crop.

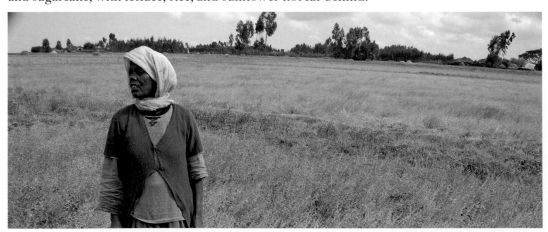

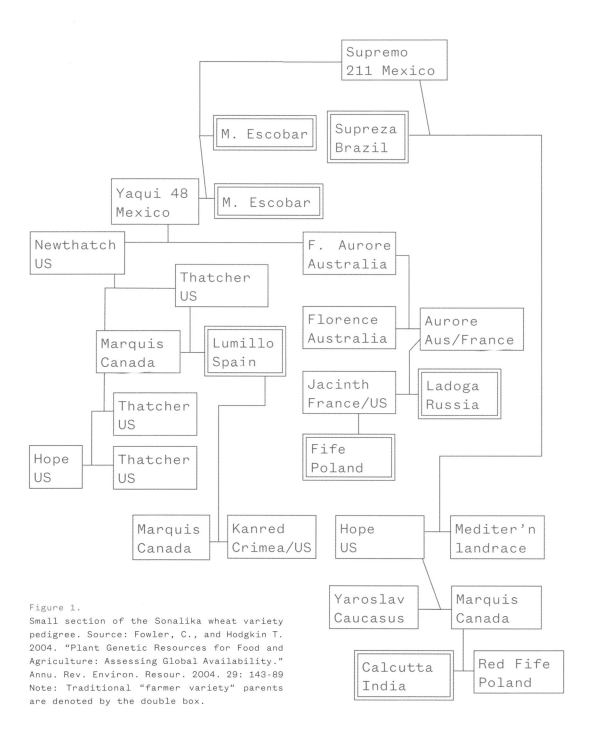

Figure 1.
Small section of the Sonalika wheat variety
pedigree. Source: Fowler, C., and Hodgkin T.
2004. "Plant Genetic Resources for Food and
Agriculture: Assessing Global Availability."
Annu. Rev. Environ. Resour. 2004. 29: 143-89
Note: Traditional "farmer variety" parents
are denoted by the double box.

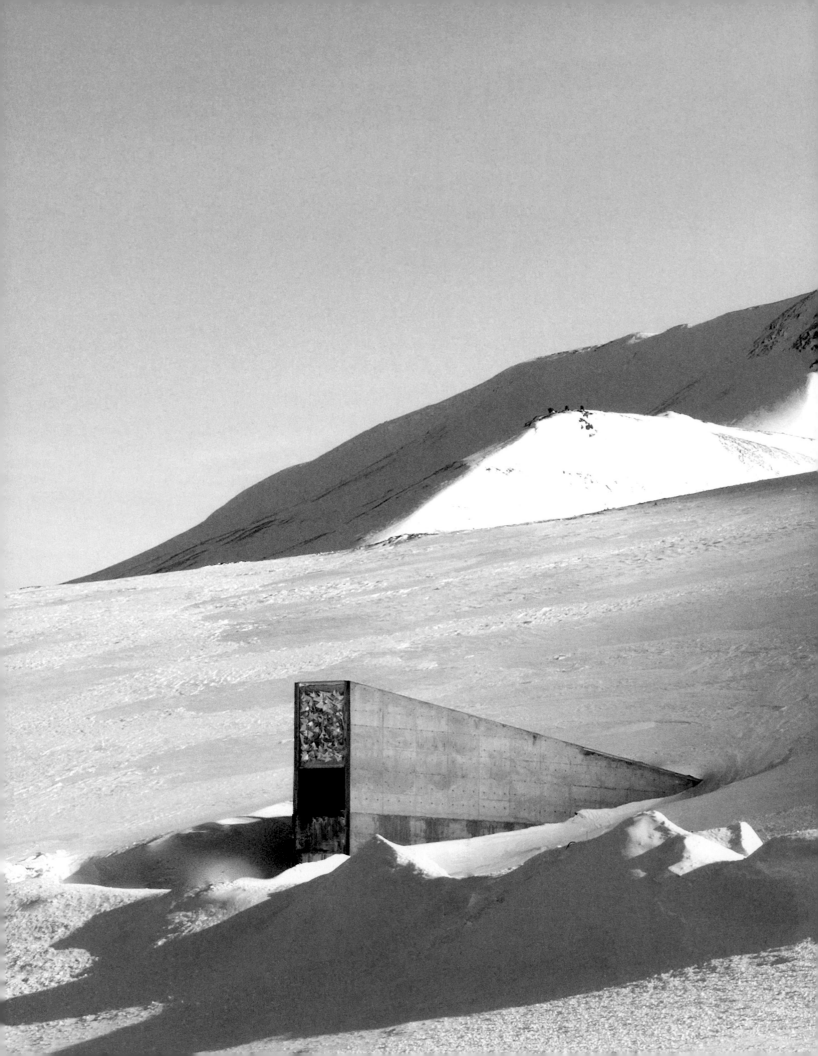

THE SVALBARD
GLOBAL SEED VAULT

In the early days of this century, the big international genebanks of the CGIAR, dotted around the world in nine developing and one developed country, undertook a massive upgrading of their facilities courtesy of a major grant from the World Bank. Dr. Henry Shands of the national genebank in the United States came in to lead the project along with Jane Toll of CGIAR's System-Wide Genetic Resources Program. The results were gratifying. The facilities emerged greatly improved. The seeds couldn't be safer. Or could they?

Everyone in this profession lives with a head full of stories of mishaps, accidents, and calamities at genebanks. Extinction is forever. There are no second chances. The loss of even a single sample can mean the extinction of something unique. It's not coming back.

The events of 9/11 caused many to rethink what "safe" means. Moreover, in the aftermath of Hurricane Katrina in the United States, we heard a withering question asked of anonymous experts and authorities. If they knew that sooner or later such a big storm would hit New Orleans, and if they knew that the levees would not be able to withstand the strain, why didn't they do something about it?

One day in 2003, Henry Shands and I pondered a similar question. Henry observed that CGIAR's international genebanks were in

vulnerable locations. Not all samples were safety duplicated or housed in a reliably secure location. Couldn't we do better?

We knew that sooner or later a major genebank would be lost and this would cause inestimable damage to the future of agriculture. Were anyone to ask, "Why didn't *they* do something about it?" the "they" would refer to us, people such as Henry and me. So what were *we* going to do about it?

The Nordic genebank was already storing about ten thousand duplicate samples of their Sweden-based seed collection in an abandoned shaft of a coal mine in Svalbard. Henry wondered if this could be expanded to accommodate more. We mulled over the idea and the long odds.

As professor of environment and development studies at the Norwegian University of Life Sciences (formerly the Agricultural University of Norway) at the time, I was in a position to explore the subject informally with officials in Oslo and with NordGen (then the Nordic Genebank). I did, and both indicated their openness to considering the idea. It would need to be developed properly of course. I was dividing my time between the university and the CGIAR. I represented this consortium of research institutes and their genebanks at FAO in international negotiations for a treaty on plant genetic resources, and helped with a number of policy matters concerning the collections of crop diversity. This put me into almost daily contact with genebank staff. I felt that I understood their work and their fears and frustrations, and I certainly shared their passion about crop diversity.

I drafted a one-page piece on Svalbard for upcoming meetings of these genebank managers and a separate group that advised the CGIAR on genetic resource policy matters, which I served as secretary. The paper laid out a simple proposition:

> Assuming that the idea is politically, technically and financially feasible, a Svalbard facility could: offer ultimate security from natural disasters, civil war and strife and acts of terrorism . . . [and] demonstrate the resolve of the international community to conserve PGRFA [plant genetic resources for food and agriculture] against all dangers and provide a powerful statement of the importance of PGRFA to the world.

A long tunnel, partially encased in a steel tube, leads from the entrance to the vault rooms 130 meters deep inside the mountain.

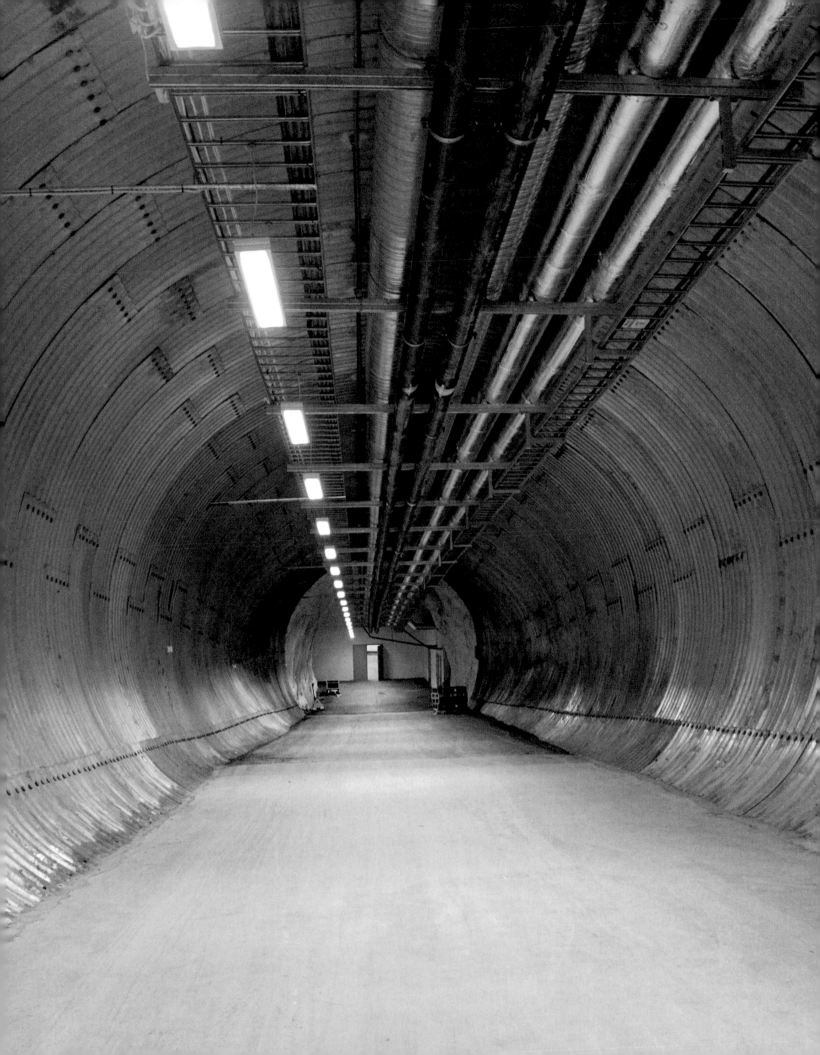

The paper asked that the genebank managers discuss the idea and concluded by suggesting, "If this is deemed worthwhile, then the government of Norway might be approached and a process for studying the matter put into place."

In February 2004, I raised the issue both with genebank managers at a meeting in Malaysia and with the policy advisory committee in Rome. In neither case was the topic the main agenda item for the meeting. The official minutes of each meeting devoted only three sentences to Svalbard. But the sentences were positive. With the support of both gatherings, I drafted a letter to the Norwegian authorities. Emile Frison, the director general of Bioversity International, signed on behalf of all. The letter expressed the interest of the genebank managers in looking into the feasibility of establishing an international seed bank in Svalbard to provide fail-safe security for national and global collections. We were neither sufficiently knowledgeable nor bold enough to ask for more than a study.

My colleagues at the CGIAR genebanks and I had not written to Norway out of the blue. There was a history of storing seeds in Svalbard. The Nordic Gene Bank placed a backup copy of part of its collection in the coal mine shaft in 1984. Periodically they would monitor the viability of those seed samples as part of a planned hundred-year experiment on the effects of storage in those conditions. The coal mine did not provide the lowest temperatures permafrost had to offer, but it was constantly below freezing, about −2°C to −3.5°C. It also did not provide very good physical security, as I would learn during my first visit. The seeds had to be put in a reinforced steel shipping container to protect against a cave-in.

In 1989, five years after the Nordic countries placed seeds in Svalbard, Norwegian scientists including Arne Wold of Norwegian Seed Testing and Ole Heide of the Agricultural University in Ås, Norway, realized that if the mine shaft were just lengthened, it could accommodate seeds from other countries. This altruistic idea took root and Norway formally approached FAO in Rome with an offer to establish the "Svalbard International Seedbank." Norway, however, did not foresee upgrading the storage conditions. Seed would be stored in the mine at ambient temperatures, 15°C warmer than ideal.

Unopened boxes of seeds—more than 880,000 different types—fill the shelves. This is the largest collection of agricultural biodiversity on earth.

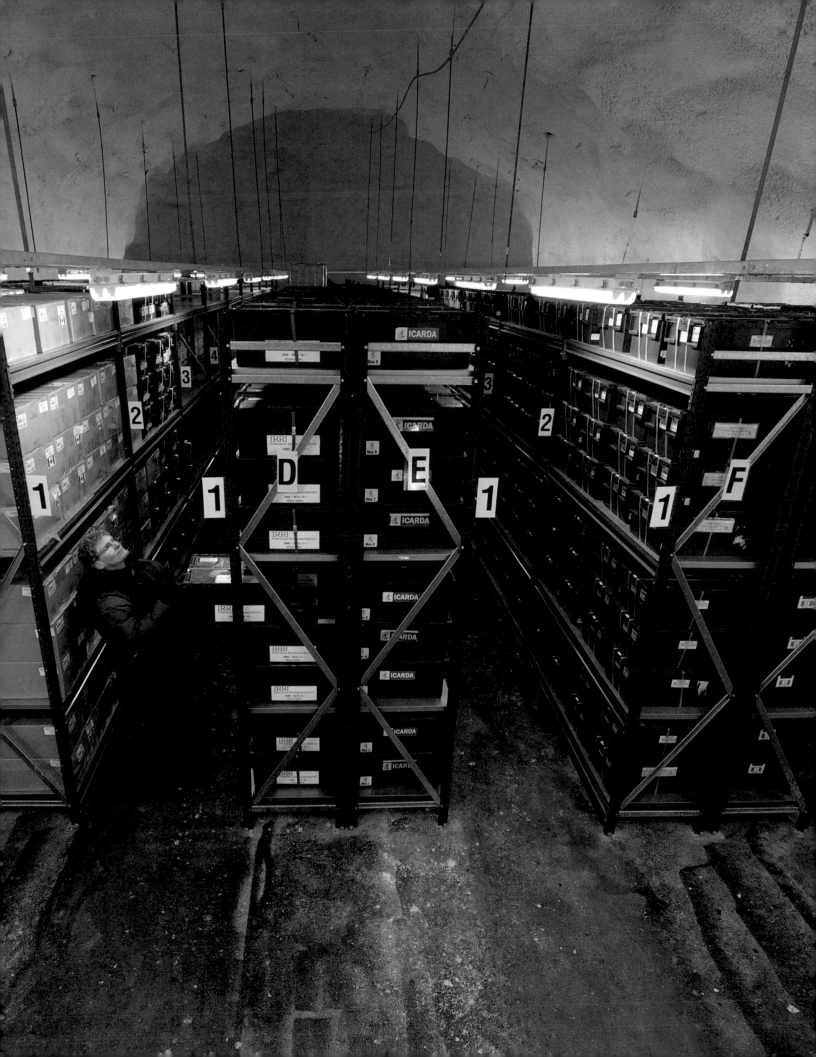

Nor would Norway finance the facility. FAO or someone else would have to come up with the money as a demonstration of commitment. It was a well-intentioned offer, but it was dead on arrival at FAO. No genebank was interested in having their safety duplicated samples stored in substandard conditions; that was not their idea of a *safety* backup. No one was willing to fund it. In addition, there were nagging questions and suspicions about property rights. Who would own the seeds once they got to Svalbard? The offer was unceremoniously rejected. Even I voiced concerns and opposition at the time, in meetings in the late 1980s, as the representative of a prominent nongovernmental advocacy group.

Years later, the history of this previous proposal provided a context that I realized would both enable and hinder consideration of our inquiry to the Norwegian foreign ministry to revisit the idea. The authorities would understand that seeds could be stored in Svalbard; their own scientists were doing this, albeit on a small scale and in primitive conditions. But they would also be extremely wary of being publicly embarrassed again. It would not be feasible for a new initiative to be anything like the first. There would be seeds and they would be in Svalbard. The similarities would end there. In all other respects the plan needed to be and would have to be very different, and it would have to work for all parties, domestic and international, and at all levels: scientific, legal, political, and financial. Most of all, it would have to work for the

Light installation by Norwegian artist, Dyveke Sanne, above the portal of the Seed Vault.

seeds. Then finally someone at a rather high level in the Norwegian government would have to take a risk and say, "This time it's going to be different."

Shortly after our letter was sent, and now back at my desk at the university in Norway, I got a call from someone in the foreign ministry. I forget whom. It seems the ministry had received a letter from a "prestigious group of international agricultural research centers." Norway would have to respond of course, the caller asserted. Could I head an international committee to look into the issue? At this point I felt obliged to mention that I had actually drafted that letter and perhaps my participation on a committee would constitute a conflict of interest. The caller responded by saying that he already knew I was responsible for the letter. But, he persisted, the letter requested that Norway look into the feasibility of the idea. Did I know the answer to my own question? Was it feasible? I hoped so but, honestly, I hadn't a clue, I replied. Great, the caller responded. You're the perfect person to find out the answer.

By posing the question, it seems I had inadvertently volunteered to chair the committee. My institute at the university, the Department of International Environment and Development Studies (Noragric) was given a contract, and I was given an assignment.

PLANNING

My first task was to identify committee members. I called upon Henry Shands as well as Geoff Hawtin (former head of the International Plant Genetic Resources Institute and my former boss for the work I did with the CGIAR genebanks) and William George (an engineer with experience in building and remodeling genebanks). Bent Skovmand, director of the Nordic Gene Bank, who had formerly overseen the wheat collection at the International Maize and Wheat Improvement Center, a CGIAR institute in Mexico, joined us a little later, but illness and other duties prevented him from participating fully. I also corralled my very competent graduate student Marte Qvenild to do research, compile information, and help with logistics for a planned August 2004 committee meeting in Svalbard.

The committee's mandate was to ascertain the feasibility of establishing an international seed bank in Svalbard. Immediately, two advantages of Svalbard were evident. It was remote and thus far away from many of the world's dangers. And it was cold, really cold, which was good for conserving seeds.

The committee faced a huge challenge that became evident immediately. How could we assess the feasibility of establishing a facility when there was no plan to assess? We would first have to draw up the best and most practical plan, then take a step back and ask whether it would actually work. We would need to consider building issues; scientific issues associated with seed conservation; institutional, political, and legal issues; financial considerations; and we would have to develop a credible set of goals, technical protocols, and management plans.

And that would be just the beginning. Before a single shovel touched the soil in Svalbard, the plan would have to secure political approval and funding. Then architects and engineers and builders and lawyers and all sorts of people would have to get involved. The committee began its work with equal measures of enthusiasm and naïveté. All of us harbored the suspicion that, even if we found the idea feasible, it would surely never be implemented. Things like this just don't happen.

We booked our travel to Svalbard. The history, the complexity—all of this was in the back of my head, making it seem highly improbable to me that anything would come of our trip to the top of the world.

None of us had ever laid eyes on the place. Our plane stopped over in Tromsø to take on more passengers, supplies, and fuel for the second leg across the Barents Sea to Svalbard. Visibility was low, winds were high, and the plane was bouncing and rocking about as it threaded its way through the mountain passes east of the village of Longyearbyen in Svalbard. Twice the pilot attempted to land, twice he had to pull up. After the second attempt, he informed us that we would have to head back to Tromsø and try again tomorrow; he didn't have enough fuel to make a third attempt. My first trip to Svalbard ended without ever setting foot on it. It was not an auspicious beginning.

The next day we succeeded in landing. It was August 2004. A cold summer day in Svalbard.

Our first day on Svalbard soil as a committee began disastrously. Rune Bergstrøm assembled local government leaders, mine officials, and others around a large table in the governor's office. Introductions were made and I explained why we were there. Could we expand the shaft in the now abandoned coal mine to accommodate more seeds? This seemed the obvious approach. Arne Kristoffersen, a straight-talking coal miner spoke up first. Our idea was a terrible one, he declared. Absolutely unworkable. Coal mines are dangerous places. They're dirty. They cave in, catch on fire, even explode! It was impossible to imagine this being a good or safe place for seeds. Heads nodded in agreement.

We had come straight from the airport into this meeting and now I wondered whether we might be able to catch the same plane back if we hurried. I felt stupid. My little committee had flown all the way to Svalbard at some expense for what amounted, in terms of substance, to a one-minute meeting.

After an inhumanely long pause, Arne continued. If you really want to create a great place for seeds, he advised, don't use the coal mine. Tunnel into the solid stone away from the coal seams. No gas, no fire, no cave-in—just a solid structure that will last forever, a brand new structure. It was not what we had been thinking but suddenly we were back in business.

Our small feasibility study team understood from the beginning that if there were, at last, to be a real insurance policy for the world's seeds, it could not be a genebank like any other. It would have to be virtually immune to the kinds of problems we had witnessed elsewhere. It

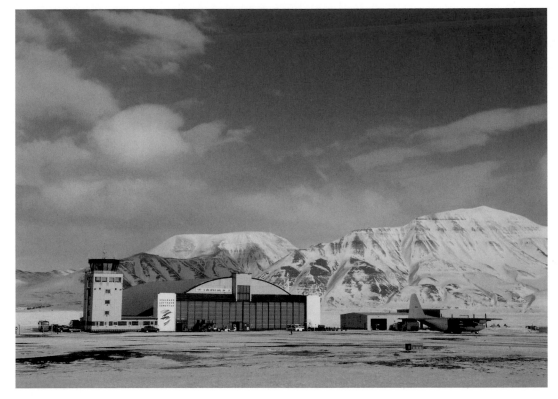

would need to be far removed from the dangers of war, uprisings, industrial accidents, and the general insanity and mayhem of modern life; shielded in some way from hurricanes, tornadoes, and floods; and unaffected by earthquakes, rising sea levels, and even tsunamis. Somehow, it would have to operate almost automatically, by itself. The more human involvement, the bigger the chances of something going wrong. Management would have to be slim and uncomplicated. To be sustainable over the long, long term, the entire endeavor had to be inexpensive. If it were not cheap to operate, it would be vulnerable to budget cuts. In fact, to guarantee funding year after year, it would need an endowment.

As it happened, Geoff Hawtin was serving as interim executive director of the Global Crop Diversity Trust, an endowment fund established by FAO and CGIAR to ensure the conservation of crop diversity "in perpetuity." And though we didn't know it then, I would succeed him as head of the Crop Trust. It was a perfect match, and perfect timing for the Seed Vault.

There was a logical order to our committee's assignment. First we had to develop a plan. We had to have something concrete against which to test "feasibility." We had to find a suitable location, conceptualize the design of the structure and determine if it could be constructed, figure out how much it would cost to build and operate, identify who would run it, hash out

the administrative structure, and ascertain whether genebanks in the "real world" would actually make use of it.

Then, and only then, could we step back and address the original question and the Norwegian government's charge to the committee— is it feasible? Will it work? Could it provide robust protection for years, centuries, millennia to come? Might we finally put a halt to the genetic erosion, the extinction of crop diversity taking place in the fields and genebanks? We did not have answers to these questions. The small committee was constituted with pragmatists. We knew there was no perfect solution. We knew that nothing we could conjure would provide an iron-clad guarantee. Such guarantees don't exist in this world. But we were tired, fed up, and frankly scared of the steady, cumulative losses of crop diversity. We were in problem-solving mode.

There was a long list of obstacles to overcome before we could consider pronouncing the idea of establishing a facility in Svalbard feasible. But we were already aware of some of the powerful advantages that Svalbard offered. First and most important was Norway's reputation in the international community. It had long been a leader in environmental matters. It was one of the most generous foreign-aid donors in the world. Even though questions of ownership of and access to crop diversity had long pitted developing against developed countries, Norway's reputation as an honest and fair player in the debate was second to none. Norway tended to look for solutions, not fights. In short, Norway would have no perceived conflict of interest in hosting a global facility. The recent adoption of the International Treaty on Plant Genetic Resources for Food and Agriculture additionally served to lessen tensions.

Svalbard made sense for many other reasons, one of the biggest being immediately evident when we stepped off the plane. Its remoteness provides security. Yet it is still accessible. Seeds could easily be transported to and retrieved from Svalbard. We needed that combination.

And is it ever cold! In Svalbard, one could take advantage of the permafrost, the soil and rock that remain frozen year-round below the surface layer. Svalbard's permafrost offers natural freezing for the seeds, a key requirement for long-term conservation. Additional mechanical cooling down to −18°C, the international standard, could be easily accomplished. If anything happened to the cooling system,

Placing boxes on the top shelf requires some balance.

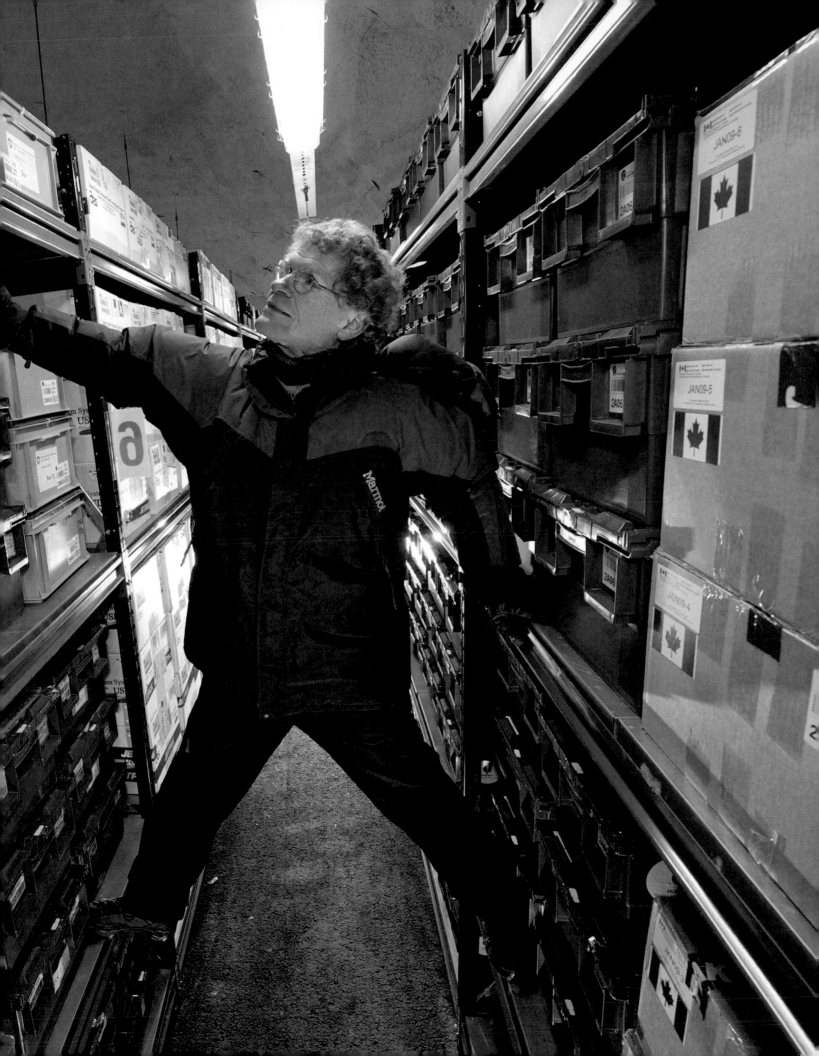

the permafrost would be more than adequate for keeping the seeds frozen until repairs could be made.

In Svalbard, unlike some other remote, mountainous, and cold places we know, the political situation is stable. Military activity is prohibited under the terms of the Svalbard Treaty signed in Paris in 1920.

The local government is highly competent and helpful. The local community, while small, is very skilled and supportive.

Infrastructure is excellent. Norway had invested huge sums on this, more than a village of two thousand people could ever expect anywhere else in the world. There is an airport (with a runway long enough for the Airbus 380 to test land) and a harbor sufficient to accommodate rather large ships. Locally mined coal provides power generation; there is no dependency on outside sources of fuel. Communication links are superb.

The technical conditions are nearly ideal. A mountain-encased structure would increase security and provide excellent insulation. The area is geologically stable. Radiation levels inside the mountain are virtually nonexistent, ranging from zero counts per second to 100. Humidity is relatively low. Methane levels are very low. And it was possible to position the facility far above the point of any projected or even possible sea-level rise due to climate change. Indeed, we calculated that if all the glaciers and ice in the world melted, raising sea levels by 70 meters (230 feet) and there were a tsunami of record-breaking height, the location we had our eyes on would remain 20 meters (or about the height of a six- or seven-story building) above it all, and dry.

The plan was beginning to take shape technically. It didn't hurt that some of us had ties with and access to policy makers in Norway, facilitating serious consideration of the proposal at high levels in the government.

Signaling that this would not be a regular genebank with seeds moving in and out routinely, someone suggested that a different name was needed, thus the "seed vault." And since "international" can apply to something involving as few as two countries and the Seed Vault was to be much more inclusive, it became the "global" seed vault: the Svalbard Global Seed Vault.

As envisaged from the beginning, the purpose of the Svalbard Global Seed Vault is to provide insurance now and forever against both incremental and catastrophic loss of crop diversity held in traditional seed banks around the world. The Seed Vault offers "fail-safe" protection for one of the most important natural resources on earth. It serves as an essential element in a global network of facilities that conserve crop diversity and make it available for use in plant breeding and research. Its genesis lies primarily in the desire of scientists to protect against the all too common small-scale loss of diversity in individual seed collections. With a duplicate sample of each distinct variety safeguarded in the Seed Vault, genebanks can be assured that the loss of a variety in their institution, or even the loss of the entire collection, will

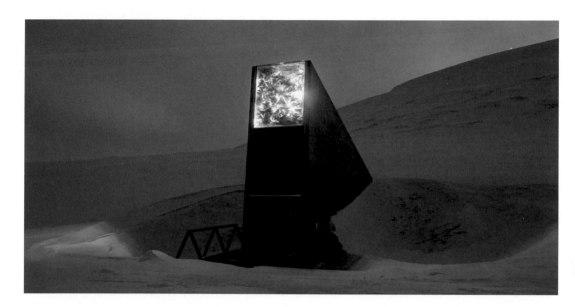

The Seed Vault
bathed in
Arctic blue.

not mean the extinction of the variety or collection and its diversity. The Seed Vault will have a "spare copy" that can be restored to the seed bank that deposited it.

In undertaking this study, the Committee recognized and accepted the compelling need of the international community to plan for the "worst case scenario," the need to ensure the long-term conservation of plant genetic resources, protecting them from both old and new threats, routine as well as unprecedented occurrences. The Committee, therefore, undertook to assess whether a facility located in Svalbard might provide ultimate "fail-safe" protection for the world's most valuable natural resources, and whether it might be able to do so in a manner that is efficient, sustainable, inexpensive, and politically and legally acceptable.

Our conclusion, detailed in this report, is that a Svalbard facility can provide all of these things, and can thus make a major contribution to food and environmental security and to the safety and well-being of human beings for as far into the future as we can see . . .

—Fowler, George, Shands
Skovmand, 2004

Excerpt from "Study to Assess the Feasibility of Establishing a Svalbard Arctic Seed Depository for the International Community," 2004. Cary Fowler, William George, Henry Shands, Bent Skovmand. Prepared for the Ministry of Foreign Affairs (Norway). Center for International Environment and Development Studies, Agricultural University of Norway and Nordic Gene Bank.

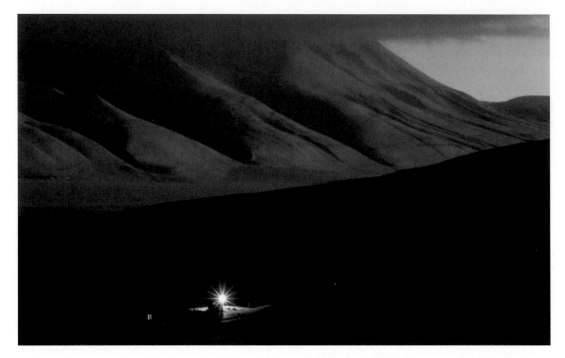

We don't need to experience apocalypse in order for the Seed Vault to be useful and to repay its costs many times over. We who proposed and designed and built the Seed Vault were not anticipating the end of the world. We never thought of it as a "doomsday vault" and never used this term. We did not foresee global catastrophe. We were not the type to parade around with signs saying "Repent, The End of the World Is Near." We were pragmatists, maybe idealistic pragmatists, but pragmatists. We wanted to address a problem we were already experiencing: the loss of diversity in individual genebanks. If the Seed Vault simply resupplied genebanks with samples those genebanks had lost, we understood that this would repay our efforts and the costs a thousandfold. In the unlikely event of a large-scale regional or global catastrophe, the Seed Vault could prove indispensable to humanity.

Submitted to the Norwegian government in September 2004, the feasibility study was drafted in two parts: a technical and financial study, and a legal and political study. The foreign ministry specifically requested the latter, and I was asked to draft it by myself "in confidence," because the foreign ministry wanted a completely candid assessment of how countries felt about placing their seeds in such a facility. As much as I wanted the plan to move forward, I knew this confidential assessment had to be rigorous, and if it uncovered anything troubling, it had to be put squarely on the table. Would countries really use the facility as we foresaw it? Were there any political or legal impediments? Would there be a controversy of any kind?

That document remains classified, but the conclusion is no secret. There were no significant political or legal impediments. Every country I contacted welcomed the idea, and I contacted all the major holders of crop diversity. Despite this positive reception within the small scientific community that deals with crop diversity, it didn't occur to us that the media or public would take the slightest interest in what we were doing. Indeed, the word "media" does not appear in our report.

The feasibility study completed, I took the train into Oslo to hand deliver it.

I was ushered in to see Olav Kjørven, a tall and surprisingly young man considering that he was state secretary for international development at the Ministry of Foreign Affairs. The walls of his office were charmingly decorated with the drawings of his young children. I had a half hour to present the findings of our feasibility study. He listened intently, but silently, and I couldn't read his body language. I had no idea whether he liked the plan or thought it was nuts. Finally he leaned across the table and said:

"Let me get this straight. You're saying these seeds are the most important natural resource on earth?"

"Well, yes, I guess so."

"And you're saying that Svalbard is the best place in the world to conserve them?"

"Yes," I said with conviction. "It is."

Then with a shrug of his shoulders and upturned palms he replied, "Well, then how can we say no?"

A tingling sensation darted through my body. Could this be happening? Did he just say yes?

The government would require much more than a feasibility study, however, before it would formally approve the project and allocate funds. It would need a blueprint of the construction, a more detailed management plan, and a serious budget. The government established a steering group comprised of staff from five ministries. A neighbor, the Ministry of Agriculture and Food's Grethe Evjen, became heavily involved.

In the fall of 2005, Statsbygg, the public-sector company that plans, builds, and owns such public buildings on behalf of the government, was tasked with formulating a tender for design and construction of the proposed facility. Magnus Bredeli Tveiten jumped in and led the process at Statsbygg superbly. The challenge was immense. Nothing quite like this had ever been done; the number of architectural, engineering, and construction firms skilled and daring enough to respond to the tender were few. Barlindhaug Consult AS (now Multiconsult AS) was charged with developing the physical plan with Peter Søderman, a Finnish architect based in northern Norway. For the facility to function as we in the seed world needed it to, the architect and engineers and eventually the builders needed to understand what we were going to do inside the mountain. What were our working requirements? How cold did the

seeds have to be? How much space would they occupy? Magnus relayed their questions. When unsure or stumped, I turned to Geoff Hawtin, who played the lead role in formulating the scientific management plan for the facility, or to Henry Shands with his experience at a big national genebank.

The initial endorsement by the foreign ministry initiated many months of behind-the-scenes talks and negotiations among several ministries over what portion of the construction costs each would pay. None had budgeted for a seed vault. All the while, Søderman and the engineers were at work with Statsbygg, the government's steering group, and the feasibility study committee on a blueprint that might never be used.

Peter Søderman, the architect, had never designed a seed vault in the middle of a mountain. No one had.

Originally, as a security measure, we had all speculated that the facility might best be situated at some distance from the town of Longyearbyen; not easily accessible, even hidden. So Søderman's first challenge was to figure out how to make the facility inconspicuous. There could just be a simple door in the side of the mountain. That would be minimalist. But he quickly realized the complication. The door would frequently be obstructed either by snow or by accumulations of loose rock and stone sliding down the mountain.

The notion that we could successfully hide such a facility while moving tons of seeds inside came to be seen for what it was: totally unrealistic. Indeed, having the facility close to the village, visible through binoculars to people in the control tower of the airport, actually increased security. Søderman's job became a little easier. He understood the structure would have to protrude from the mountain to facilitate entry. He thought first of having two concrete slabs in a V-shape configuration jut out "like a knife that would slice into the rock" but soon settled on a single wedge. He wanted the visible part of the structure to convey a certain feeling. He wanted people to feel that it was "like a little gem—here's something important." Yes, "it would be a secret, but it would be for all of us." For the most part, however, Søderman was engrossed in the technical issues, which were far greater than usual.

Gradually plans, designs, budgets, environmental assessments, and legal documents started to come together late in 2006. At a meeting in a second-floor conference room at the Ministry of Agriculture and Food in Oslo, Magnus unveiled the drawings for the Seed Vault. I couldn't stop smiling. It was just what we had wanted though, I must say, the design was visually different from the one the committee had first sketched out two years earlier. I had foreseen a facility that was subtle yet modern, one that blended into the contours of the mountain, philosophically Norwegian. Instead here was a wedge jutting from the mountain like something from *2001: A Space Odyssey*. It was stunning, and still, somehow, so Nordic.

The design called for a sleek and very visible portal building, opening into a long tunnel terminating more than a hundred meters later in vault rooms in the coldest recesses of the

mountain, in order to capture the full cooling benefit permafrost could offer. In Svalbard, permafrost starts one and a half meters or so below the surface layer that is exposed to the sun and not always frozen.

We asked only a few questions of Magnus. No one, however, had any doubt as to whether this design was what we wanted. It was beautiful, simple, and supremely functional. We were enthralled.

Having an idea to create a Seed Vault is easy compared to implementing it. There are people whose tireless yet unseen work and advocacy inside the government were responsible for securing the tangible political and financial support that made the Seed Vault possible. Establishing a facility in Svalbard necessarily involved many different government ministries. Funding for a Seed Vault was not in any ministry's budget, so the initiative required allies throughout the government. Friends and acquaintances from my agriculture-related work at FAO, and from my time as a resident of Norway, stepped forward. They understood the importance of the issue. Grethe Evjen in the Ministry of Agriculture and Food, Jan Borring in the Ministry of Environment, and Gunnvor Berge and Jostein Leiro (now ambassador to the UN agencies in Rome) in the Ministry of Foreign Affairs did the "heavy lifting." Later, the foreign ministry's Anne Kristin Hermansen entered and gave a much needed push. I backed them up with technical information and rationales when questions were raised, and consulted on strategy. Dozens of times, approval was threatened. But these Norwegian civil servants were creative and persistent. They brought the relevant government ministries together,

Tourists set out in a Zodiac to examine one of Svalbard's many glaciers.

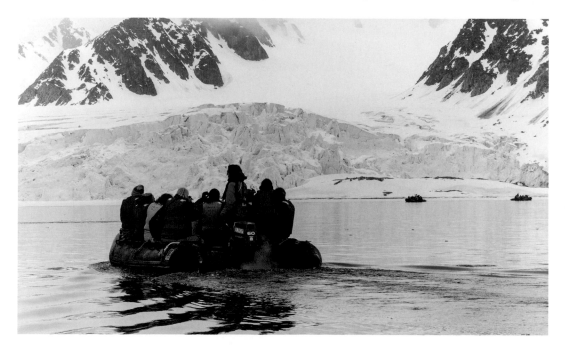

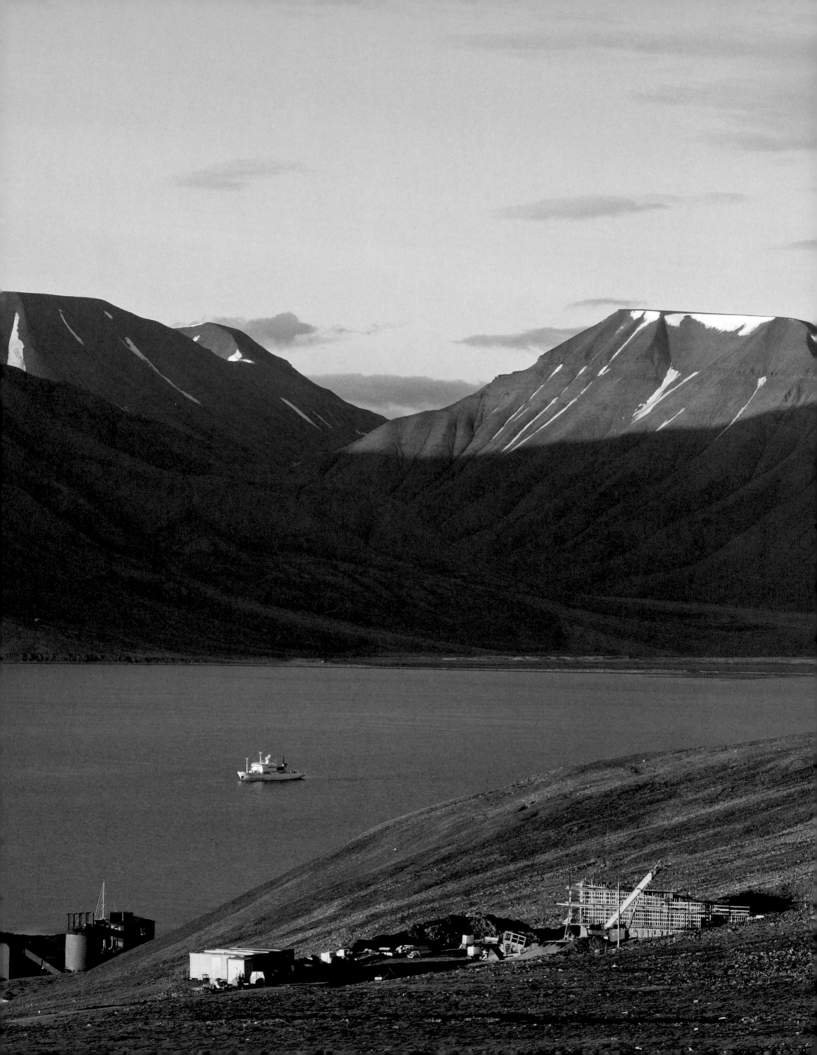

assuaged doubts, and solved countless political and bureaucratic problems—hundreds of them. Each of them played an essential role in creating the Svalbard Global Seed Vault and making it functional, and I cannot imagine having a Seed Vault today if a single one had not been involved.

In fact, it took two years to work through the details and get the final approval and two and a half years before ground was broken in May 2007. Everyone can look back now and say that the Seed Vault was a good and obvious idea, and that of course the Norwegian government should have approved and funded it. But back in 2004, before there was a Seed Vault, it might equally have been viewed as a crazy, impractical, unnecessary, and expensive idea, another grand government folly. Government administrations the world over are risk averse. A room for storing seeds inside a mountain near the North Pole? Are you kidding?

Norway said yes.

CONSTRUCTION

Funding secured entirely from Norway (50 percent from the Ministry of Foreign Affairs and 25 percent each from the Agriculture and Environment Ministries), the project was now in Statsbygg's hands to implement. Magnus Tveiten continued in charge of the project, and on the government's side, Geir Dalholt chaired a steering committee. Barlindhaug, with offices in northern Norway, had extensive experience in Svalbard; it took charge of design and engineering. The construction contract went to Leonhard Nilsen og Sønner, virtually the only construction company with extensive experience and a local presence in Svalbard.

The government arranged for an official groundbreaking ceremony involving the prime ministers of Norway, Sweden, Denmark, Finland, and Iceland. Looking a little bemused, maybe even skeptical, they clamored up the side of a hill near coal mine No. 3 with a few journalists and people like me who had been involved in the planning. There were a couple of short speeches from the prime ministers and me followed by a photo-op with each leader emptying a small bag of seeds into a clear Plexiglas tube containing local stones. The idea

The Seed Vault early in the construction process in the summer of 2007.

was to symbolize the union of mountain and seeds. As it turned out, seeds and stone would never meet again at this location. The ceremonial site was too near coal seams. The Seed Vault would be built in another location nearby. Nevertheless, the groundbreaking was a success and we adjourned to Huset for a special dinner courtesy of Norwegian prime minister Jens Stoltenberg and his wife.

Formal approval for the Seed Vault came in May 2006 and the contract for construction was finalized with remarkable speed in November. Construction on the $9 million completely Norwegian-funded Seed Vault began in the spring of 2007 with snow on the ground. At 5:25 p.m. on May 18, sporting the regalia of his office, Kjell Mork, head of Longyearbyen's local government, lit the fuse detonating the first blast in the side of Plateau Mountain high above the airport. Tunneling could now begin in earnest.

The bedrock in Svalbard—layers of sandstone, siltstone, and claystone—is not ideal for tunneling and regardless of what the plans might look like on paper, a tunnel in Svalbard needs to follow the rock seam to ensure a stable and strong layer of sandstone above. Before blasting and tunneling, no one can tell with precision what this will mean.

Tunneling equipment, the same used in roadway construction in mountainous Norway, was shipped in for the job from the mainland and began to rip away at the rock. Excavation and the warmth generated by the machinery temporarily thawed the permafrost, creating a cold wet work site. Small stones fell from the top while the workers stood in puddles and flowing meltwater below.

Following the seam, the tunnel slopes gently downward for about a hundred meters. Melting snow that seeps in at the entrance end of the tunnel, where there is no permafrost barrier, therefore has to be mechanically pumped out some meters down the tunnel. Two pumps, one midway down the tunnel and a second farther down, were installed as a precaution, as was a backup generator. The situation poses no threat to the seeds; they reside far beyond the pumps and at a higher level and are additionally protected by frigidly low temperatures that would turn water into ice long before it reached their location. Still, engineers are working on this issue in 2016. They aim either to seal the upper section of the tunnel from this water or to devise passive systems that will channel the icy meltwater away from the tunnel and reduce or eliminate the need for pumping, though the pumps will stay just in case.

My calculations used in the planning process indicated that the Seed Vault needed to be able to store 3 million samples. While I was convinced that no more than 1.5 million unique varieties or populations existed and we could never expect to get seed samples of 100 percent of them, I acknowledged the need for significant leeway in an endeavor such as this, both to accommodate error and new diversity as it arose. The biggest and best surprise during the construction process came when I was informed that for structural reasons the height of the two vault rooms would be lowered. This would result in a reduction of excavated volume

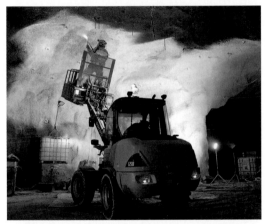

Scenes from the construction of the Seed Vault. In the photo of the workers, Dag Brox, the leader of the construction team, is on the far left. Cary Fowler is second from the right.

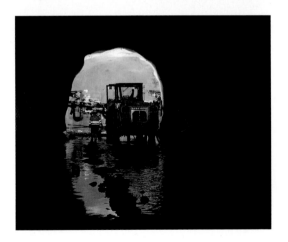

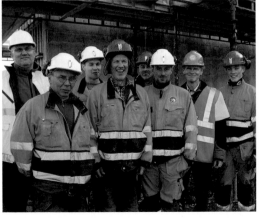

that in turn would allow for the creation of a third room, increasing the Seed Vault's capacity from 3 million samples to 4.5 million, without increasing the cost of construction. The one thing about which I am certain is that capacity will not be reached in my lifetime or that of my children. And if I am wrong about that, then a little more tunneling will suffice to create more room. It's a big mountain.

As head of the feasibility study team, I stayed closely involved on technical issues and made regular visits to the building site, getting to know Magnus Tveiten of Statsbygg in Oslo, Dag Brox, the always helpful and friendly construction supervisor, Jarle Berg-Oksfjellelv, the site manager, and their men, as well as Tor Sverre Karlsen of the Statsbygg office in Longyearbyen, who was intimately involved.

All materials and machinery used to build the 1,720-square-meter (18,514 square feet) Seed Vault had to be imported by ship or plane, including the giant equipment used to tunnel into the mountain. A supply ship typically arrived once a week, on Friday, with equipment and materials. On one occasion, in very bad weather, a ship lost propulsion on the way up, and had to be rescued and towed into Longyearbyen.

Working conditions for building anything in Svalbard are less than comfortable. It was cold, often wet, often dark, and there was danger. Three times during the construction process the site was visited by polar bears. Once, workers saw one walking up the road just below the site. On two other occasions, workers emerged from the tunnel to find polar bear tracks in the snow just outside. This is why, especially in winter, I always look carefully—360 degrees—when I get out of the car at the Seed Vault, and when I open the door of the Seed Vault to step out. The chances that a bear is nearby are small, but why bet your life?

Initial notebook sketches of the Seed Vault made by the architect, Peter Søderman.

I was always amazed when I visited the site, both to see how hard everyone worked and to see how few construction workers there were. Though many were involved, even if marginally (see appendix B), the Seed Vault was built by a relative handful of people. One of the construction workers was a tall young Swedish fellow with long blond hair. Carrying timbers for the scaffolding for the entrance, he paused to talk. "What do you think about working here," I asked, hoping for and half expecting some lofty response befitting the purpose of the

Seed Vault. "Oh, it's like any other construction site," he said matter-of-factly motioning to all the construction debris and equipment lying around. He paused then and added, "But for me, it's the job of a lifetime." He went on to say that it was about time that the countries of the world got together to do something positive. The attitude, and the quiet pride, was something I came to experience from all of the workers. In my office at the Global Crop Diversity Trust, I had only one photograph from Svalbard on the wall. Of all the stunning photos that Mari took, the one I wanted most was a photo of the workers, to remind me who really built the vault.

In Norway, government-funded building projects typically include art. Indeed, projects exceeding a certain cost are required to budget for art. The art at the Svalbard Global Seed Vault is visible to all. Facing the Seed Vault, you see the portal building, the triangular concrete wedge, or fin, protruding from the mountain. On the upper part of the wall above the front door of the facility and wrapping around the roof is a light sculpture designed by the Norwegian artist Dyveke Sanne.

As construction workers raced to finish their work ahead of a February 2008 opening, installation of the light fixture fell to the artist herself. The construction workers knew it was a woman from the mainland. There was some skepticism. It was January, polar night, completely dark. The temperature was bone-numbingly cold and the wind was howling. "It's cold in a way you can't imagine," Dyveke recalled. "I wore motorcycle goggles because the cold wind can pop your eyes. When I was working outside alone," she said, "I would take overexposed photographs of my surroundings with my digital camera in order to check for ice bears." For a week, Dyveke labored away on top of the Seed Vault, exposed to the elements. Finally the lighting for the artwork, which she titled *Perpetual Repercussion,* was put into place and began to glow. On my next trip to the site, I heard absolute reverence for this artist in the voices of the workers.

Perpetual Repercussion is made of hundreds of small triangular pieces of polished steel with a mirrorlike quality, as well as dichroic glass consisting of layers of non-translucent glass and metals or oxides, which give the glass different colors as one's angle of view is altered. Behind these small plates, which seem to float in space, lie two hundred fiber-optic cables producing a bluish-green light that appears to pulsate and twinkle slightly. Without the need for electrical assistance in the arctic light of summer, the light sculpture reflects the environment, as the seeds reflect theirs. But in Dyveke Sanne's view it is more than that. "The thought or idea of the installation is precisely to insist on reflection, that who you will meet in the mirror is yourself and that whatever needs doing is up to you." In the dark periods of polar night, the light sculpture emits a muted glowing greenish-turquoise and white light, a "beacon to humanity" as she sees it. It is the gem the architect envisaged.

Dyveke Sanne and her *Perpetual Repercussion* were recognized with the Norwegian Lighting Prize for 2009.

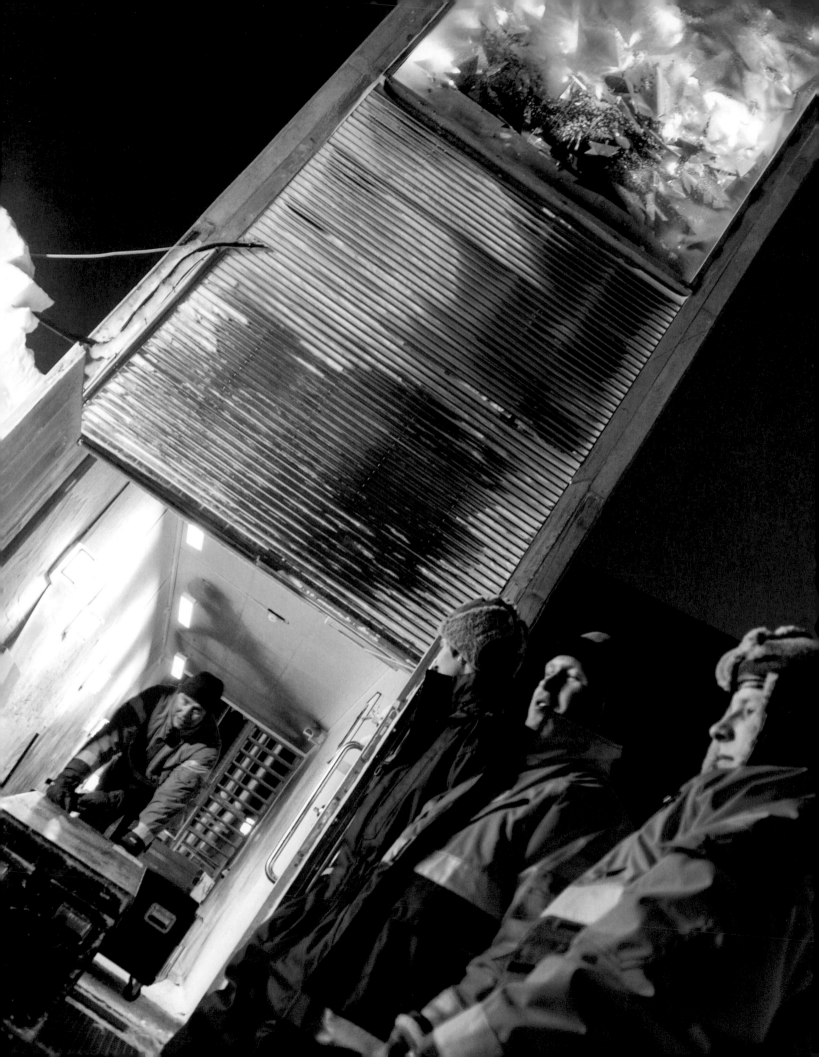

STEP INSIDE

Strip away the romanticism and intrigue, ignore the exotic location and purpose, and the Svalbard Global Seed Vault becomes a tunnel, a hole in the mountain with seeds. Standing outside the angular concrete wedge, the portal entrance that juts out of the landscape, no one sees this as a simple tunnel, no one manages to divorce structure from purpose, from resolve, from time.

Everything about the Seed Vault is simple, pragmatic, and focused on the immediate task, yet evocative of a larger vision. There is a single entrance. You step across a short grated metal bridge to the door. Across the treeless mountainside, wind sweeps over and beneath the bridge, helping clear the entrance of snow in the winter. In the architect's view this conceptual device also serves to suggest a grander intent: the seeds preserved within bridge past and future, both for agriculture and for us.

The entrance faces north, catching the wind and avoiding the marginal warmth that would come from a southern exposure during Svalbard's short summer. Beyond is a stunning panorama of sea, mountains, and glaciers. Closer, but far below the elevation of the entrance of the Vault, the airport and a dock area are visible. The village of Longyearbyen is out of sight, just around the mountainside to the east.

A number of factors combined to suggest the precise location of the Seed Vault. Ideally, the Seed Vault needed to be near the village of Longyearbyen for ease of access and transport of seeds. It also needed to be near an existing road. Roads are expensive to build in Svalbard, and for environmental reasons one would wish to avoid building new ones. The site chosen necessitated construction of only a short access drive off an existing road to a SvalSat facility. The spot had to be away from coal seams that could present a risk of fire or explosion, and might be the target of future development. And it needed to be away from any cultural or historic relic (an old protected mining entrance from the pickax days is nearby but sufficiently distant).

Standing in front of the Seed Vault, the 2.5-meter-wide, 8-meter-high facade of the portal building seems smaller than you might expect, but the shape is dramatic and stark against the barren backdrop of Plateau Mountain.

The portal building houses a 10-kilowatt compressor linked to pipes that run the length of the tunnel to the vault rooms. The machine cycles on every few minutes, blowing air out and taking it in. Standing at the entrance it seems as if the entire Seed Vault is alive, slumbering, breathing heavily.

The frigid air generated by this system supplements the –5°C offered naturally by the frozen mountain itself in the vault rooms. Locally produced electricity, generated from locally mined coal, powers the compressor. During the initial cooling phase an additional compressor was brought in, a much larger one (30 kilowatts), and placed beside the entrance to boost the cooling and quickly reestablish the permafrost temporarily lost when the tunnel and vault rooms had to be heated to set the concrete and asphalt.

Opening the heavy locked metal entrance door, you step into the portal building. Stairs to the right lead to the cooling system's compressor and the electrical networks for the light sculpture. Just beyond the stairs is a concrete closet housing a small backup generator. Inside, the portal building feels like the narrow corridor it is. There is a door straight ahead at the end of the portal building, which is actually just inside the mountain itself. Open this door and the expanse, the length of the tunnel, becomes visible.

The surface layer of rock is loose, the result of repeated freezing and thawing for millennia, so the beginning of the tunnel is encased in a heavy steel tube. Beyond this shallow, unstable, and fragmented layer of rock and soil, the permafrost area begins and the rock is solid. The slight downward slope of the tunnel for the first ninety meters or so has made it easier to haul boxes of seeds in a handcart from the entrance into the belly of the mountain, but the dampness during the short summer snow melt, combined with the freezing cold, can combine to make the walk down the tunnel slippery.

Regardless of the season, visitors instantly observe that the Seed Vault is not a pristine, antiseptic laboratory. It was not designed as a research facility or tourist attraction. It's a

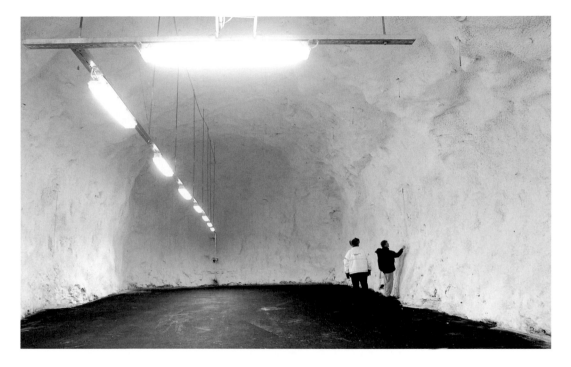

practical facility all about freezing seeds. Pipes overhead carry cold air to the farthest reaches of the facility where the seeds are stored. Past the steel-tube section, the tunnel transitions to rock, chiseled out in irregular shapes by the tunnel-making equipment and then spray coated with a layer of white plastic-fiber-impregnated concrete. It's a bright tunnel. But austere. On the right side at the end of this tunnel are two small rooms that serve as an office when staff are present, as well as two additional rooms housing electrical equipment and circuits. The office can be heated to provide tolerable working conditions for logging samples in and out of the Seed Vault, a procedure that staff from the Nordic Genetic Resource Center in southern Sweden come up to do a couple of times a year when prearranged seed deliveries arrive.

There is no running water in the Seed Vault. No toilet, aside from a portable chemical one that's never been used. And no permanent on-location staff. Sitting in a cold windowless Seed Vault all day watching frozen seeds would not be the world's best job. Luckily, it isn't necessary. Keeping everything simple, and keeping it cheap, having a facility that virtually operates by itself without exposure to too many human interventions or potential mistakes, a facility that does its job even if the mechanical cooling goes on the blink—all these factors are key to having a Seed Vault that functions properly over the long term, is secure, and is economically sustainable.

The tunnel terminates at the office area. But there is a set of closed, locked double doors just

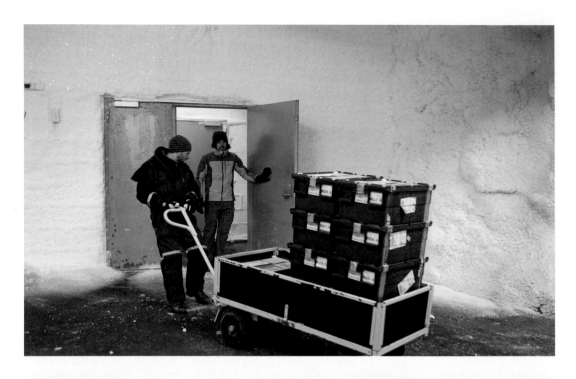

Above
Ola Westengen
and Simon
Jeppson of
NordGen carting
seeds into
the Vault room
for permanent
storage.

Below
Ola Westengen
(background)
and Cary Fowler
(foreground)
shelving new
seed deposits

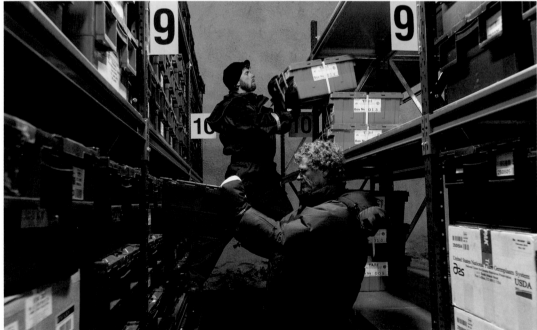

beyond at the very end of the tunnel. Open these and you enter an awe-inspiring, cavernous room in the heart of the mountain, a huge and colder room with tall ceilings coated with millions of tiny glistening ice crystals. It is brightly lit, more so than the long tunnel that leads to it. I have always thought of this as the "cathedral room." It lies at right angles to the tunnel and serves as a staging area for preparing boxes to go into the frozen vault room.

How do seeds from all over the world get to the vault?

Boxes filled with small packages of seed from depositing institutions around the world arrive at the Longyearbyen, Svalbard, airport. This sounds simple. It's not. Even before construction started, plans were under way to rescue the most vulnerable samples. While I headed the Global Crop Diversity Trust, it initiated a project led by Jane Toll, one of the most knowledgeable and dedicated veterans in the field, to identify unique and endangered samples in crop genebanks around the world. Partnering primarily with facilities in developing countries, from 2007 onward the Crop Trust provided technical assistance and funding and managed to rescue, literally from the doorstep of extinction, some eighty thousand unique crop varieties in five years. Imagine. It was a remarkable accomplishment, one that Peter Raven of the Missouri Botanical Garden described as possibly the largest biological rescue project of its type in history. With fresh new seed produced from these samples, preparations were made to duplicate the rescued varieties in Svalbard.

For these and all other shipments, Ola Westengen, Simon Jeppson, and others at NordGen and Amanda Dobson at the Global Crop Diversity Trust engaged with depositors months ahead of time. They ran through a checklist of topics that needed addressing: the deposit agreement, packaging quality and size requirements, data requirements, and financing of shipping costs. Then the logistical nightmare would begin: trying to make certain that boxes of seed from all over the world made it to Oslo without spending too much time baking on a tropical country airport tarmac, and that they all arrived about the same time so that these shipments, often from multiple continents, could be consolidated in Oslo, put on a cargo plane, and arrive simultaneously in Longyearbyen for processing. It's impractical to travel to Svalbard and open up the Vault whenever an institution wants to deposit a box of seeds, so NordGen and the Crop Trust have always worked together around three or four dates a year when the Vault is opened and seeds are placed inside. This has usually been done during the cold winter months.

Airlines might lose luggage on a regular basis but, remarkably, 2,291 boxes have been shipped to the Seed Vault thus far and 2,291 have been received. It's a perfect record. Once boxes arrive in Longyearbyen, they are x-rayed at the airport to ensure that seeds are inside, and nothing else.

From the airport, a cleverly named local transport company, Pole Position, loads the boxes of seed into a truck and drives them to the entrance of the Vault. From here, NordGen's staff, headed by Dr. Ola Westengen, take over. Ola, a congenial, soft-spoken, dedicated young

Norwegian scientist, was responsible for the management of the Seed Vault's treasures from opening day until 2015. Aided by Simon Jeppson and one or two others from NordGen and myself, Ola piled the sealed boxes, each containing four to five hundred packets of seed, onto a small hand pushcart for the trip down the tunnel. The computer database and tethered bar-code printer housed in the office churn out individualized labels for each box, which are attached in the cathedral room just outside the doors of the vault chamber. The computer system keeps track of where each box is in the vault: which aisle, which shelf, which position. Both the depositing institute and the Seed Vault management have an inventory cataloging the contents of each box. And the depositing institute will additionally have specific information about the origin, traits, and characteristics of each sample within its boxes, much of this publicly available through an online global information system called Genesys.

The three vault rooms lie on the far side of the cathedral room. Two lie to the left of the tunnel shaft, one to the right. The layout is purposeful. None of the vault rooms are situated in a direct line down the tunnel from the entrance. Instead, at the architect's behest the workers carved out a concave indentation in the rock as a security measure. Were there to be any explosion inside the facility, this feature would direct the shock waves back out the tunnel, diverting them from the vault rooms on either side.

The seed storage vault rooms are located both where the natural temperature was coldest and where the quality of overhead rock was the best for structural integrity. Each of the three vault rooms is approximately 27 meters long, 9.5 meters wide, and 5 meters high. Only one room is currently needed and in use. It is likely that this will store all, or virtually all, of the existing diversity found today in genebanks around the world. New variation arises in crops, and genebank collections will certainly grow over time and be duplicated for safety in the Seed Vault, though probably very slowly. Additionally, we might discover that seeds of some crops are best conserved at a different temperature than the standard $-18°C$ provided, which would indicate the use of one of the other rooms cooled to a different temperature. I don't think the third room will ever be needed. I think it will be empty a thousand years from now. The extra capacity is there just in case.

A small portion of the thousands of seed-filled boxes in their icy stone fortress.

Entrance to each of the three vaults off the cathedral room is through a set of double, keyed air-lock doors. Seeds are currently stored in the middle of the three rooms, imaginatively named Vault Room 2, which is the only one being further cooled mechanically. The outer ice-encrusted chamber door is an indicator of what lies within. We enter and leave as quickly as possible, never pausing with either door open. The air-lock door serves primarily to keep the cold air from escaping during the brief periods when people deliver or retrieve seeds, but the frigid air of this vault room emanates outward through the rock and the sturdy metal doors and freezes everything within its grasp.

Sensors have been inserted into the rock at varying distances in all three vault rooms as well as the cathedral room and the tunnel to measure the temperature of the mountain at different distances. These temperatures are checked and logged regularly so we can recognize any anomalies and learn more about how the rock holds temperature. More than a hundred meters into the mountain, change comes slowly; none has been detected thus far except from our additional cooling of the room with the seeds.

Inside Vault Room 2, aisles of tall shelving spread out before you. It is bitterly cold, and fans spewing out cold air create an additional wind chill factor. A walk down these aisles is an incredible and affirming experience. The depositing institutes have affixed identifying labels and logos to each box, so the wide geographical and political scope of this endeavor becomes immediately evident: seeds from the United States, and Russian genebanks. Boxes of seed from South Korea, and nearby heavy dark-magenta-colored wooden boxes from North Korea. There are dozens of boxes from Canada each with the Canadian maple leaf flag. Even more boxes from the major international agricultural research centers in Syria, Mexico, Philippines, Ethiopia, Colombia, Peru, India, Kenya, Nigeria, and Ivory Coast. And additional boxes from genebanks in Armenia, Australia, Austria, Azerbaijan, Bangladesh, Benin, Brazil, Bulgaria, Burundi, Chile, China (Taiwan), Costa Rica, Czech Republic, Denmark, Ecuador, Finland, Georgia, Germany, Greece, Iceland, Indonesia, Ireland, Israel, Italy, Japan, Kenya, Mali, Mongolia, Myanmar, Netherlands, Nigeria, Norway, Pakistan, Peru, Philippines, Portugal, Russia, Sudan, Sweden, Switzerland, Tajikistan, Thailand, Uganda, Ukraine, United States, Uzbekistan, and Zambia. The Vault contains a sizable collection from the US-based Seed Savers Exchange, the largest organization of gardeners working to conserve heirloom vegetable varieties. And there are 750 samples from Parque de la Papa, a potato park in Peru, managed by six indigenous communities. On another aisle are maize varieties prized for making polenta sent from the University of Pavia in Italy. At present, there are no seed samples belonging to a commercial company; few companies conserve seed samples for the long term and thus do not have a need to store anything of their own in a safety backup facility such as the Seed Vault.

Every genebank with which I am familiar, and certainly any sizeable one, has acquired

 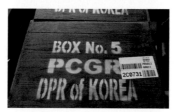

An array
of boxes
from some
of the seed
depositors.

131

materials from multiple countries. The genebank at the International Rice Research Institute in the Philippines contains samples of rice from 110 countries. Even more impressive than a list of depositing institutions and their host countries is the "census" of where the seed samples themselves were originally sourced. Today, the Seed Vault contains crop samples from virtually every country on earth, including a number that no longer exist as originally entered into the databases of depositing institutions. A couple of small island states such as Kiribati and Nauru are missing from the list. And the Holy See (Vatican). But, as the map shows, the Seed Vault is very international in scope and coverage.

Origin of Seeds Housed in the Seed Vault

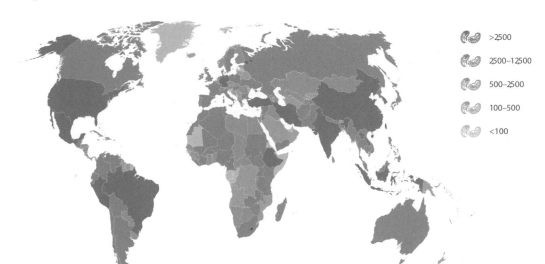

>2500

2500–12500

500–2500

100–500

<100

Data source: Nordic Genetic Resource Center

Where else can one find a positive, cooperative, future-oriented initiative involving so many countries?

The Seed Vault's job of attracting and securing the world's crop diversity is still under way. As of the fall of 2015, after just seven years of operation, samples of more than 880,000 crop varieties or populations are being preserved. That's about 500,000,000 seeds, some forty tons.

It is not easy to convey the almost unimaginable magnitude of the growing amount of diversity stored in those sealed packets inside the sealed boxes behind the locked doors of the Seed Vault. And it is tempting not to provide numbers in a book, since the numbers will become instantly outdated as samples are being added constantly; several hundred thousand more samples will certainly be added before deposits begin to taper. But a book about the Seed Vault needs to provide some numbers. As exotic and impressive as the physical structure

might seem, the diversity within is even more so. It is diversity both of the number of crops and varieties of crops.

Currently, for example, there are samples of roughly 154,000 types each of both wheat and rice, 75,000 kinds of barley, 47,000 sorghums, 35,000 kinds of maize, 33,000 different bean varieties, 29,000 kinds of chickpea, 22,000 soybean samples, and a similar number of pearl millets, as well as 17,000 kinds of cowpea (black-eyed peas for some of us), 15,000 different kinds of peanuts, 8,000 different kinds of faba beans and another 8,000 mung beans, 4,000 lettuces, more than 3,000 tomatoes, and even seed samples of 3,700 types of potatoes, which typically are not conserved as seed due to the difficulty of obtaining seed. There are 1,000 types of grass pea (one of my favorites and an important crop for the future), 2,500 kinds of turnip, 2,500 peppers, 2,000 cucumber samples, and more than 1,100 kinds of Kentucky bluegrass, a forage.

A simple single-space listing of all the crops in the Seed Vault would run fifty-five pages long. In addition to crops everyone has heard of, I take pleasure in the fact that the Seed Vault conserves diversity of colorfully named crops with which I am largely unfamiliar: Monkshood, giant hyssop, prickly poppy, saltbush, wallrocket, goosegrass, Mormon tea, bastard cabbage, skullcap, and many, many more. It is safe to say that few readers would imagine so many crops and so much diversity exist. And yet, more seeds are on the way to Svalbard.

Svalbard Global Seed Vault, by the Numbers

Unique seed samples*	881,473
Number of seeds**	563,272,050
Genera	946
Species	5,128
Continents of origin	8
Countries of origin	233
Depositor institutions	66
Seed deposit events	171
Samples restored to depositor	38,073

*As of early 2016 (includes samples restored to depositor which will be multiplied and returned to the Seed Vault)
**Estimated

Tucked away inside a frozen mountain, the Seed Vault effectively puts an end to extinction of all these crop varieties, ensuring that they will be available for future generations, and for us.

Even given worst-case scenarios for global warming, all three vault rooms will remain naturally frozen for up to two hundred years according to the Norwegian Meteorological Institute. And very cold and exceptionally well insulated for as far into the future as one can

imagine: the temperature sensors will give years of advance warning of any approaching warmth and provide data for calculating how changes might affect the insulating properties of the rock and temperatures inside the Vault if the mechanical refrigeration machinery falters.

Under any scenario, therefore, the Seed Vault in Svalbard remains, in absolute and relative terms, the best possible place for providing secure and reliable conditions for seed storage. The extreme cold of Vault Room 2 has permeated meters of solid sandstone around the room and created insulation for the room itself. If refrigeration equipment fails, the facility will remain cold and the seeds frozen, as the temperature would gradually warm from $-18°C$ to about $-5°C$, the natural and steady temperature in this part of the mountain. Thus there will be plenty of time, decades, to have the equipment repaired before damage is done to the seeds. NordGen's original safety backup collection in a nearby coal mine was stored in slightly warmer and less desirable conditions than exist naturally without mechanical cooling in the Seed Vault. There was no measurable decline in the viability of these seeds after more than twenty-five years.

The Seed Vault has multiple security systems. Most important is its remote location. But of course the facility also employs additional measures: a series of locked doors, motion, fire, smoke and gas detectors, cameras, alarms, and other security features. Electronic equipment constantly monitors the temperature in the Seed Vault as well as gas levels (methane, radon, oxygen) and transmits data to local authorities in Longyearbyen. Additionally, there is a local police force and often a coast guard presence.

Most of all, the Seed Vault benefits from the fact that it is an unlikely target of any purposeful hostility. And it has the support of the local community that keeps a sensitive eye out for anything unusual. Still, we know that bad things happen in this world, and one must be prepared.

Anyone seeking access to the seeds themselves will have to pass through at least five locked doors. Keys are coded to allow access to different levels of the facility. Not all keys will unlock all doors and some require numbered combinations. A log is automatically generated for all entries into the Vault.

The vault rooms themselves are located more than 130 meters on a horizontal plane from the entrance and, vertically, are more than 60 meters below the surface of the top of the mountain.

One sometimes hears the question, "Could the Seed Vault survive being hit with a nuclear bomb?" This of course is a highly unlikely scenario, as the Vault is not a target of any country having such a weapon and it's beyond imagination that an errant missile would happen to zoom up to Svalbard and land on Plateau Mountain. My glib answer to such questions is that it depends on how big the bomb is. One can always imagine a scenario in which the Seed Vault could be damaged or destroyed; the human mind is creative and Hollywood helps us visualize even the impossible. No structure on earth, including the Seed Vault, can offer iron-clad guarantees of safety. Tellingly, no depositor, scientist, journalist, or politician who has ever gone down into the Seed Vault has emerged to question the safety of its contents.

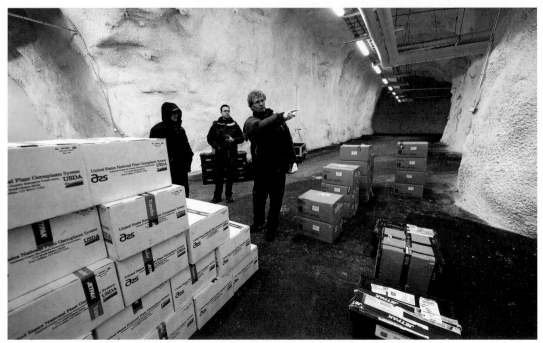

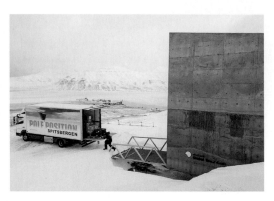

MANAGEMENT POLICIES AND PRACTICES

Security is not just about bomb-proof facilities, steel doors, sturdy locks, motion detectors, and other physical impediments to entry. It is even more about management, about curtailing risks, avoiding accidents, and keeping costs within reason. The management system for the Seed Vault was developed with the goal of ensuring the longevity of the seeds, minimizing risk, and minimizing cost.

We who planned and designed the Seed Vault envisaged a structure and a management system that would almost operate by itself, with scant human intervention. This is a major safety and sustainability feature. The seeds don't require day-to-day management; there is nothing that needs to be done with or to seeds that are lying frozen in foil packages inside sealed boxes. The cooling system simply needs always to be on. Maintenance functions large and small fall to Statsbygg (the Norwegian Directorate of Public Construction and Property) in Svalbard, which has been headed by the ever helpful and cooperative Tor Sverre Karlsen and Bente Naeverdal. Tom Oredahl of Statsbygg drives up to the Seed Vault several times a week from his office in Longyearbyen for a visual check to see that everything is functioning properly. If the electronic systems produce an alert of any kind, Statsbygg goes immediately, day or night. In addition, cooling and security systems are monitored remotely at UNIS, the university center in Longyearbyen. So the Seed Vault is a managed facility, albeit without full-time staff on-site. It is certainly not a "time capsule" that is sealed and forgotten.

Storage in the Seed Vault is free to all depositors. Depositing genebanks are responsible for paying shipment charges to Svalbard, and for the costs of return shipment, if necessary. However, the Global Crop Diversity Trust has financed the preparation and shipment of seeds from developing countries and international agricultural research centers. This accounts for 75 percent of the seeds deposited in Svalbard.

Think of the Seed Vault as functioning like a safety deposit box at a bank. The bank owns the building and the vault, the depositors own the contents of their boxes. In this case, Statsbygg "owns" the facility and the depositing genebanks own the seeds they send. Each depositor signs a deposit agreement with NordGen acting on behalf of Norway. The agreement specifies that Norway does not claim ownership of the deposited samples and that ownership remains with the depositor, who has the sole right of access to those materials in the Seed Vault. There is no transfer of ownership, no change in the status of the physical or intellectual property rights associated with the seed. No one has access to someone else's seeds from the Seed Vault in Svalbard. If and when seeds depart Svalbard, they are only sent back to their original depositor, their owner. Otherwise access to that diversity is handled directly by the depositor's facility, which maintains the original copy of the seed sample. For the 135 countries plus the European Union that are party to the International Treaty on Plant Genetic Resources for Food and Agriculture, that should for the most part be access in accordance with its terms and conditions. Organizations, as opposed to countries, that are not party to this treaty are not bound by its terms unless they have taken a separate initiative with the treaty to associate themselves with it. In any case, deposit in Svalbard does not affect this.

These management provisions were put into place to avoid any confusion, complications, or controversy about property rights, and to minimize operational costs for the Seed Vault. Most crop diversity held by genebanks in the world is available under terms of the international treaty and is thus available from genebanks closer to a user than the North Pole, so it makes sense that these genebanks handle such requests for access. The Seed Vault was never meant to be an active supplier of seed to researchers and plant breeders or farmers. Plant breeders and researchers are the normal constituency of genebanks. Unique among all seed conservation facilities in the world, genebanks are the constituency of the Svalbard Global Seed Vault, the sole constituency.

Most seeds are packaged in heat-sealed, laminated, moisture-proof, air-tight foil packages, though NordGen has used sealed glass ampoules for some of their samples. Foil packets are routinely used for long-term storage of dried seeds in genebanks around the world. The Global Crop Diversity Trust worked with a British firm to design a new robust packet especially for the Seed Vault. This foil package is constructed of multiple laminated layers, including one of aluminum, making it both air tight and puncture resistant. Prior to the opening of the Seed Vault, the Crop Trust purchased 300,000 of these packets for international genebanks and developing countries. Genebank managers describe these as the "Rolls-Royce" of packets. One manager gave the prototype the "stomp test" before the order was placed. He put seeds inside the packet, sealed it, threw it on the floor and stomped on it to see if the packet would rupture or if the seeds would puncture holes in it. It passed the test.

The packets are stored inside boxes: plastic or sometimes heavy cardboard, or wooden. The

Crop Trust purchased thousands of sturdy recycled polypropylene boxes and supplied them to developing countries and international centers. The boxes have a usable volume of forty-six liters and stack nicely on the shelves that were designed to accommodate them. They have proven to be very tough, and to tolerate the freezing temperatures with no problem.

Typically 400 to 500 samples with about 500 seeds each fit in a box depending on the size of the seed. When Vault Room 2 is filled with close to 1.5 million samples, about the maximum number of distinct varieties we think exist, it will contain nearly a billion seeds with a weight approaching eighty tons. This is a lot of lifting for Ola Westengen, the Oslo-based former operations manager of Seed Vault, his successor Åsmund Asdal, and their colleagues!

The depositor seals the boxes prior to shipment to Svalbard. By prior arrangement, the boxes bypass plant quarantine inspection in Norway. No one associated with the Seed Vault opens them in Svalbard; the original seals remain unbroken. We refer to these as "black boxes" because the contents are not visible or available to those providing the cold storage.

Though the boxes are sealed, the contents are known when they arrive. Prior to shipment to Svalbard, a depositor will provide detailed information on each sample. A database of stored samples is kept in the Seed Vault as well as at NordGen in Sweden. Information concerning depositors, samples, countries of origin, etc., can be found at the Seed Vault's "portal" maintained by NordGen: http://www.nordgen.org/sgsv/. In addition the Global Crop Diversity Trust, working with a number of partners, has developed a comprehensive database called Genesys (http://www.genesys-pgr.org) with much more detailed information. Genebanks routinely test and screen their samples to learn more about them. Information is added to their databases and then made available to Genesys. This job never really ends. But were there to be a disaster in an individual genebank or even regionally, we would still know which samples were in the Seed Vault and where, and the data we have about the particular characteristics of each sample would be preserved.

The long life expectancy of seeds stored in optimal conditions such as those in Svalbard leads some to assume that once a seed sample reaches the end of its days, all will be lost. It is true that eventually even seed conserved in the best conditions will die. But the Seed Vault is not a time capsule where one places seeds, walks away, and forgets about it. It is a backup system for functioning genebanks. Seed in working genebanks never reaches the thresholds given in the table. Genebanks simply do not keep a sorghum sample for twenty thousand years or even a lettuce sample for seventy-three, because genebank seed stocks are drawn down long before that by breeders and researchers accessing the seeds. These drawdowns necessitate periodic multiplication of fresh seed from remaining stocks.

Predicted Longevity of Seeds of Selected Crops

Crop	Expected Longevity at 5% moisture content stored at -20°, in Years
Barley	2,061
Chickpea	2,613
Cowpea	5,342
Lettuce	73
Maize	1,125
Onion	413
Pea	9,876
Pearl millet	1,718
Rice	1,138
Sorghum	19,890
Soybean	374
Sunflower	55
Wheat	1,693

Source: H. W. Pritchard and J. B. Dickie, "Predicting Seed Longevity: The Use and Abuse of Seed Viability Equations," in Dickie Smith et al., *Seed Conservation: Turning Science into Practice* (Kew, UK: Royal Botanic Gardens, 2003).

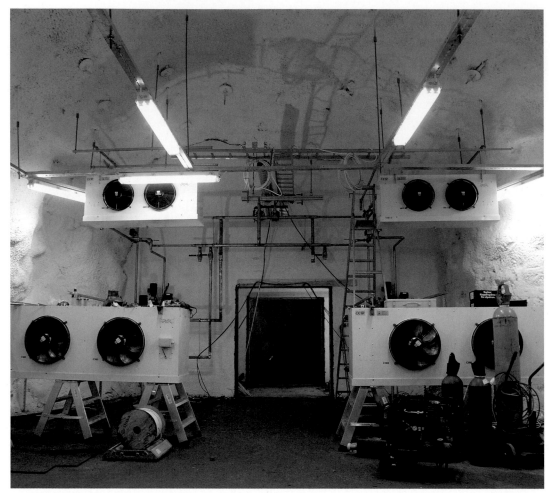

Vault Room 2
during the
construction
phase.
Supplemental
cooling units
were brought
in to lower the
temperature
to -18C more
quickly.

Most genebanks also regularly monitor the viability of the seed stocks in their facilities. When seeds begin to lose viability (with germination rates dropping below 85 percent of the original level), management protocols specify that some seeds from the sample should be taken out, planted, and new fresh seed harvested to replenish the genebank's sample of that variety. Why? Because the seeds are a representative sample of what was found in a particular farmer's field and that field may have contained, and typically does contain, different types. Whatever causes a few seeds in a seed sample to die before others might be linked to rare traits that are important to conserve. As the germination rate of a sample declines, the risk of loss of unique traits increases. Good genebanks monitor germination rates carefully, and when necessary take seeds out and grow them in order to get fresh seed.

When this process takes place, genebanks using the Seed Vault will send a fresh new sample to Svalbard. Because the Seed Vault offers conditions second to none, seed samples stored there will not lose viability faster than in the best of the traditional genebanks elsewhere. Thus seed will be "renewed" regularly and in a timely fashion and the Seed Vault will always have a good, healthy sample ready just in case it is needed.

Genebanks are sending seed samples to Svalbard as they routinely regenerate their existing stocks. The wait is worth the risk, as it will stock the Seed Vault with good new healthy seed in adequate per-sample quantities. Indeed, it may take some years to assemble a virtually complete set from depositors; in some respects the job will never be finished. Nevertheless, a significant portion of the world's diversity, surely the major portion for our major crops, is already safely stored in Svalbard.

The Seed Vault will not be storing multiple copies of the same variety, at least not intentionally. Storing one is sufficient. Genebanks are cautioned not to send anything to Svalbard that is already there and available through another depositor. While the Seed Vault has more than enough capacity to store a sample of all the unique crop diversity genebanks contain, it could never have enough room to store a limitless number of duplicates. Nor does it need to. Seed banks depositing samples in Svalbard will continue to keep one sample themselves, meaning that each distinct variety will be safeguarded in at least two different locations: Svalbard and somewhere else. Ideally, they should be kept in three places to maximize security and access.

The Seed Vault does not accept samples of plants that are not food or agriculture related. Why?

First, one has to prioritize and start with something. Conserving "only" agriculture's crop diversity is a big enough challenge. Second, an international legal framework exists for plant genetic resources for food and agriculture that makes it possible to manage the Seed Vault efficiently for the benefit of all. A similar framework facilitating cooperation and transfer of samples does not exist for medicinal species, for example. So while each sample in Svalbard is "owned" by its depositing institution, it should be available, albeit sometimes on varying terms, directly from the depositor from the stocks the depositor has on hand.

Similarly, the Seed Vault cannot store and take primary responsibility for seed of other plants, such as the thousands of different types found in the tropical rain forests. Few collections of such plants exist in genebanks. The Millennium Seed Bank at Kew Gardens is a significant and important exception. Unlike Kew, the Seed Vault is not in the position to research, document, or periodically grow these seeds to obtain fresh supplies when original deposits begin to lose viability in storage, or to provide access. The Seed Vault does, however, house a half a million seeds, collected in 2008, of some of eighty-eight native plant species of Svalbard, including twenty species that are "red listed," or highly endangered.

The guidelines used for determining what seed is stored in the Seed Vault, and what seed is not, make no attempt to determine which diversity is worthy of being conserved for future generations; that would be presumptuous and risky. The Seed Vault conserves diversity. It does so safely and for the long term. Anyone who claims to see into the future and discern what should or should not exist, what will or will not be useful in future climates to future generations, is a fool. The Seed Vault has tried to remain neutral, which is the only honest and scientifically valid approach.

Many people are curious about whether genetically modified (GMO) seeds are stored in Svalbard. They are not. Perhaps this is the exception to the policy of neutrality, but it's a necessary exception because Norwegian legislation formulated prior to (but not because of) construction of the Seed Vault effectively prohibits the importation and storage of GMOs. Most genebank collections, however, were assembled before the advent of GMO technology and such samples surely constitute only a tiny fraction of one percent of what is held, so the Seed Vault's depositors would have little if anything to send anyway.

It is safe to say, however, that there is one thing, and perhaps one thing only, most GMO opponents and proponents agree upon: the importance of the Seed Vault. Both sides in this raucous debate recognize the importance of crop diversity and want it conserved, though perhaps for different reasons. How could anyone who knows the slightest thing about agriculture or evolution be against the conservation of diversity? Stick around long enough and you'll see which side of this debate was right. Whichever it is, they will be happy the Seed Vault was protecting the biological foundation of agriculture.

Perhaps because a magazine writer dubbed it the "doomsday vault" early on, and because it is so inaccessible and "hidden" within a mountain, the Seed Vault has attracted more than its fair share of conspiracy theories.

Conspiracy theories used to arise to explain why something truly terrible had happened, when straightforward explanations seemed insufficient. Unfortunately, as I have now discovered, even things as positive as the Seed Vault can generate emotions approaching paranoia. If it's that good, it's too good to be true. We live in a cynical, suspicious world and the Internet gives voice to all sorts of insecurities, frustrations, and anger.

First there were people who claimed the Seed Vault was connected with a Mayan calendar prediction of the end of the world in 2012. But 2012 passed without incident. Then there were people who claimed the Vault was the centerpiece of a global eugenics plot connected with Hitler. No kidding. Then the Vault was said to be a secret NATO facility.

Finally, the Internet lit up with accusations involving Monsanto: that the company funded the Seed Vault (it didn't, not a penny) and that the whole effort involving Norway and many other countries as well as a large number of institutions and scientists around the world was an elaborate ruse to assemble and turn seeds over to Monsanto (again, totally false). Passions

flared; I even got anonymous physical threats. A couple of universities employed security for my public lectures about seed saving.

Fast-forward: the Seed Vault is in its eighth year. The sky hasn't fallen. None of the accusations or fears has come true, not even with a single one of the Vault's 880,000+ seed samples, even once. That really says it all, doesn't it?

ADMINISTRATIVE STRUCTURES AND FINANCING

The Svalbard Global Seed Vault is the result of a formal partnership between the government of Norway (specifically, the Ministry of Agriculture and Food), the Nordic Genetic Resource Center (NordGen), and the Global Crop Diversity Trust.

The government of Norway funded construction of the Seed Vault in its entirety. The final cost of the facility was 48,350,000 Norwegian crowns, about $6 million at current exchange rates, but closer to $9 million then. No private funding was involved or needed. The government has signed a long-term contract with Statsbygg to provide ongoing maintenance of the structure at a cost of approximately $100,000 a year.

The Global Crop Diversity Trust, established as an endowment fund to ensure the permanent conservation of crop diversity (not just in Svalbard, but also at and through other genebanks globally), provides annual funding for operational costs. The Norwegian Ministry of Agriculture and Food has been supplementing this during these early years when more frequent trips to Svalbard to take in seed deposits and accommodate media attention have tacked on extra start-up related costs. Routine total operating costs should settle at around $250,000 annually. To put that in perspective, a show of Brice Marden paintings on loan to the San Francisco Museum of Modern Art from another museum for just three months in 2007 cost more than $1 million to insure. By that standard, the Seed Vault is cheap insurance indeed.

NordGen, the Nordic Genetic Resource Center, provides for the practical management of

the facility. Together with the Global Crop Diversity Trust, it arranges and coordinates seed shipments to Svalbard and is responsible for their placement in the Seed Vault, their management, and the maintenance of the computer databases associated with this.

The independent International Advisory Council for the Svalbard Global Seed Vault oversees the facility, visits periodically, and advises the Norwegian Ministry of Agriculture and Food on technical and policy matters. It has worked on the provisions of the deposit agreement that depositors sign prior to sending seed to Svalbard, on the question of requests to deposit material that falls outside the mandate of the Seed Vault, and on the policy regarding visitation by the media and others to the Seed Vault. The council, composed of depositors, scientists, representatives of civil society organizations, FAO, and others, provides independent oversight of the operations of the Seed Vault and thus increases transparency and confidence.

While the facility is not open to the public, and no one in Svalbard is authorized to give access, all depositing institutions have the contractual right to inspect the facility. On rare occasions, access has been given to media and to special visitors (such as President and Mrs. Jimmy Carter, UN Secretary General Ban Ki-moon, EU president José Manuel Barroso, FAO directors general Jacques Diouf and José Graziano da Silva, Nobel laureate Wangari Maathai, Ted Turner, the Norwegian royal family, and others). The Norwegian government, NordGen, the Global Crop Diversity Trust, and the International Advisory Council all understand that such visits help to publicize the importance of conserving crop diversity and thus serve the broader mission of the Svalbard Global Seed Vault, without compromising security of the seeds.

Seeds from ICARDA (International Center for Agricultural Research in Dry Areas), then headquartered in Syria, enter the Vault.

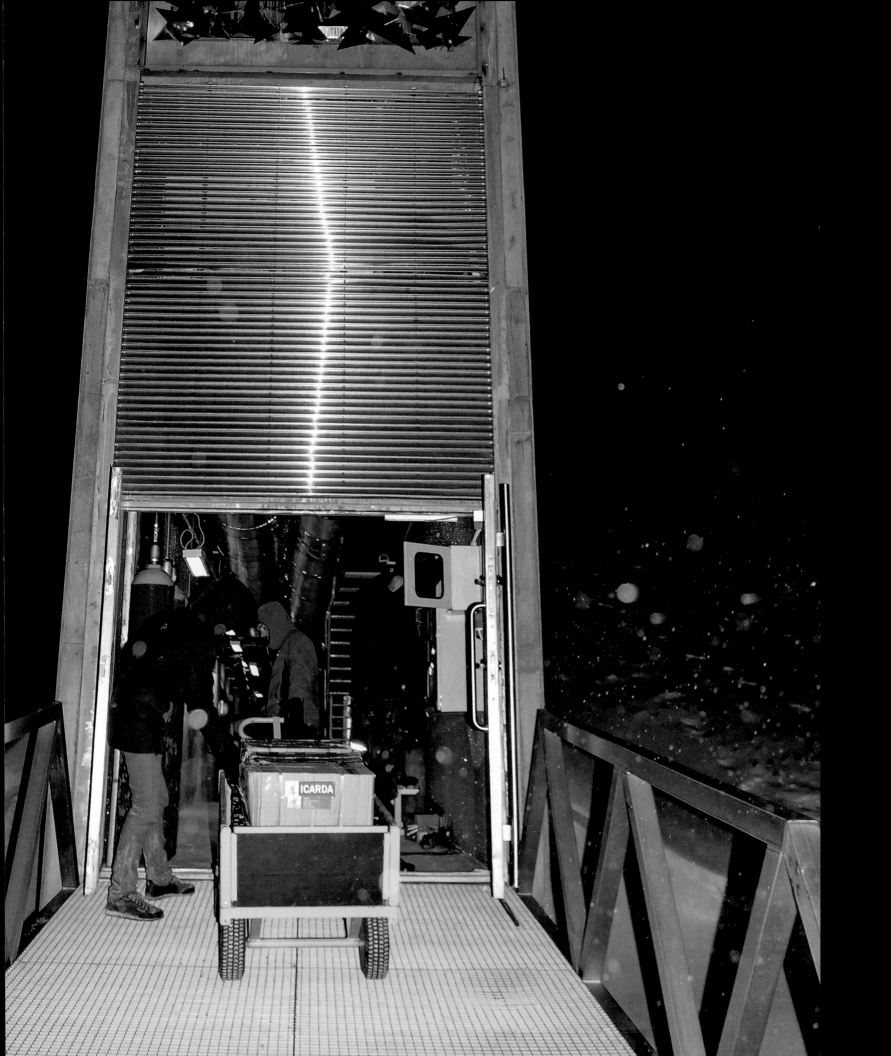

As fighting broke out in Tunisia and elsewhere in the early days of what is now called the Arab Spring, I got on the phone with my old friend Mahmoud Solh, the director general at the International Center for Agricultural Research in the Dry Areas (ICARDA) then based in Syria. ICARDA specializes in plant breeding for dry areas and it has one of the world's largest and most important collections of wheat, barley, chickpea, lentil, faba bean, vetch, grass pea (*Lathyrus sativa*), and legume forages. It not only conserves this diversity, but also supplies twenty-five thousand samples to plant breeders and researchers annually for their use.

Mahmoud and I agreed that the troubles in other countries of the region were ominous, but concluded that Syria, and the ICARDA collection, would likely escape the turmoil. (How wrong we were.) But I suggested to Mahmoud that we should try to get a duplicate copy of his collection up to Svalbard as soon as possible, just in case. "Just in case" is what the Seed Vault is all about.

ICARDA was able to get seeds of virtually everything up to Svalbard—116,000 different varieties: more than 58 million seeds. Months later, fighting erupted in Syria. The research station changed hands between government and rebel forces. YouTube videos showed triumphant soldiers from one side or another firing celebratory shots in the air just in front of the headquarters building where colleagues and I had posed more than once for group photos following a scientific meeting.

In retrospect, it was certain to happen. The fierce and prolonged fighting in Syria made it almost inevitable that Aleppo-based ICARDA would need to retrieve the seed samples it had deposited in Svalbard as a backup. ICARDA's international staff had long since been evacuated from Syria. Heroic local staff continued to try to maintain ICARDA's seed collection, but the hope gradually disappeared that normalcy would return and that their genebank could once again be

used to supply seeds internationally to plant breeders and other researchers.

New varieties released by ICARDA in recent years have powered important productivity gains in these crops from Sudan and Ethiopia to Egypt and beyond. ICARDA's contribution to food and human security is enormous, but ultimately it is based on its seed collection. As Dr. Ahmed Amri, the head of their genebank put it, "Crop diversity represents a heritage of human ingenuity that helps counter the man-made threat of our age." But there was no access to it in war-ravaged Syria.

In early September 2015, ICARDA requested the return of seeds from its duplicate stores in Svalbard. A staff member was sent to prepare the shipment in collaboration with NordGen staff. On September 23, 128 boxes of seeds, samples of 38,073 varieties of wheat, barley, lentil, chickpea, faba bean, grass pea, and a number of samples of crop wild relatives and forages were carried back out the front door of the Seed Vault and placed on a plane bound for Morocco and Lebanon, where ICARDA is reestablishing working genebanks to serve the research demand for this diversity. ICARDA will first sow the seeds it receives from Svalbard in carefully managed plots, grow plants, and harvest fresh new seed. This will increase supplies and enable ICARDA to service plant-breeding needs, and also provide seed to replace those samples withdrawn from Svalbard. ICARDA's capacity to grow out and produce new seed is limited, so this process will take place in stages over some years. Each unique sample will find a home in the new ICARDA facilities and will once again be safety duplicated in Svalbard.

The first withdrawal of seeds is obviously a momentous occasion. It serves to underscore the importance—the necessity—of having the Seed Vault, and the enormous and lasting "return on investment" of having built it. It is also a bittersweet moment. Using an insurance policy is never anyone's first choice. Everyone hopes this is the last time the Seed Vault will be used for the purpose for which it was established. But I know it won't be.

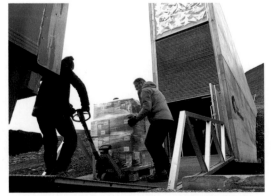

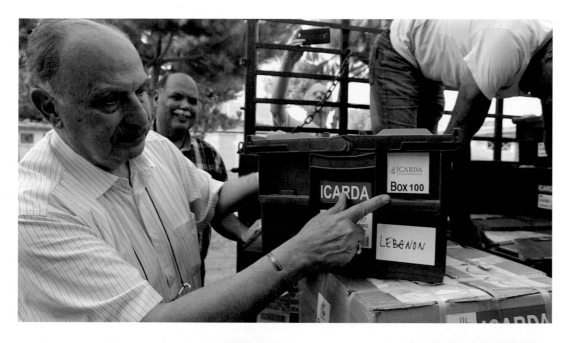

Left
Seeds leaving the Seed Vault on their way back to ICARDA, the depositor.

Right (Above)
Repatriated seed samples from Svalbard arriving back at ICARDA to reestablish its genebank, formerly in Syria, to Morocco and Lebanon.

Right (Below)
The ICARDA gene bank in Syria in better days.

LOOKING FORWARD

The Svalbard Global Seed Vault has already proven its importance to conservation and food security. Yet it is not the complete answer to the many threats to agricultural biodiversity that exist in our world today: the diversity of some crops simply cannot be conserved efficiently, or at all, by freezing seed. Bananas, berries, citrus, and certain other fruits, and some root and tuber crops will not be found in Svalbard. The Global Crop Diversity Trust works with genebanks to protect such crops through other means: field collections, tissue culture, and cryopreservation.

While scientists in surveys have consistently estimated that most of the existing diversity of the major crops, particularly the grains, has been collected, and while we know that much of it is now in Svalbard, we also know that considerable diversity of less economically important crops still remains in the field, managed by farmers and gardeners, primarily in developing countries. Such conservation is important but terribly vulnerable to weather and pests, to decisions to replace old crop varieties with new ones, and to anything else that might happen to the farm or farm family. The Seed Vault is full of heirloom varieties and landraces no longer grown by farmers, diversity that would be extinct were it not for genebanks.

It is difficult to know what is being conserved—and how well—on farms, but what's clear is that the success of such an informal approach depends on an unbroken continuum of generations of farmers, each willing to conserve a particular variety year after year, century after century. Civil society organizations are

Across the
Svalbard
landscape.

sometimes involved with these on-farm efforts, but such organizations are themselves vulnerable. And, in any case, knowledge of and accessibility to such diversity, direct from farmers or via organizations, is generally quite restricted.

While we celebrate the contribution and effort of farming communities and acknowledge that the diversity that arose there over time is the original source of most of what is in the Seed Vault, we also have to recognize that conserving diversity at the farm level has limitations. There is a great and continuing need to collect such diversity and strengthen its conservation by placing seed samples in a traditional genebank, and in Svalbard. This is particularly the case with very "minor" crops, for which few comprehensive collections exist.

When proponents of one method of conservation denigrate other methods, seeds lose, and the discussion becomes one about politics, not conservation. *Diversity can be conserved through diverse means.* Different methods are complementary not competitive or exclusionary.

One also occasionally hears the assertion that new technologies—including some that currently exist only in our imagination—will eventually make the Seed Vault and its diversity obsolete. Some say we'll routinely create and edit genes. We'll design whatever our heart desires. We'll no longer need to conserve our heritage of crop diversity even as an insurance policy. I rather doubt it. As Charles Darwin observed, "natural selection is daily and hourly scrutinizing, throughout the world, every variation, even the slightest…" The most important attribute of the Seed Vault is that it contains the results of this scrutiny, the countless unrepeatable evolutionary experiments conducted on our agricultural crops and their forbears over millennia, the tradeoffs our crops made in the past, and the winning genetic combinations that emerged. Saving it is prudent and will remain so regardless.

Some national genebanks have yet to participate in the Seed Vault. Some countries are still considering the matter (even though there is no cost to deposit, they retain ownership over all their samples, and there is no downside and much to be gained by safety duplicating holdings in Svalbard). This is normal governmental variation. If providing security for national art collections is good management and business as usual, should protecting agriculture's living treasures be different? Clearly not, which is why these countries will surely participate in the future.

Do any of these countries have important collections, diversity that is unique and vital to safety duplicate in the Seed Vault? Yes. China, Ethiopia, India, Iran, Japan, and Mexico certainly fall into this category of countries that have significant collections and yet have not participated substantially or, in some cases at all, in the Svalbard effort though seeds from all these countries sourced by other institutions are held in fairly large numbers in the Seed Vault. As the International Treaty on Plant Genetic Resources mandates that all parties take steps to conserve their diversity, and as the UN Food and Agriculture Organization has formally welcomed the Seed Vault initiative, it is fair to say that the international community would be pleased were these countries to join the global effort. And crop diversity would be more secure for future generations.

The Seed Vault was built to the highest building code standards that exist in Norway. Those specify a minimum longevity of two hundred years. But there is no reason to believe that the basic structure, the mountain, won't be around for far longer. Indeed, there is no reason to believe that the Seed Vault could not continue to function for as long as people and agriculture need it to, even if that turns out to be thousands of years. It was designed and constructed as though there were no end date to its use. In this regard, the Seed Vault is a unique structure. Seldom in history have people built anything to last "forever."

The Seed Vault is today guarding against the extinction of the natural resource upon which human civilization rests. Without crop diversity there is no adaptation to climate change, pests, and diseases. Without crop diversity there is no sustainable route to food security. Without crop diversity there is, in fact, no agriculture.

The conservation of this diversity should be high on the priority list of all governments. It is not.

The Seed Vault provides insurance against natural disasters, wars, and accidents as well as the losses that countries inflict upon themselves by shamefully allowing their national genebanks to deteriorate. In this regard, no country is innocent. This is no exaggeration.

We have the Seed Vault. What an incredible gift from Norway and its partners, NordGen and the Global Crop Diversity Trust, to the world and future generations! And what an act of foresight and solidarity by the genebanks that have deposited seed! We should not, however, allow this to breed complacency. The time has come to provide the Seed Vault itself with an insurance policy by making sure that the collections held by depositors are also secure through an adequate endowment at the Global Crop Diversity Trust. Anything less, even in the context of Svalbard, is taking a risk we can ill afford.

Is it technically and financially feasible to have a global system of genebanks, successfully conserving crop diversity, screening it for important and useful traits, and passing along seeds and breeding materials to plant breeders and farmers to improve agriculture and build food security? Of course. The cost of holding the Olympic Games one time, if placed instead in an endowment, would generate as much as fifty times the annual funding required to conserve all crop diversity in perpetuity. Ask yourself, which is the better investment?

Since the dawn of agriculture, farmers, and more recently plant breeders and genebank staff, have protected and nurtured crop diversity. All are heroes of this story.

The Svalbard Global Seed Vault was not built in a spirit of pessimism. It was not built by people obsessed with "doomsday." It was conceptualized and constructed by optimists and pragmatists, by people who wanted to do something to preserve options so that humanity and its crops might be better prepared for change.

Along with many others, I was fortunate to be part of that effort. Regardless of whether you think it was fabulous or flawed, I urge you to improve it or fix it. Don't assume someone else is responsible for this living heritage. You are. Together, we are.

THE NEXT CHAPTER FOR THE SEED VAULT

The Svalbard Global Seed Vault continues to fascinate. Enter "Seed Vault" in an internet search engine, and you will be rewarded with 18,000,000 hits.

It has won awards, is regularly included in lists of "the most inaccessible" or "secure" or "important/famous" facilities in the world that you will never set foot in. It is the subject of feature-length documentaries, most notably Seed Battles by Kees Brouwer at VPRO Backlight and Sandy McLeod's Seeds of Time, which itself has won many awards. In one form or another, it has appeared in or been the inspiration for many TV series' episodes and it features in science fiction and action-oriented novels. Forget trying to count the number of TV news segments, newspaper articles, and other media stories. There are postage stamps, songs, cartoons, poems, children's books, and art works. There are also imitators: various projects to conserve whatnot that have adopted the image by calling themselves "vaults." The Seed Vault has become part of popular culture.

The real story, however, still lies in the purpose and the performance of the Seed Vault as revealed in these impressive numbers. As of the fall of 2023, here are the tabulations:

```
Seed Samples: 1,255,000
Genera: 1,160
Species: 6,110
Taxon Names: 11,475
Countries of Origin: 230
Depositor Institutes: 100
Deposit events: 370
Numbers are rounded down.
```

The Seed Vault continues to attract diverse depositors. For example, in 2020, to considerable fanfare, the Cherokee Nation deposited seeds of Cherokee White Eagle maize, the tribe's most sacred corn used in ceremonies, along with several varieties of beans and squash. As the Cherokee Principal Chief explained, "It is such an honor to have a piece of the culture preserved forever. Generations from now, these seeds will still hold our history and there will always be a part of the Cherokee Nation in the world."

Asia is the continent of origin of the largest number of samples—more than 450,000. There are over 175,000 different rice samples, most originating in Asia. But wheat is the clear overall numerical winner with more than 250,000 samples.

The total number of samples now housed in the Seed Vault represents a 40 percent increase in the last seven years. The most important thing that could possibly be said is this: To date, all samples have been safely and successfully conserved. Let me add a note for the curious: none of the conspiracy theories referenced earlier in the book have come true. The conspiracists have gone silent; none have reemerged to claim their predictions have been borne out. Clearly they were wrong.

Simply stated, the Seed Vault is fulfilling its purpose in providing security for the world's crop diversity.

For the latest information about the Seed Vault, its holdings and operations consult the official website: https://seedvault.nordgen.org

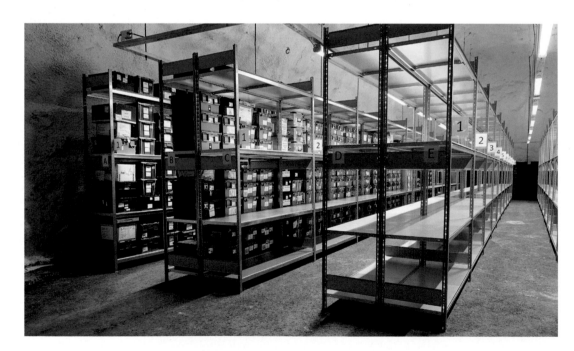

New vault room opened up.

Everyone takes
selfies;
here's mine.

ORIGINS AND PRIMARY REGIONS OF DIVERSITY OF AGRICULTURAL CROPS

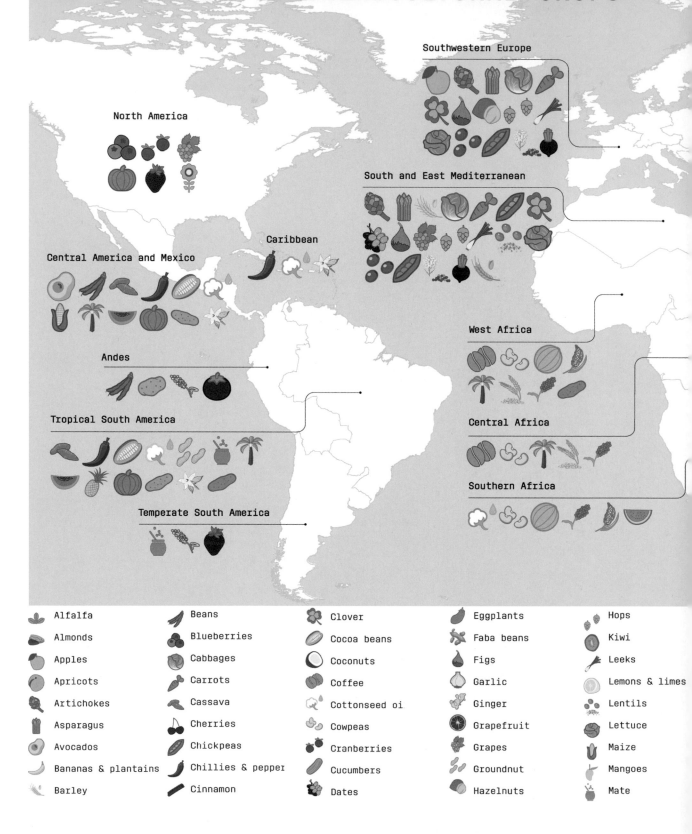

Southwestern Europe

South and East Mediterranean

North America

Caribbean

Central America and Mexico

West Africa

Andes

Tropical South America

Central Africa

Southern Africa

Temperate South America

Alfalfa
Almonds
Apples
Apricots
Artichokes
Asparagus
Avocados
Bananas & plantains
Barley

Beans
Blueberries
Cabbages
Carrots
Cassava
Cherries
Chickpeas
Chillies & pepper
Cinnamon

Clover
Cocoa beans
Coconuts
Coffee
Cottonseed oi
Cowpeas
Cranberries
Cucumbers
Dates

Eggplants
Faba beans
Figs
Garlic
Ginger
Grapefruit
Grapes
Groundnut
Hazelnuts

Hops
Kiwi
Leeks
Lemons & limes
Lentils
Lettuce
Maize
Mangoes
Mate

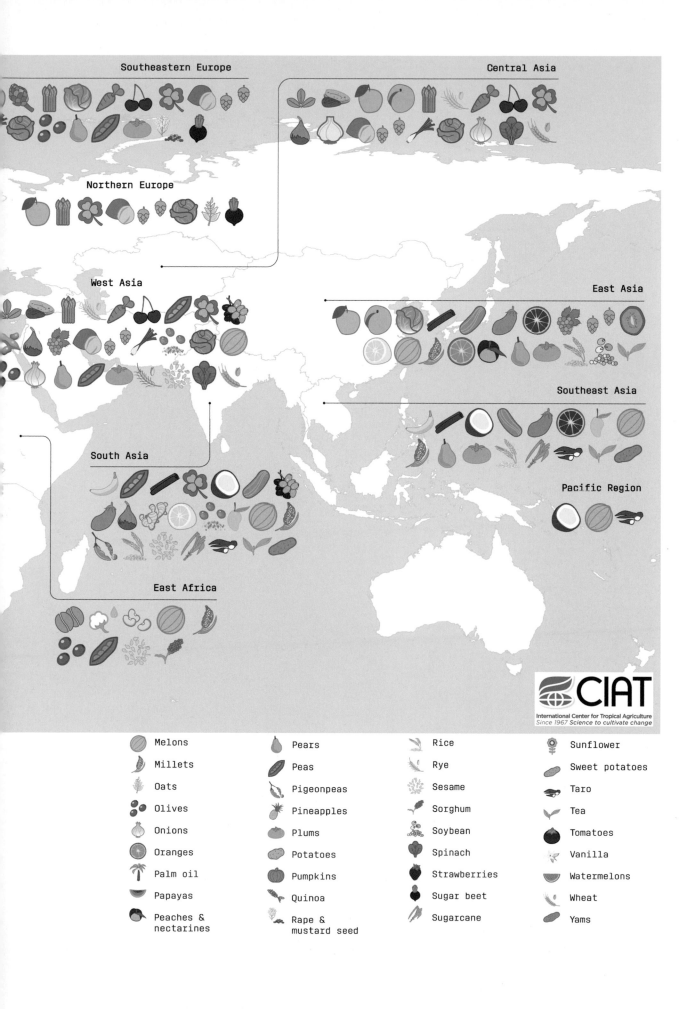

Southeastern Europe

Central Asia

Northern Europe

West Asia

East Asia

South Asia

Southeast Asia

East Africa

Pacific Region

CIAT
International Center for Tropical Agriculture
Since 1967 Science to cultivate change

Melons

Millets

Oats

Olives

Onions

Oranges

Palm oil

Papayas

Peaches & nectarines

Pears

Peas

Pigeonpeas

Pineapples

Plums

Potatoes

Pumpkins

Quinoa

Rape & mustard seed

Rice

Rye

Sesame

Sorghum

Soybean

Spinach

Strawberries

Sugar beet

Sugarcane

Sunflower

Sweet potatoes

Taro

Tea

Tomatoes

Vanilla

Watermelons

Wheat

Yams

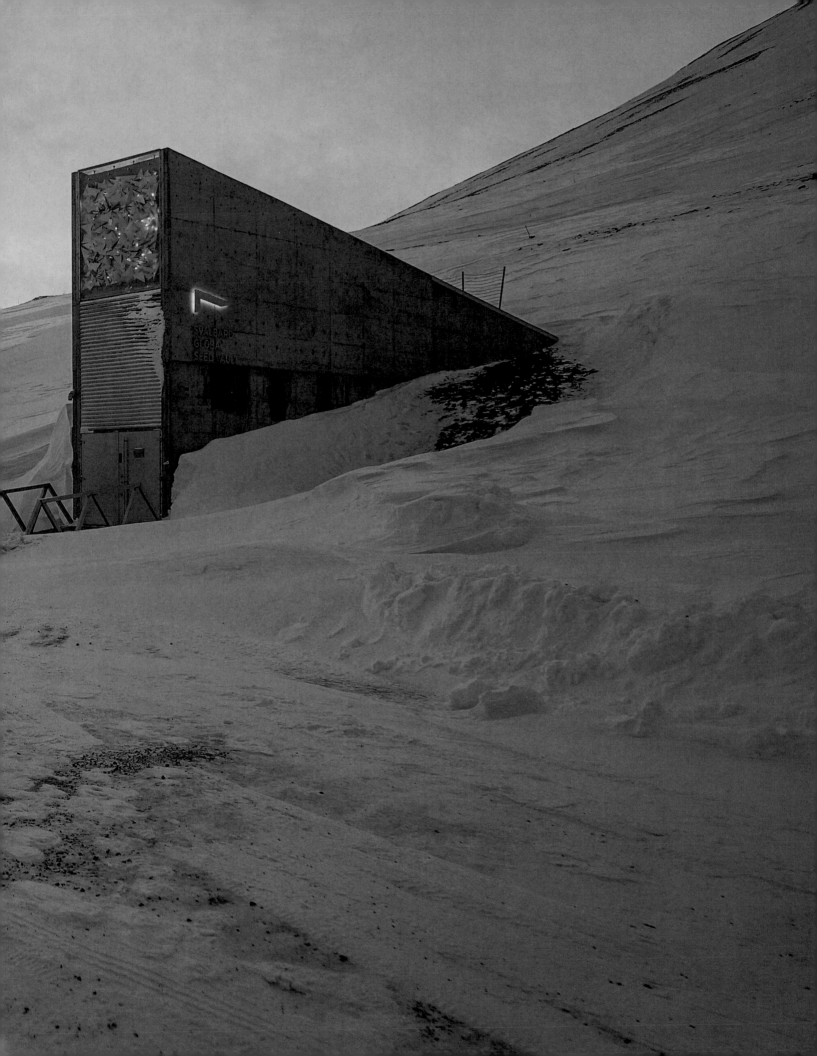

The most surprising development since the opening of the Seed Vault in 2008 has been the dramatic change in climate. While global warming was a known factor and consideration at the time of construction, who would have guessed that Svalbard would warm twice as fast as other areas of the Arctic and six times faster than the global average?

This warming proved problematic for the Seed Vault—more precisely for the access tunnel leading to the vault rooms—but not for the seeds themselves. I'll explain.

First, how about the seeds? Wasn't the Seed Vault located in Svalbard precisely because of the frigid Arctic temperatures and the fact that long-term conservation requires freezing the seeds, which nature would provide for in Svalbard? Yes. The optimal temperature for this, however, is -18C. No place on earth reliably and conveniently provides this, so the naturally cold vault rooms deep in the mountain have always been mechanically cooled down further to this temperature. How will global warming affect this? In the same way it affects the refrigerator and freezer in your kitchen. With increasing temperatures your appliance will, whether you notice it or not, need to cycle on a little more frequently to maintain the proper temperature, as will the Seed Vault's cooling system. It's that simple. Climate change or not, Svalbard will remain cold and thus ideal for long-term seed conservation relative to any other viable alternative. Despite the warming that has clearly taken place in Svalbard since the opening of the Seed Vault in 2008, the seeds themselves have remained frozen at a steady -18C.

The Svalbard Vault is Built Deep in the Mountain

SOURCE: GLOBAL CROP DIVERSITY TRUST

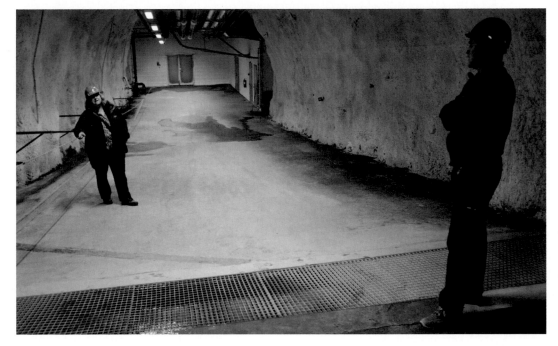

The warming trend in Svalbard has, however, affected the Seed Vault structure if not the seeds themselves. The Seed Vault consists of three different sections as depicted in the associated Figure. First, there is the Portal Building. This is the iconic, wedge-shaped structure that juts out of the mountain. At the far end of this building and just inside the mountain hidden from view is a long sloping access tunnel that leads to the third section of the Seed Vault, the vault rooms themselves chiseled out of solid stone. Think of the access tunnel as the transition from the outside world through loose rock and dirt to the solid core inner sanctum of the mountain where the seeds reside.

When first constructed, the tunnel was built sturdily and built to last, but it was not built to be absolutely watertight. The assumption was that the permafrost would return post–construction and this layer of frozen rock and soil would, as its name implies, form a permanent frozen barrier around the tunnel and prevent any seepage of water into it. But that didn't happen. In the upper part of the tunnel closest to the surface, water leaked in when, as normal, snow melted during the short Svalbard summer. At first this was a nuisance. It was a trickle through seams slightly above floor level in the tunnel.

The tunnel followed the rock seam that the excavators found which, unfortunately as it turned out, gently sloped downward. At the lowest part of the facility, still quite far from the vault rooms, drains and pumps were installed to catch and remove water that seeped in. If the first drain or pump failed or was overwhelmed, a second one slightly lower in the tunnel took over. As Svalbard warmed, more water came in.

A technical 2016 government report on the water intrusion caught the eye of a journalist in May 2017, leading to a rather dramatic article about "flooding" in the Seed Vault as if it were happening then and there. Other journalists (none of whom were on location) picked up the thread and suddenly there was a flood—a flood of media reports. Alarmed but not on-site myself, I contacted Bente Naeverdal, the always helpful and competent head of the local Statsbygg office, the agency entrusted with physically maintaining the Seed Vault. I couldn't believe there could be water coming in, much less a flood, prior to the summer melt. Bente wrote back: "Nothing has happened in the Vault now, it's still winter and cold in Longyearbyen." Water had gotten into the tunnel unusually in October the previous year, indeed more than ever before. The report cited this. Some was pumped out; the rest froze before it could be pumped.

The entrance to the actual vault rooms where seeds are stored is protected by a set of two doors to create an air lock. In elevation, it's also above the low point that one passes through in the tunnel before getting to the vault rooms. Any water overwhelming the second drainage system at the lowest elevation and managing to rise enough to reach the first door would freeze and create a barrier to the entry of water into the vault room. It wouldn't get past the first of the two doors. Indeed, not a drop of water during the "flood" ever managed to intrude. Had it, it would have encountered a temperature of -18C with seeds in sealed packets inside sealed boxes on shelves above the floor, and the water would, of course, have frozen solid.

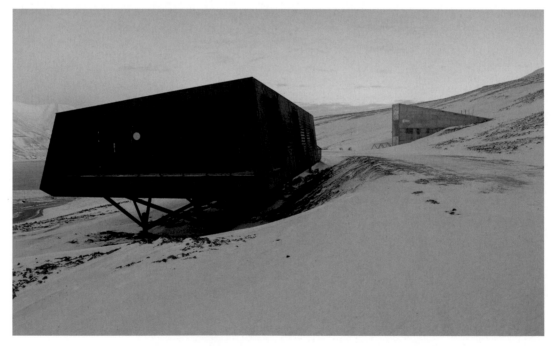

In the foreground, the new facility that houses offices, electric and cooling equipment, and a visitors' center.

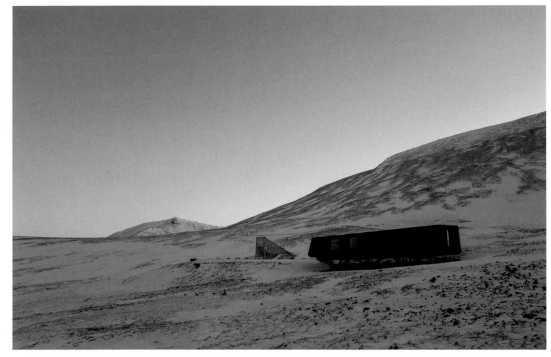

In other words, there was no danger to the seeds or the initiative, except the considerable loss of confidence, however unwarranted, that the situation and associated media reports were causing. I pondered the irony that the Seed Vault has not infrequently been described as a Noah's Ark for seeds. Both, it seems, survived their floods.

The International Advisory Committee expressed its concern formally and informally. The committee and the government had for some years endeavored to understand and correct the problem of water intrusion. Studies and remedial measures were undertaken, obviously without complete success. It is not easy to see what cannot be seen inside a mountain. What became clear was that the permafrost was not going to provide a reliable barrier against snow melt water leaking into the access tunnel. The decision was taken to correct the problem once and for all. The Norwegian Parliament authorized 200 million Norwegian crowns (a little less than $20 million at current exchange rates) to make the access tunnel completely watertight and institute a suite of other improvements.

Work commenced in 2018 and was completed in early 2019. The original access tunnel was removed. In its place, crews built and sealed a new tunnel drawing on the technology employed by oil platforms in the North Sea for waterproof legs anchoring those platforms to the seabed. All doors—there were five in total between the outside world and the room with the seeds— were replaced.

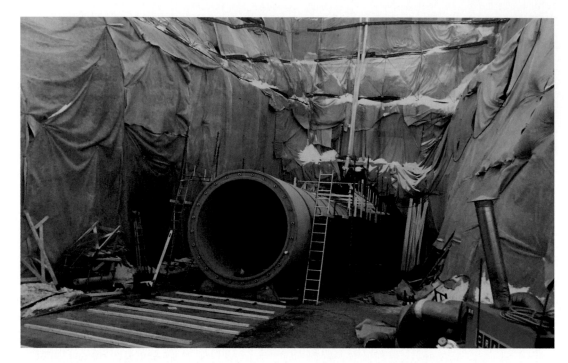

Above
New waterproof
tunnel
section under
construction.

Below
New tunnel
section
connecting
to the portal
building.

49 / 04.06.2018

Thick bank-vault style doors were added, as was a sophisticated new security system never mind that there still has never been a threat or a security issue at the facility. New, low-energy lighting systems replaced the old. All cooling equipment previously housed in the Portal Building was removed and a new system placed in a separate equipment and visitors' center built apart from the Seed Vault. This eliminated all internal sources of heat created by the machinery and electronics.

The visitors' center—not routinely staffed and open only occasionally—provides a space where groups can be assembled to hear about the Seed Vault and how it operates. In the interest of maximizing security, the Norwegian government has taken the decision not to grant entry to the Seed Vault to anyone other than those who have official duties there. In practice, this means that only staff of Statsbygg and Nordgen enter to monitor systems and perform routine maintenance, in the case of the former, and to put incoming samples into the Seed Vault, in the case of the latter.

The Seed Vault was constructed with three separate vault rooms to contain 4.5 million samples, considerably more unique types (i.e., not multiple copies of the same sample), than are believed to exist. I doubted that I would live to see the first room full; happily, I was wrong. With the influx of samples, the decision was taken to open a second room. The original room could still accommodate more samples, but for convenience a staging area in the front of the room was left without shelving, thus decreasing its capacity. If the Seed Vault continues to follow its mandate and conserve only samples thought to be unique, it will be decades, centuries or perhaps never that the second room will be filled. But just in case, there's a third room the same size as the first two.

LOOKING AHEAD

The chief task of the Seed Vault is to ensure that the genetic diversity of our agricultural crops is conserved forever and thus remains a resource for future crop breeding. The Seed Vault's immediate constituency is the genebanks that contribute duplicate copies of their collections for safeguarding in case anything goes wrong in their facilities. Much can go wrong as the conflict in Syria demonstrated, leading to the relocation of one of the world's largest crop breeding institutes and the repatriation of their seed collection that underpinned those efforts. Today, conflicts rage in other countries. One can imagine, for instance, that the thousands of samples collected in and provided by Ukraine, one of the world's breadbaskets, will someday make the trip back to Ukraine from Svalbard.

Eight hundred million people are food insecure today. Efforts to promote food security face an historically unique set of major challenges, including climate change, conflict, pandemics such as COVID, stagnating agricultural research and development budgets, trade restrictions, and the many and diverse vulnerabilities of seed collections maintained in buildings nationally and privately.

As impressive as the numbers are of samples now safeguarded in Svalbard, some national genebanks with considerable unique crop diversity have yet to make use of the free insurance policy that depositing duplicate samples in Svalbard provides. Notably, China, Ethiopia, and Japan have not yet participated, and India and Russia have deposited only sparingly. I hope all will someday put aside politics or pride or whatever motivates them to eschew this added layer of protection for their own crop diversity, which is so important for the entire world. It is a common heritage of all humankind to which all owe the duty of stewardship. I further hope that the collection and conservation of "minor" but very important indigenous crops, as well as the wild relatives of all our domesticated crops, will receive much more attention and be further collected and conserved before it is too late. These crops and this diversity are critically important to strengthening the resilience of our food systems and to the provision of good nutrition for all. The Food and Agriculture Organization of the United Nations and the Global Crop Diversity Trust are well positioned to lead the necessary efforts.

When the Svalbard Global Seed Vault opened in 2008, it inspired and gave hope that humanity could successfully steward this vital resource. It delivered. It remains and I hope will always be, in the words of UN Secretary General Ban Ki-Moon, "an inspirational symbol of peace and food security for the entire humanity."

APPENDIX A: RESOURCES

**The Seed Portal of the
Svalbard Global Seed Vault**
www.nordgen.org/sgsv/
The site for practical information regarding deposit of seeds, etc. It also provides an inventory of what is in the Seed Vault by crop, depositing institute, and country from which the sample was initially collected.

**The three partners in
the Svalbard Global Seed Vault**
**Norwegian Ministry of
Agriculture and Food**
www.seedvault.no
The government's website
for the Seed Vault.

Nordic Genetic Resource Center (NordGen)
http://www.nordgen.org/index.php/en/
content/view/full/2
Information about the Seed Vault and
the center's broader conservation activities.

Global Crop Diversity Trust
www.croptrust.org
Here you will find news and information about the Seed Vault as well as about the larger effort to ensure the conservation and availability of crop diversity forever.

Additional Internet resources
**International Treaty on Plant Genetic
Resources for Food and Agriculture**
www.planttreaty.org

**FAO Commission on Genetic Resources
for Food and Agriculture**
http://www.fao.org/ag/cgrfa/default.htm

**Consultative Group on International
Agricultural Research (CGIAR)**
www.cgiar.org

Bioversity International
www.bioversityinternational.org

And for Information about Svalbard
The Governor of Svalbard
www.sysselmannen.svalbard.no/eng/

Published Resources
Evans, Lloyd T. *Feeding the Ten Billion: Plants and Population Growth.* Cambridge University Press, 1998.

FAO. The State of the World's Plant Genetic Resources for Food and Agriculture, 1998.

Fowler, Cary and Pat Mooney. *Shattering: Food, Politics and the Loss of Genetic Diversity.* University of Arizona Press, 1990.

Fowler, Cary and Toby Hodgkin. "Genetic Resources for Food and Agriculture: Assessing Global Availability." *Annual Review of Environment and Resources*, 2004.

Fowler, Cary, William George, Henry Shands, Bent Skovmand. "Study to Assess the Feasibility of Establishing a Svalbard Arctic Seed Depository for the International Community." Prepared for the Ministry of Foreign Affairs (Norway). Center for International Environment and Development Studies. Agricultural University of Norway, 2004.

Harlan, Jack R. *Crops and Man.* American Society of Agronomy and Crop Science Society of America, 1975.

Hermansen, Pål. Svalbard Spitsbergen Guide. Myrland Media/Gaidaros forlag, 2007.

Møkleby, Torgeir and Steward Simonsen. *Tragedy in Kobbebukten: The Diaries of Møkleby and Simonsen on Danskøya*. http://polarlitteratur.no/hefter.htm.

Qvenild, Marte. *Sowing Seeds in Permafrost: An Idea Whose Time Has Come. Master of science thesis*. Department of International Environment and Development Studies, Norwegian University of Life Sciences, 2005.

Seabrook, John. "Sowing for Apocalypse." *New Yorker*, August 27, 2007, 60. Interview at http://www.newyorker.com/reporting/2007/08/27/070827fa_fact_seabrook.

Slatsbygg. Svalbard Global Seed Vault (undated), http://www.statsbygg.no/files/publikasjoner/ferdigmeldinger/671_SvalbardFrohvelv.pdf.

Multimedia Resources

Seeds of Time, an award-winning feature-length documentary about the Seed Vault and the effort to conserve crop diversity: http://www.seedsoftimemovie.com.

A Journey to the Doomsday Vault, CBS's *60 Minutes*: http://www.cbsnews.com/news/a-visit-to-the-doomsday-vault/.

One Seed at a Time: Protecting the Future of Food. (TED talk by Cary Fowler): http://www.ted.com/talks/cary_fowler_one_seed_at_a_time_protecting_the_future_of_food.

APPENDIX B: FOR THE RECORD: THE INSTITUTIONS AND PEOPLE BEHIND THE SVALBARD GLOBAL SEED VAULT

Partners
Royal Norwegian Ministry of Agriculture and Food, on behalf of Norway
Nordic Genetic Resource Center
Global Crop Diversity Trust

Planning and Construction Stage: 2004–2008
Feasibility Study Committee
Cary Fowler (chair)
William George
Henry Shands
Bent Skovmand
Geoff Hawtin (observer)
Marte Qvenild (research assistant)

Building Commissioner
Statsbygg

Property Manager
Statsbygg Nord

Steering Group
Geir Dalholt (chair)
Grethe Evjen
Jostein Leiro
Anne Kristin Hermansen
Jan Petter Borring
Idunn Eidheim
Oskar Petter Jensrud
Royal Norwegian Ministry of Government Administration and Reform
Kirsten Vesterhus
Ingegjerd Nordeng
Hilde Nordskogen

**Construction Project Group
at Statsbygg**
Magnus Bredeli Tveiten
 (project manager)
Rolf Jullum (building and geo)
Pål Inge Waage (mechanical service)
Jan Erik Jensen (electrical)
Tore Gloppe (finance)

Planning Group
Barlindhaug Consult AS, Tromsø
 (overall planning)
Dag Brox (project group leader:
 Longyearbyen)
Bjørnar Løvhaug (project group
 coordinator: Tromsø)
Peter W. Søderman MNAL, Barlindhaug
Consult AS (architect)
Sverre Barlindhaug (consultant
 geotechnical engineer)

Landscape Architect (Multiconsult AS)
Ivar F. Nilsen
Thormod Sikkeland

Barlindhaug Consult AS
Erik Wikran (concrete engineer)
Ulf Hjorth-Moritzsen (electrical,
 engineer)
Kurt Olaussen (heating, ventilation,
 air conditioning)

Clerk of Works
Barlindhaug Consult AS,
 Longyearbyen office

Contractors
Leonhard Nilsen og Sønner AS,
 Risøyhhamn

Subcontractors
Jensen Elektriske (electrical)
ORAS, Trondheim (ventilation)
Spitsbergen VVS (refrigeration)

**The Construction Team
(both Svalbard and Tromsø based)**
Dag Brox (Svalbard construction
 manager)

Jarle Berg-Oksfjellelv (site manager)

Kjell Abrahamsen, Tommy Albrigtsen,
Henri Amundsen, Ronald Amundsen,
Tommy Amundsen, Geir Anderson,
Richard Barslett, Bjørn Berntsen, Ola
Berntsen, Bjørn Arne Bjørkmo, Roger
Bladin, Vegard Blom, Richard Brekke,
Bjørn Brekmo, Arve Bertil Brækkan,
Jon Magne Bugge, Knut Bårdseth,
Ola Magnus Båtstad, Jack Edvardsen,
Harald Eilertsen, Arne Elgåen, Geir
Olav Ellingsen, Johan Eriksson, John
Petter Eriksson, Knut Fastvold, Jon
Kåre Fiskum, Bugge Joachim Førde, Hans
Martin Galleberg, Christian Gangstø,
Håkon Gausdal, Odd Morten Grønningen,
Roger Grøtan, Eirik Jessen Gschib,
Gunther Rikard Gschib, Michel Gyøry,
Gudmund Jarle Hansen, Magnus Hansen,
Stig Ernst Hansen, Pål Lovin Hansen,
Einar Ståle Haugen, Sigbjørn Haugen,
Svein Robert Helgesen, Dag Waldemar
Hekne, Øystein Andre Hofstad, Tom
Rickard Holm, John Lennart Horn,
Stein Isaksen, Trond Isaksen, Kjell
Jacobsen, Einar Asbjørn Johannessen,
Knut Johannessen, Andreas Johansen,
Bjørn-Ruben Johansen, Ole Jørgen
Johansen, Risto Johansen, Vidar
Johansen, Kurt-Eirik Johnsen, Leif
Kuno Jolanki, Stig Arne Jonsson,
Kjell-Arild Jørgensen, John-Ewald
Karlsen, Kim Kristiansen, Johan Krokå,
Johnny Krokå, Leif Erik Kvinnegård,
Vidar Langnes, Geir Larsen, Jørn Tore
Larsen, Rolf Larsen, Tommy Larsen,
Timo Olavi Leinonen, Jonas Lissner,

Thomas Lissner, Atle Morten Lynge, Oddbjørn Løseth, Gudmund Løvli, Paul-Ivar Mathisen, Thomas Moaksen, Rudolf Moen, Espen Mortensen, Tom Andre Mortensen, Eirin Helen Myrvang, Jochen Mønning, Geir Arne Nicolaisen, Bengt Olav Nikolaisen, Arnt Nilsen, Per Erling Nordby, Mats Are Nyland, Cato Andre Olsen, Jimmy Olsen, Rune Olsen, Svein Kåre Paulsen, Geir Arne Pedersen, John Anders Pedersen, Ola Pepke, Harald Pettersen, Norvald Pettersen, Odd Erik Pettersen, Kjell Rask, Øyvind Reppe, Jon Richardsen, Rolf Rustad, Frank Arne Velsvik Ruud, Kåre Magne Ruud, Bjørn Rønneberg, Arne Rørvik, Yngve Johan Salomonsen, Jim Sandberg, Martin Sandnes, Gunnar Sandvei, Raymond Skarstein, Herbjørn Simonsen, Inge Skogli, Jarl Skogli, Siril Sneve, Trond Solbakk, Rune Solberg, Vegard Solberg, Arne Steinstø, Stefan Sunde, Terje Joar Sve, Torbjørn Sverkmo, Tore Sæverås, Marius Sørensen, Tone Terjesen, Reidar Thoresen, Terje Thoresen, Tord Tofte, Ruben Torkildsen, Arne Tørvik, Iver Traaseth, Olav Tuftene, Benny Tuven, Vidar Anders Vadnem, Knut Vassdal, Linda Marie Vassdal, Karstein Vie, Ledvin Wang, Lars-Erik Wyren, Arnt Øvergård, Odd Terje Øyeflaten, Geir Hugo Øynes, Grete Marie Aabrekk, Tom Aamodt.

Art Project
Public Art Norway (KORO): Elisabeth Tetens Jahn (project executive)

Art Committee
Jenny-Marie Johnsen (chair)
Geir Dalholt
Peter W. Søderman
Magnus Bredeli Tveiten

Artwork
Perpetual Repercussion by Dyveke Sanne

Operations Stage: 2008
Nordic Genetic Resource Center (NordGen)
Jessica Kathle (center director),
Erling Fimland (center director),
Arni Bragason (center director)
Ola Westengen (coordinator of operation and management, Svalbard Global Seed Vault)
Åsmund Asdal (coordinator of operation and management, Svalbard Global Seed Vault, from August 2015)
Simon Jeppson (seed store manager at NordGen)
Dag Terje Endresen (information technology)
Johan Bäckman and Jonas Nordling (information technology and logistics)
Eva Jorup Engstrom (economy)
Roland von Bothmer (relations with media and visitors)

Global Crop Diversity Trust
Cary Fowler (executive director, 2005-2012)
Marie Haga (executive director, 2013-)
Julian Laird (fundraising, and communications)
Mellissa Wood
Luigi Guarino
Godfrey Mwila
Charlotte Lusty
Gerald Moore (legal)
Jane Toll (project manager, seed regeneration)
Amanda Dobson (transportation arrangements for seed)
Anne Clyne (finance)
Jenin Assaf

Melly Preira
Brian Lainoff
Fernando Gerbasi (chair, interim panel
 of eminent experts)
Margaret Catley-Carlson (chair,
 executive board)

**Norwegian Ministry
of Agriculture and Food**
Geir Dalholt
Pål Vidar Sollie
Grethe Evjen
Marianne Smith
Heidi Eriksen Riise
Elisabeth Koren

Norwegian Ministry of Foreign Affairs
Jostein Leiro
Anne Kristen Hermansen

Ministry of Environment
Jan Borring
Birthe Ivars

Statsbygg (Longyearbyen)
Tor Sverre Karlsen
Bente Naeverdal
Tom Oredalen
Tommy Sjoo Frantzen
Steinar Strøm
Morten Andreassen
Audun Fossheim
Magne Skogstad

Seed Transportation Arrangements
Global Crop Diversity Trust
NordGen
JetPak
Pole Position, Longyearbyen

Funding for seed multiplication
 and transportation provided by
 the UN Foundation and Bill
 & Melinda Gates Foundation

Public Relations
Burness Communications
 Jeff Haskins
 Ellen Wilson
 Megan Dold
 Coimbra Sirica
 Andy Burness

**Svalbard Global Seed Vault
International Advisory Council**
Cary Fowler (chair)
Jean Hanson
Modesto Fernandez Diaz-Silveira
Emile Frison
Lawrent Pungulani
Wilhelmina Pelegrina
Ruth Haug
Arne Malme
Shivaji Pandey
Javad Mozafari
Zachary Muthamia
Bert Visser
Linda Collette
Ruraidh Sackville Hamilton
Guri Tveito
Nori Ignacio

Parties to the Treaty of Svalbard
Afghanistan, Albania, Argentina,
Australia, Austria, Belgium, Bulgaria,
Canada, Chile, China, Czech Republic,
Denmark, Dominican Republic, Egypt,
Estonia, Finland, France, Germany,
Greece, Hungary, Iceland, India,
Italy, Japan, Korea (DPR), Lithuania,
Monaco, Netherlands, New Zealand,
Norway, Poland, Portugal, Romania,
Russia, Saudi Arabia, South Africa,
Spain, Sweden, Switzerland, Ukraine,
United Kingdom, United States of
America, Venezuela.

**For more information about the book,
the issue and upcoming events,
visit: www.seedsonice.com**

ACKNOWLEDGMENTS

The Svalbard Global Seed Vault would not exist were it not for the contribution of millions of farm families throughout history, or the efforts of scientists and genebank managers who collected, conserved, and then safely duplicated this crop diversity in Svalbard. Our first and deepest acknowledgment must be to this history and these people.

Elements of *Seeds on Ice* necessarily reflect my personal history with Svalbard and its Seed Vault. Involvement with the Seed Vault and the remarkable people associated with it has been one of the greatest and most gratifying experiences of my life. I am indebted to the many people and organizations, including but not limited to those listed in the annex, who made the Seed Vault, and by extension this book, possible. Special thanks go to my friends and colleagues Ola Westengen and Simon Jeppson for patiently supplying me with information during the writing process.

Huge thanks are due to M Mark for her skillful editing of the text of this book and for her joyful encouragement.

Special thanks to Hege Njaa Aschim and Colin Khoury and also to Heather Jones.

I am grateful to Doyle Partners, particularly Stephen Doyle, Ben Tousley, and Rosemarie Turk, for their elegant and creative design work, as well as to David Wilk at Prospecta Press for his commitment to the publishing of this book, and to Staci MacKenzie for making this beautiful revised edition.

Seeds on Ice would never have been published were it not for my favorite gardener Amy Goldman Fowler's insistence and support. Her additional help with editing improved the text considerably. I thank Amy, my sons Martin and Thomas, and my entire family for their trust, encouragement, and understanding.

PHOTO AND MAP CREDITS

All photos are by Mari Tefre unless noted here:
Jim Richardson: PAGES 2-3, 16, 19 (ABOVE), 22-23, 76, 79,
85, 87 (ABOVE), 88, 91, 95, 103, 109, 129, 135.
Cary Fowler: PAGES 7, 12, 44-45, 56-57, 80, 82, 87 (BELOW),
96, 119 (MIDDLE LEFT), 131 (TOP ROW), 157
NordGen: 154, 156, 160-161, 166
Mike Ramsden / Global Crop Diversity Trust: PAGES 148, 149 (ABOVE)
Audun Rikardsen: PAGES 60-61
Peter Søderman: PAGE 120
International Rice Research Institute: PAGE 92
Illustration of Seed Bank on page 162 by @MSJONESNYC
Map design on page 132 by Levi Westerveld
Map, Pages 158-9, courtesy of Proceedings of the Royal Society B,
https://royalsocietypublishing.org/doi/10.1098/rspb.2016.0792; Used by permission

Cary Fowler led the initial effort to establish the Svalbard Global Seed Vault. He chaired the committee that assessed feasibility and developed the plan. Fowler currently serves as chair of the International Advisory Council that oversees the Seed Vault's operations. He is a former executive director of the Global Crop Diversity Trust, an international organization and endowment fund, one of three partners operating the Seed Vault.

In 2015, President Barack Obama appointed Dr. Fowler to the seven-member Board for International Food and Agricultural Development (BIFAD). Dr. Fowler is a visiting scholar at Stanford University. He is vice-chair of the board of trustees of Rhodes College, a member of the New York Botanical Garden Corporation, and an elected member of the Russian Academy of Agricultural Sciences.

In the 1990s, Fowler oversaw the United Nation's first global assessment of the state of the world's plant genetic resources. He drafted and supervised negotiations of FAO's Global Plan of Action for the Conservation and Sustainable Utilization of Plant Genetic Resources for Food and Agriculture, adopted by 150 countries in 1996. That same year he served as special assistant to the secretary-general of the World Food Summit.

Fowler is a past board member of the National Plant Genetic Resources Board of the United States, the Livestock Conservancy, Seed Savers Exchange, and the International Maize and Wheat Improvement Center in Mexico. He was a visiting professor at the University of California, Davis. Dr. Fowler was formerly professor and director of research in the Department for International Environment and Development Studies (NORAGRIC) at the Norwegian University of Life Sciences, and was a senior advisor to the director general of Bioversity International.

Fowler is the author or co-author of several books on the subject of crop diversity. He earned his PhD at Uppsala University (Sweden) and holds honorary doctorates from Simon Fraser University (Canada), Oberlin College, and Rhodes College (USA) and received the Thomas Jefferson Medal for Citizen Leadership from the University of Virginia and the Thomas Jefferson Foundation. He is a recipient of the Right Livelihood Award, the Heinz Award, the William Brown Award of the Missouri Botanical Garden, the Meyer Medal given by the Crop Science Society of America, and the Vavilov Medal. He is an elected member of the Russian Academy of Agricultural Sciences.

Cary Fowler has been profiled by CBS's *60 Minutes* and the *New Yorker* and is the subject of the documentary film *Seeds of Time* (www.seedsoftimemovie.com). In 2009, he gave a celebrated TED talk at Oxford. A native of Tennessee, he now resides on a farm in the Hudson Valley of New York.

In April 2022, President Biden appointed Fowler to be the Special Envoy for Global Food Security at the U.S. Department of State.

Mari Tefre is a renowned Norwegian photographer of the far north. On a trip to Svalbard over ten years ago, she was smitten by its spectacular wilderness and arctic light, and subsequently set up residence there. Her photographs have been published widely in leading newspapers and magazines around the world, and they appear in film and television.

In 2007, Tefre entered into a relationship with the Global Crop Diversity Trust to document the construction of the Svalbard Global Seed Vault. This allowed her unfettered and unparalleled access to the Seed Vault during its construction, stocking, and normal operational periods. Mari produced thousands of images of the Seed Vault and its surrounds in all seasons of the year.

After finishing her studies in media and journalism at Volda University College, she began her professional career as a director at the Norwegian Broadcasting Corporation (NRK). Mari produced, directed, and developed magazine programs; and she appeared on air in a daily live broadcast magazine for teens. Mari also served as a cameraperson on LET productions at NRK. She was a leading actress on *Egil & Barbara*, a popular Norwegian television comedy program. Mari is an accomplished vocalist in a bluegrass band. More recently, she directed and produced *Polar Eufori*, a deeply affecting cinematic and musical declaration of love to Svalbard with universal appeal.

Mari is now based in Oslo, where she planned a media event for the two-hundredth anniversary of Norway's constitution, and the celebrations surrounding the twenty-fifth anniversary of the king and queen's monarchy. Much of her heart remains in Svalbard, with its people, its natural splendor, and its polar bears.

A SPECIAL NOTE OF APPRECIATION TO JIM RICHARDSON

We are deeply indebted to famed *National Geographic* photographer Jim Richardson. Jim visited Svalbard and the Seed Vault on assignment for the story "Food Ark," published in the magazine in July 2011. He subsequently volunteered to donate hundreds of his images to the Global Crop Diversity Trust to help publicize the beauty and importance of crop diversity. We are grateful for his generosity. In the pages of this book his images bring to life the farming communities of the world that have nurtured and provided diversity for millennia, and provide his unique view of the Seed Vault itself. Readers can learn more about Jim, and see more of his work at www.jimrichardsonphotography.com.